Life is like
an exquisite flower
nurtured in fresh water
seeking the light
perennial with care
and a delight
well shared.

Wishing the two of you
a long, healthy,
joyful life
together.

With love,

Chantal & Larry

1/9/11
for Gayle & Brian ♡

THE
GARDEN
AT
NIGHT

*Gayle & Brian
To the magic of
nature —
Enjoy!
Linda Rutenberg*

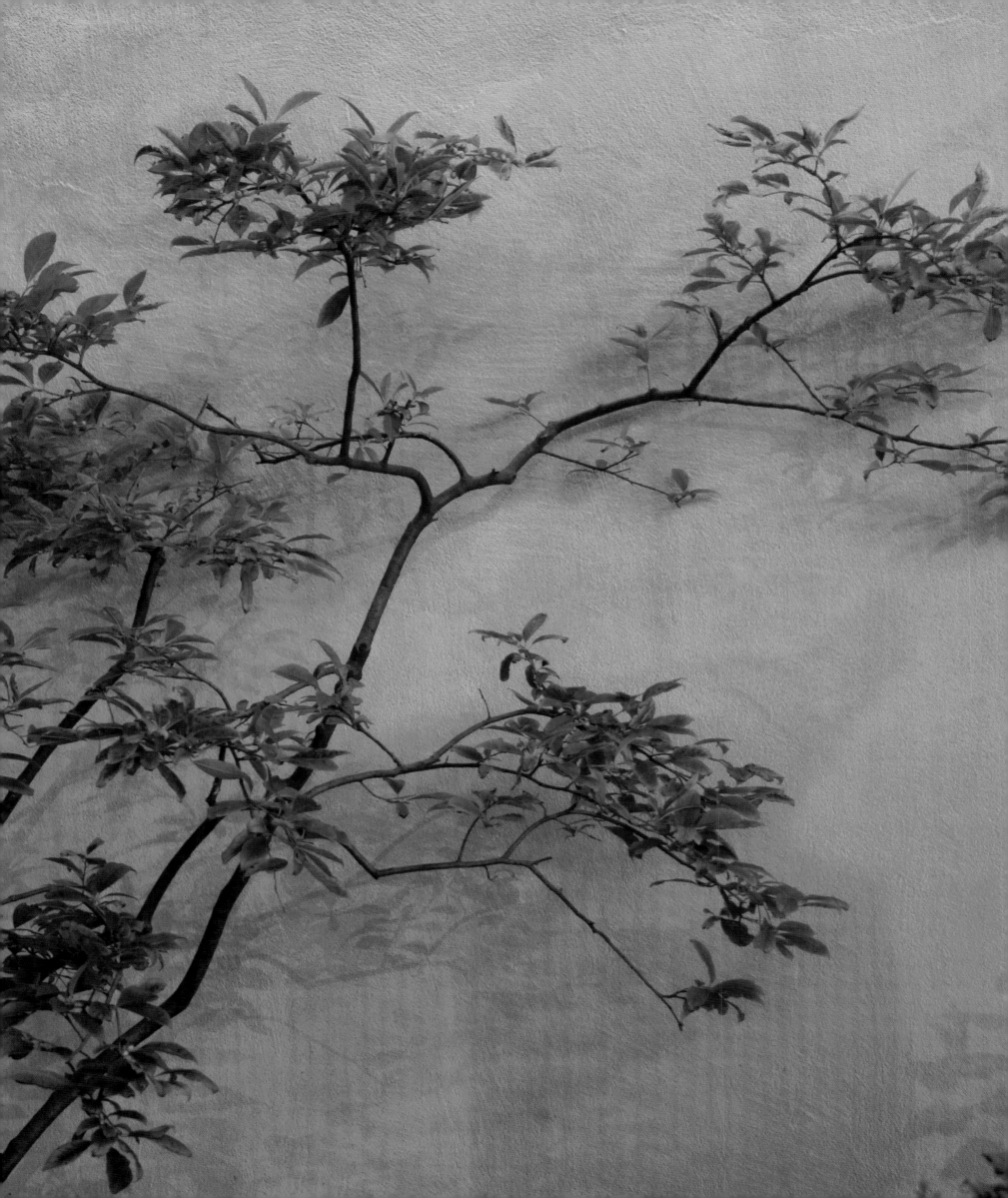

THE GARDEN AT NIGHT

PRIVATE VIEWS OF PUBLIC EDENS

PHOTOGRAPHS BY LINDA RUTENBERG

WITH ROGER LEEON

FOREWORD BY WILLIAM SHATNER

INTRODUCTION BY CHRISTOPHER DEWDNEY

CHRONICLE BOOKS

SAN FRANCISCO

Library of Congress Cataloging-in-Publication Data available.

ISBN-10: 0-8118-6133-3

ISBN-13: 978-0-8118-6133-5

Manufactured in China.

Developed and produced by Gary Chassman

Designed by Kari Finkler.

Copyedited by Myles McDonnell and Elizabeth S. Shanley.

Distributed in Canada by Raincoast Books

9050 Shaughnessy Street

Vancouver, British Columbia V6P 6E5

10 9 8 7 6 5 4 3 2 1

Chronicle Books LLC

680 Second Street

San Francisco, California 94107

www.chroniclebooks.com

www.verveeditions.com

Cover: Peony, Montreal Botanical Garden

Back cover: American lotus, Montreal Botanical Garden

Page 2: Chinese Garden, Montreal Botanical Garden

Page 5: Bromeliad, Fairchild Tropical Botanic Garden

Page 6: Vizcaya Museum and Gardens

Pages 170–171: Roses, Harry P. Leu Gardens

Page 173: Bird-of-paradise, Descanso Gardens

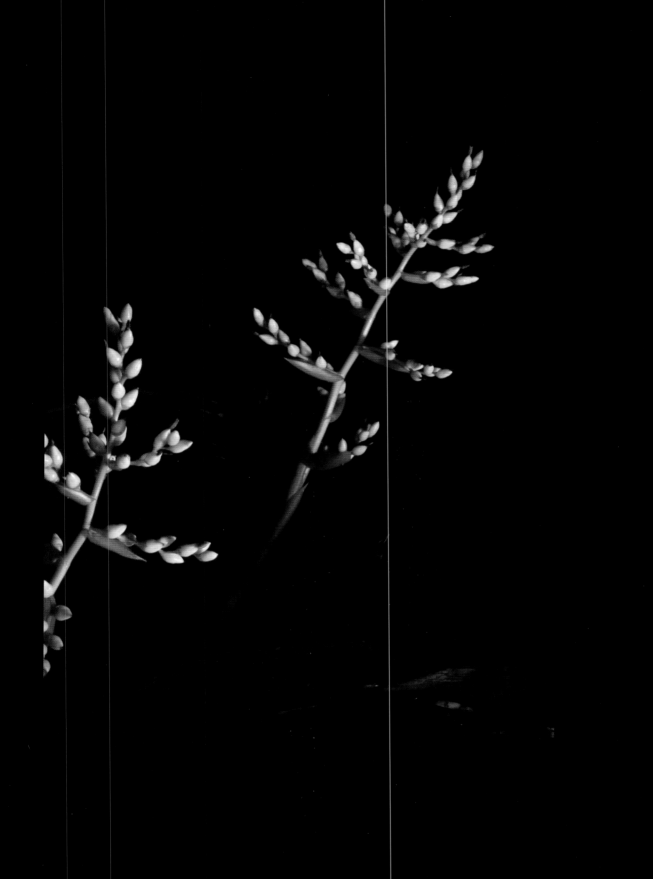

TO THE THREE SIGNIFICANT MEN IN MY LIFE—

MY FATHER, MY HUSBAND, AND MY SON.

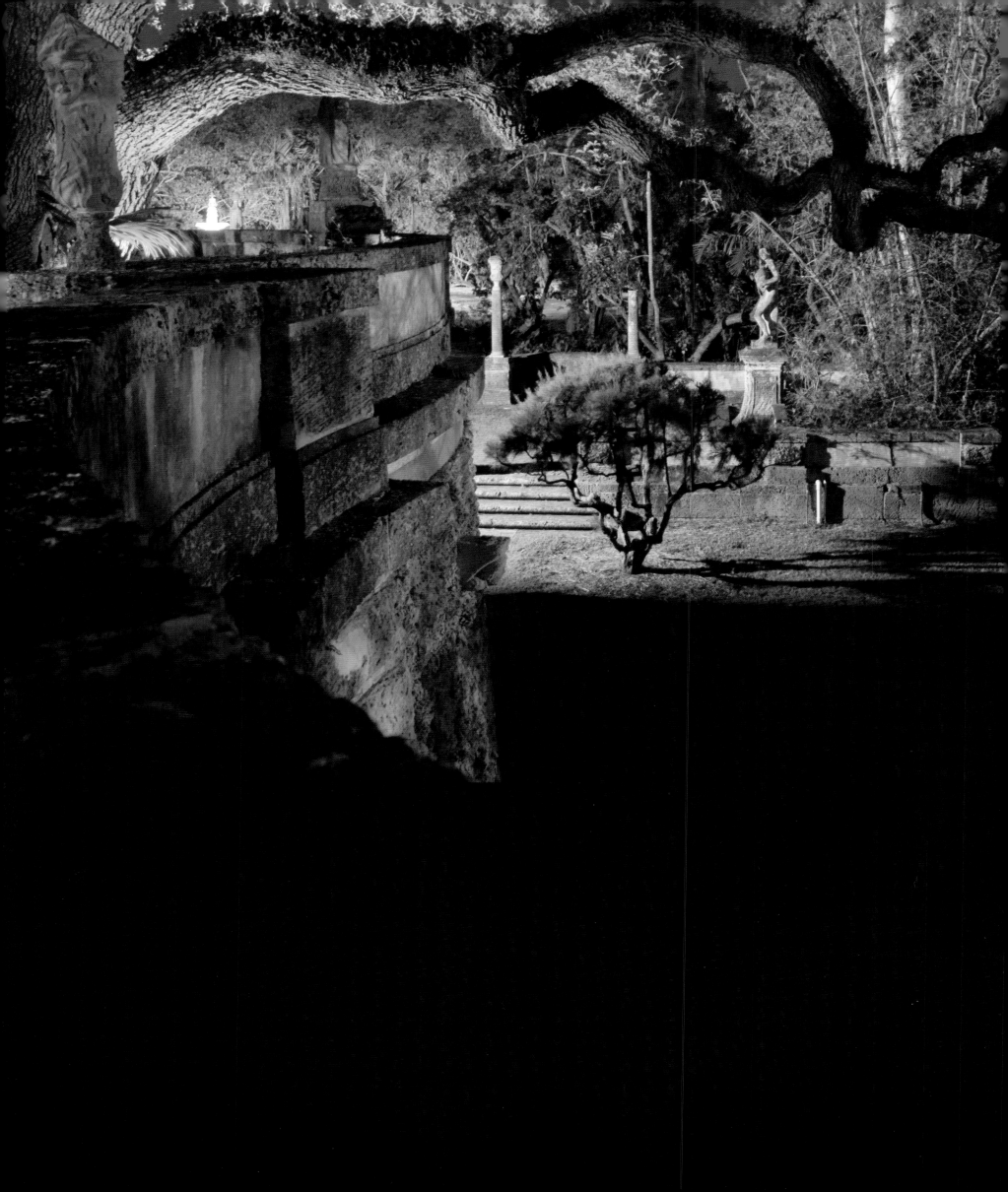

CONTENTS

IN THE REALM OF THE NIGHT

William Shatner

I WAS A CITY KID. I was 12 or 13 at a summer camp. When I looked up at the night sky without the lights of the city for the first time, I fell over backwards. I just lay there for what felt like a long time. Soon, my other senses were heightened. I could feel the dampness and texture of the grass, the rustling of leaves shimmering in moonlight. I stared straight up—until the light from the moon and stars vividly illuminated my own private world. Everywhere was darkness.

Ever since that instant of discovery, I have chosen the night. Black, bleak, dense, dull, dangerous, foreboding. These are some of the words that influence our perception of the night. Not for me. I seek the night. I shake my head in wonder at the way we try to escape it. All but a few cities throughout the world turn night into day, flooding the streets and buildings with simulated daylight. Proclaiming their dominance over nature. But not for long—as measured by the life of the universe. But night will claim its own.

Taste of it, see the northern lights, walk through a field of tall grass under a full moon, wander the streets in your own neighborhood. Make love, sleep, wait, watch; an ineffable experience awaits. Much like the imagined vastness of space, entering the domain of the night is an experience of quiet but not silence, light rather than dark. Night allows an awakening of the senses, a heightened awareness of the beauty—and a perception of the eloquence—of the natural world.

This beauty forms the essence of what Linda Rutenberg is searching for—an instant frozen in time, that so perfectly reveals the other worlds of the night. So it is with these photographs, taking you where few choose to go, and offering a gift of a rarely visited world—the realm of the night. There is much to see and know. Go there—now.

NEW YORK BOTANICAL GARDEN

INTRODUCTION

CHRISTOPHER DEWDNEY

Outside, the island was striped and patched in black and silver by moonlight. Far down in the dark cypress trees the owls called to each other comfortingly. The sky looked as black as mole-skin covered with a delicate dew of stars. The magnolia tree loomed vast over the house, its branches full of white blooms, like a hundred miniature reflections of the moon, and their thick, sweet scent hung over the veranda languorously; the scent was an enchantment luring you out into the mysterious, moonlit countryside.
—GERALD DURRELL, *MY FAMILY AND OTHER ANIMALS*

EVERY EVENING we ride the spinning earth into a mysterious domain—the kingdom of night. This realm is filled with wonders, yet its treasures go largely unseen because we are prisoners of light. The cones of our retinas, designed to detect color and detail, begin to fail as twilight descends, while the rods, which see *only* detail, start to take over. As the darkness deepens we progressively lose the ability to discern colors—blue is first to fade, then green and yellow, until only red is left. And then even red dims to grey after night has fully established itself.

That is why pigments at the warm end of the spectrum—deep Venetian yellows, Masaccio oranges, florid purples, and tropical crimsons—dominate Linda Rutenberg's dreamlike and strangely luscious photographs. But her photographs capture another aspect of our adaptation to darkness as well . . . Once we lose our sight, our other senses blossom. Touch is heightened, as is hearing. Even our sense of smell is enhanced, so that the perfumes of night-scented flowers—of lilacs, gardenias, and narcissus—seem more fragrant. Intermingling with all these scents are the subtle pheromones of moths that flit unseen

above them—their humming wings are inscribed with marvelous designs every bit as lovely as the flowers they visit. If we shine a little light on these wonders, an extraordinary, fascinating world is revealed.

The twilit garden, like the night forest, is a realm of the exotic and the unknown. Its dark depths harbor dreams and unspoken desires. No wonder these uncommon photographs trigger such visceral responses. They link us to the natural world and to the inner one. But these flowers, foliage, and landscapes are also gestural. An unfolding fiddlehead, frankly erotic with its russet down, aspires and thrusts; a line of tree trunks seem caught in the midst of a surreptitious advance, like the creeping forest of Elsinore in Shakespeare's *Hamlet*.

Indeed, there is much in these photographs of the enchanted forest of *A Midsummer Night's Dream*. Rutenberg's night garden evokes the inner, symbolic level of Shakespeare's play that Carl Jung mentioned in Alex Aronson's book *Psyche and Symbol in Shakespeare*. Here Jung spoke of the night forest as being similar to deep water, an abode of the mysterious and otherworldly. For Jung, the dark forest represented the

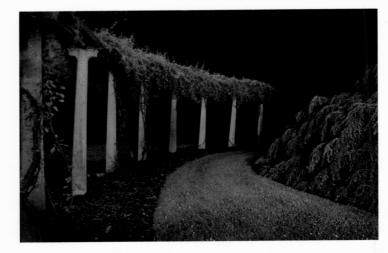

BROOKLYN BOTANIC GARDEN

unconscious, and the individual trees, like individual fish in bottomless ocean trenches, were living denizens of the unconscious. It is in this spirit that these nocturnal images explore the margin of dreams and twilight, the place where we experience the night as both enigmatic and beckoning.

The most inviting aspect of many of Rutenberg's images is the light. In some photographs it is rich and warm, like theatrical footlights, in others it has a cool, lunar radiance. With long shutter speeds she even exploits urban nightglow—a stone plinth surmounted by a decorative urn is bathed and silhouetted against the muted electric mauve of city light. Using predominantly nocturnal illumination—moonlight, city glow, even flashlights—together with a delicate, optical precision, she coaxes the best out of her light-shy subjects.

By contrast, her glowing subjects heighten the inky darkness that surrounds them. They appear to be transfixed in unearthly stillness—the stillness of night, yes, but also something more, something ambiguous. It seems paradoxical that within the vegetative statuary of these photographs, quiescent in the darkness, life is nevertheless stirring. These growing plants weave their cellular architecture on genetic looms whose pedigree holds the complexity of 60 million years of evolution. And their blossoms seem worth all the trouble—the luscious, dawnlike explosions of coral peonies

and pink hibiscuses. Even the blue passionflowers, tilting in the dark like UFOs, emit a preternatural glow. Somnolent poppies doze above budding leaves while, nearby, the alien shapes of insectivorous pitcher plants—both fantastic and uncanny—are seductively suspended on art nouveau tendrils. In another photo, a single amaryllis flames. And everywhere a muted gray-green leaks out of foliage, grass, tree trunks, and topiaries, like a kind of atmosphere. In turn, this verdant ambience amplifies and reinforces the everpresent ferns.

Textures are wonderfully heightened in Rutenberg's nocturnal garden—the wide, spreading leaves of a tropical lily appear to be fashioned from green velvet; the petals of a pink orchid glow with a skinlike translucence. There are evocative architectural tableaux as well, each with a cloistered, almost nostalgic atmosphere. In one photograph, two hanging pots of bushy ferns hang between a pair of Doric columns. The base of the limestone shaft is illuminated by a night light that smoothes the broad flagstones at its base. In another photograph, an empty, neo-classical pavilion with its filigreed dome seems conjured out of memory. Behind it, time-lapse windy foliage brushes the amethyst sky with acid green. These fantastic architectures are like the intact ruins of a vanished civilization left behind for the amusement of nocturnal creatures. What is their purpose? Are we trespassing here?

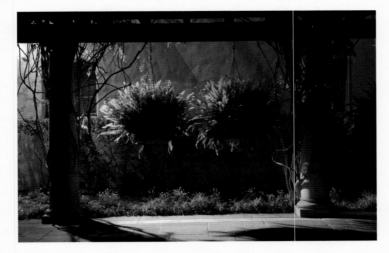

DEGOLYER PEGOLA, DALLAS ARBORETUM

Every photograph invites us into a kind of wonderland; a charmed locale that we can roam through in our imaginations. We are enticed by the lush, summer-rich foliage, the tropical ambience, and the spreading vistas. At every turn there is a new astonishment, a fairytale scene. Scale and proportion seem to lose their relativities in this dreamlike landscape. A bench beside a tree trunk looks absurdly small, something elves might use. But maybe the adjacent tree is huge, it is hard to tell. The settings inspire narratives. In the darkness behind the bench, below an opening in the foliage that reveals the electric pink of a city night, you half expect to see fabulous creatures moving in the twilight.

Perhaps we are guests at a deserted estate, whose urns and limestone stairs, niches and rusticated walls wait, like a stage set, for the first revellers of a midnight *carnevale*. Some of Rutenberg's photographs, particularly those of unpeopled nocturnal garden landscapes, remind me of a particular garden in the Yamaguchi prefecture of Japan. There, in Hofushi, an old family descended from samurai nobility tends a Zen garden called Tsuki Katsura. Katsura is the family's name, but *Tsuki* means "moon." According to legend, this austere and haunting garden, consisting only of raked gravel and large stones, was designed to be meditated upon in moonlight. Although I have never visited Tsuki Katsura by night, I can imagine the effect. Rutenberg's deserted gardens share a similar feeling of absence, mystery, and pensive silence.

There are times when these gardens appear to be submerged. The muted light has an aqueous quality, and some of the exotic plants look like seaweed or corals caught in the light of a deep-sea probe. We do not walk through these landscapes as much as we swim through them, like scuba divers in a twilit ocean—we float above the flowers and paths, the topiaries and buildings. These ornamental gardens resemble part of a horticultural Atlantis, forever immersed in the darkness at the bottom of the sea.

We have been invited here, even if we wander through these botanical landscapes in a trance. The leaves and flowers are ciphers, a series of occult signs that we must interpret in order to discern their meaning. But they are also signposts, perhaps, to the next marvel. We are reminded of the magic and mystery of Henri Rousseau's paintings of lush, tropical forests at night. Yet there is also a protective intimacy in the velvet depths of the multifoliate flowers and the plush green lawns. These flowers and foliage and cultivated landscapes are complete in themselves. Wrapped in the protective gloaming of night they dream their own shapes. The night holds many wonders, it seems. And with her photographs, Linda Rutenberg has laid claim to her own province in this enchanted domain.

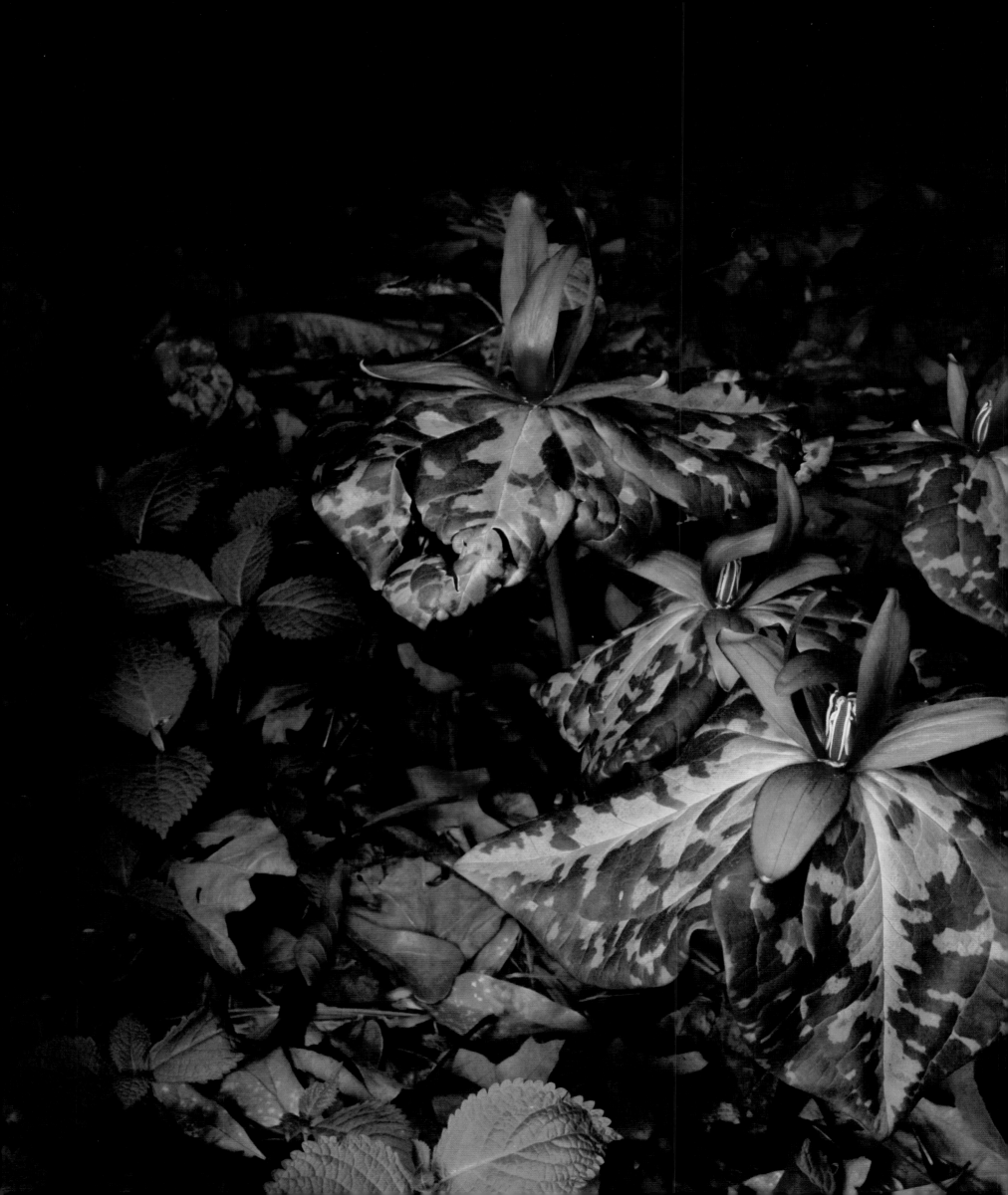

A Sensitive Plant in a garden grew,

And the young winds fed it with silver dew,

And it opened its fan-like leaves to the light.

And closed them beneath

the kisses of Night.

Percy Bysshe Shelley, "The Sensitive Plant"

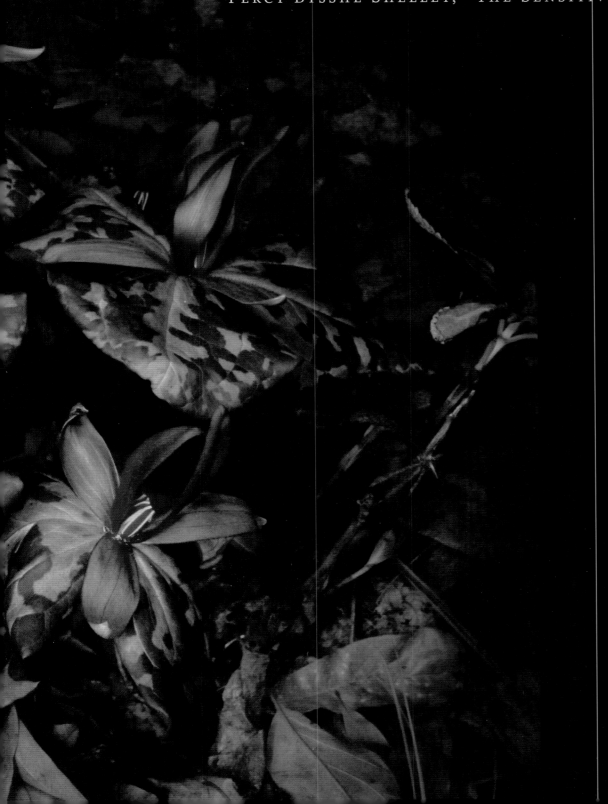

ATLANTA BOTANICAL GARDEN

brilliantly flowered

MAJESTIC 27-FOOT-TALL steel gates frame the entrance to Atlanta's thirty-acre botanical garden. The Storza Woods make up half of its area; one of the few remaining mature hardwood forests in the city, it has trees as varied as maple, oak, tulip poplar, beech, black cherry, hackberry, and flowering dogwood. The warm Southern climate allows this garden to be in bloom for all four seasons, with an impressive winter garden of witch hazels, daphnes, sweetboxes, camellias, hellebores, and wintersweets. The garden's collection of hydrangea is one of the finest in the Southeast and includes dozens of varieties in addition to its native *Hydrangea arborescens*. The five-acre Woodland Shade Garden creates a welcome retreat during the hot summer, attracting visitors with perennials like the native cobra lily (jack-in-the-pulpit) with its flowers of chartreuse, white, and purple. Habitat-themed plantings showcase rare plants of Georgia, and six themed bogs make up part of the educational

Pages 12–13: TRILLIUM—*TRILLIUM* *Above:* PHILIPPINE GROUND ORCHID—*SPATHOGLOTTIS PLICATA*
Opposite: PIEDMONT AZALEA—*RHODODENDRON CANESCENS*

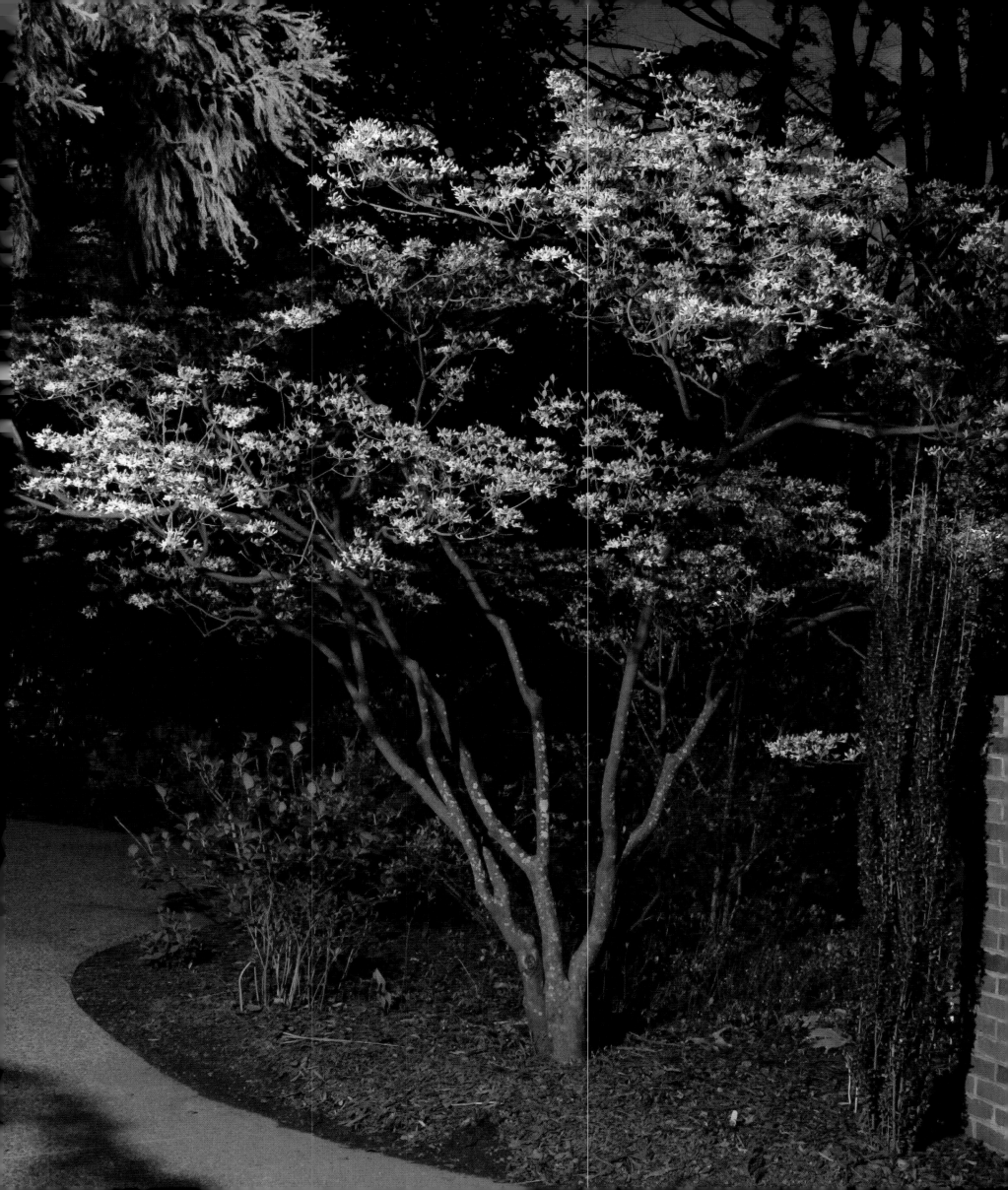

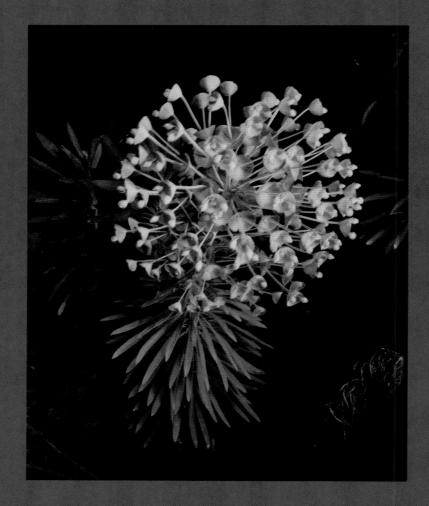

EUPHORBIA—*EUPHORBIA CHARACAIS*

component of the Native Plant Conservation Program. Hardy and nonhardy water lilies and lotuses, including a huge five-foot-wide 'Victoria' water lily, are scattered about the many pools of water, creating one of the most impressive aquatic-plant collections in the Southeast. The "gardens under glass" include the Fuqua Conservatory, an organic biosphere with an important collection of tropical palms and conifers, featuring the Desert House with collections of succulents and clusters of dart frogs, geckos, saffron finches, and turtles. The Fuqua Orchid Center possesses the foremost collection of orchids in the United States, with an exhibit room featuring three seasonal orchid displays a year, a high-elevation house with a cloud forest, and a massive granite waterfall mantled with brilliantly flowered Andean orchids. It also houses the 6,000-square-foot Orchid Display House showcasing orchids and species of vanilla from every corner of the world. Beyond the greenhouses lies an award-winning children's garden, complete with Caterpillar Maze, Sunflower Fountain, and Soggy Bog, exemplifying the innovative design that makes Atlanta's thirty-year-old garden a playground for children *and* adults.

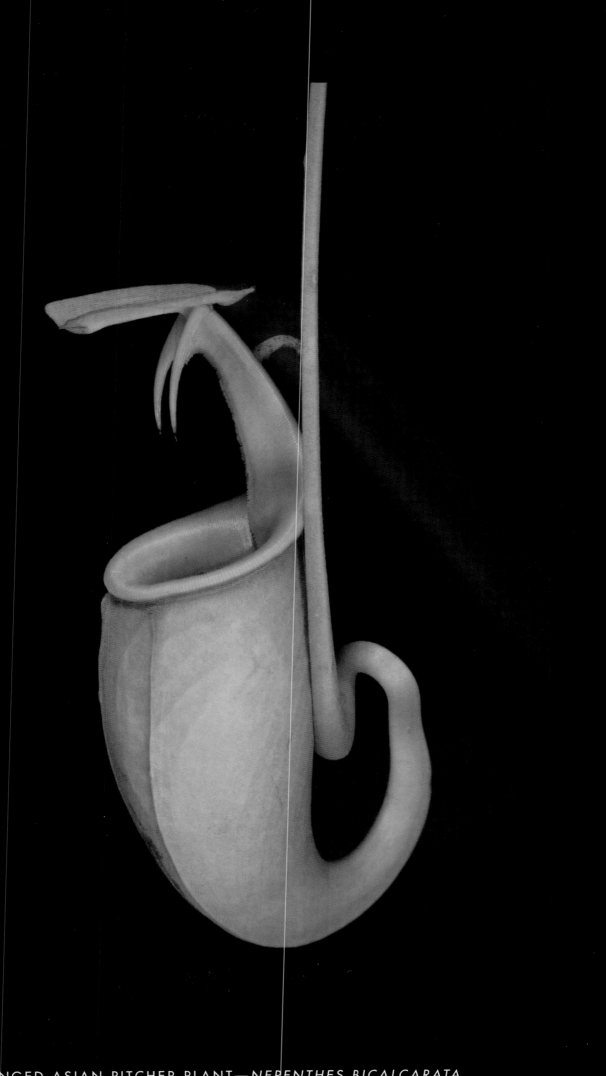

FANGED ASIAN PITCHER PLANT—*NEPENTHES BICALCARATA*

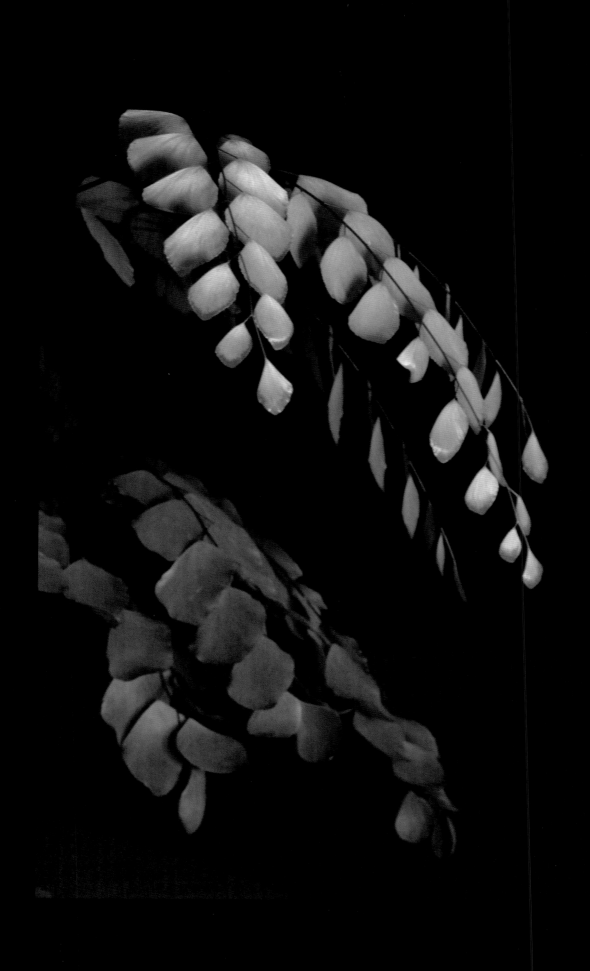

Above: SILVER DOLLAR MAIDENHAIR FERN—*ADIANTUM PERUVIANUM*

Opposite: TULIP ORCHID—*ANGULOA RUCKERI*

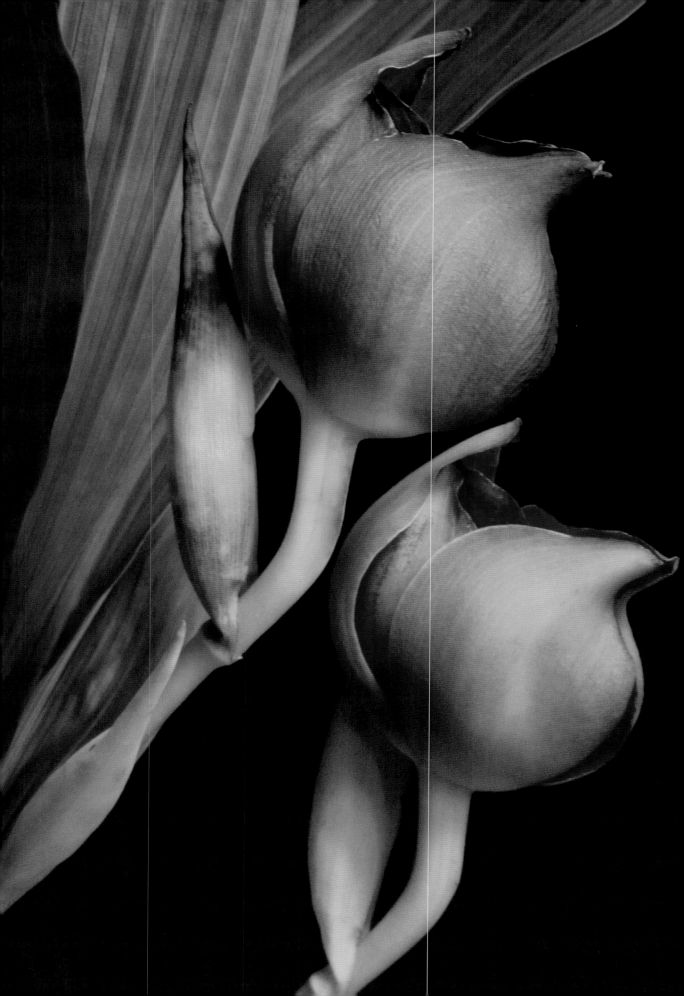

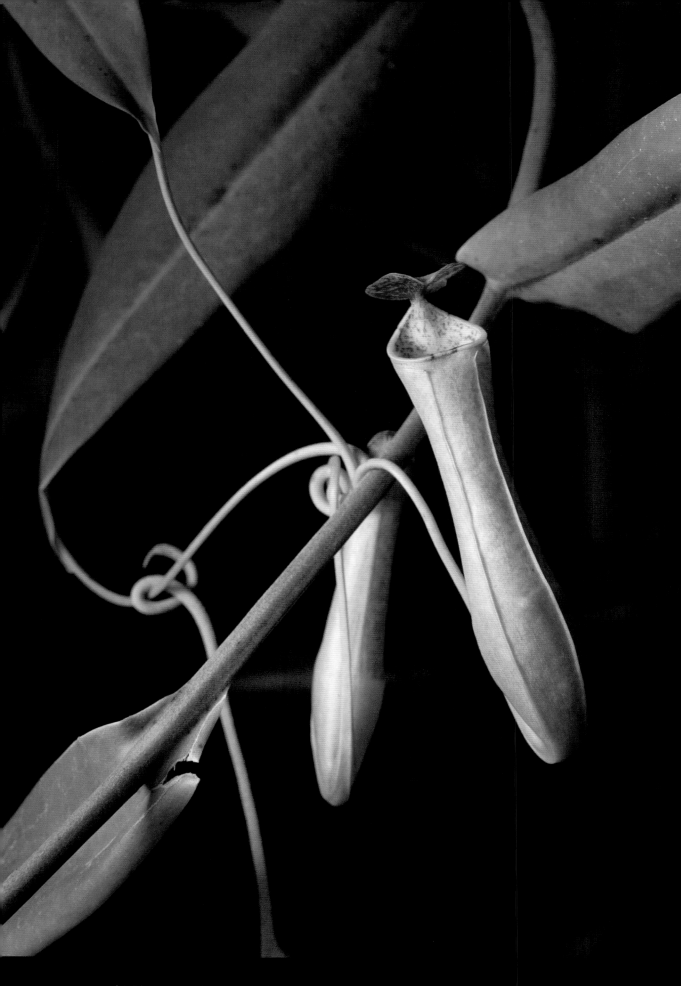

SLENDER ASIAN PITCHER PLANT · NEPENTHES GRACILIS

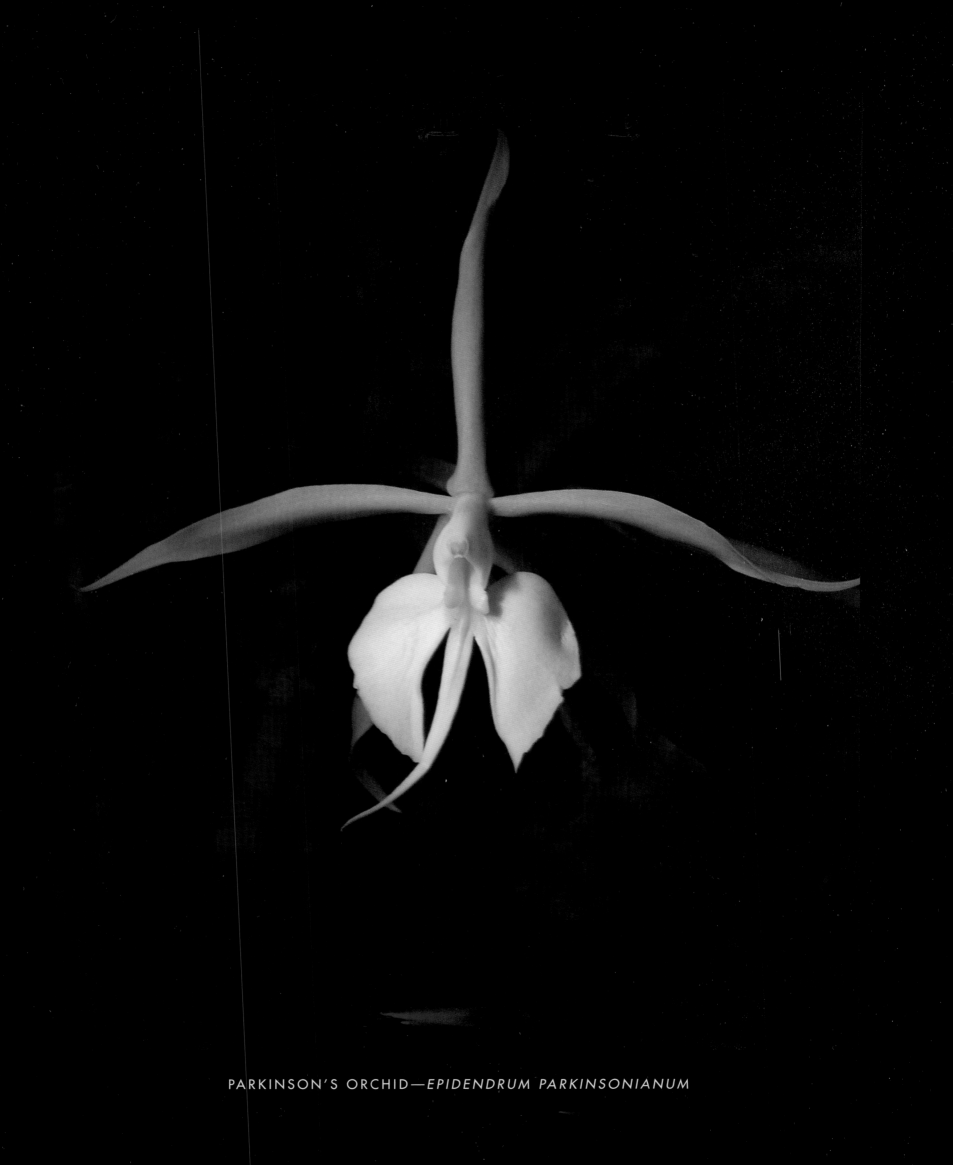

PARKINSON'S ORCHID—*EPIDENDRUM PARKINSONIANUM*

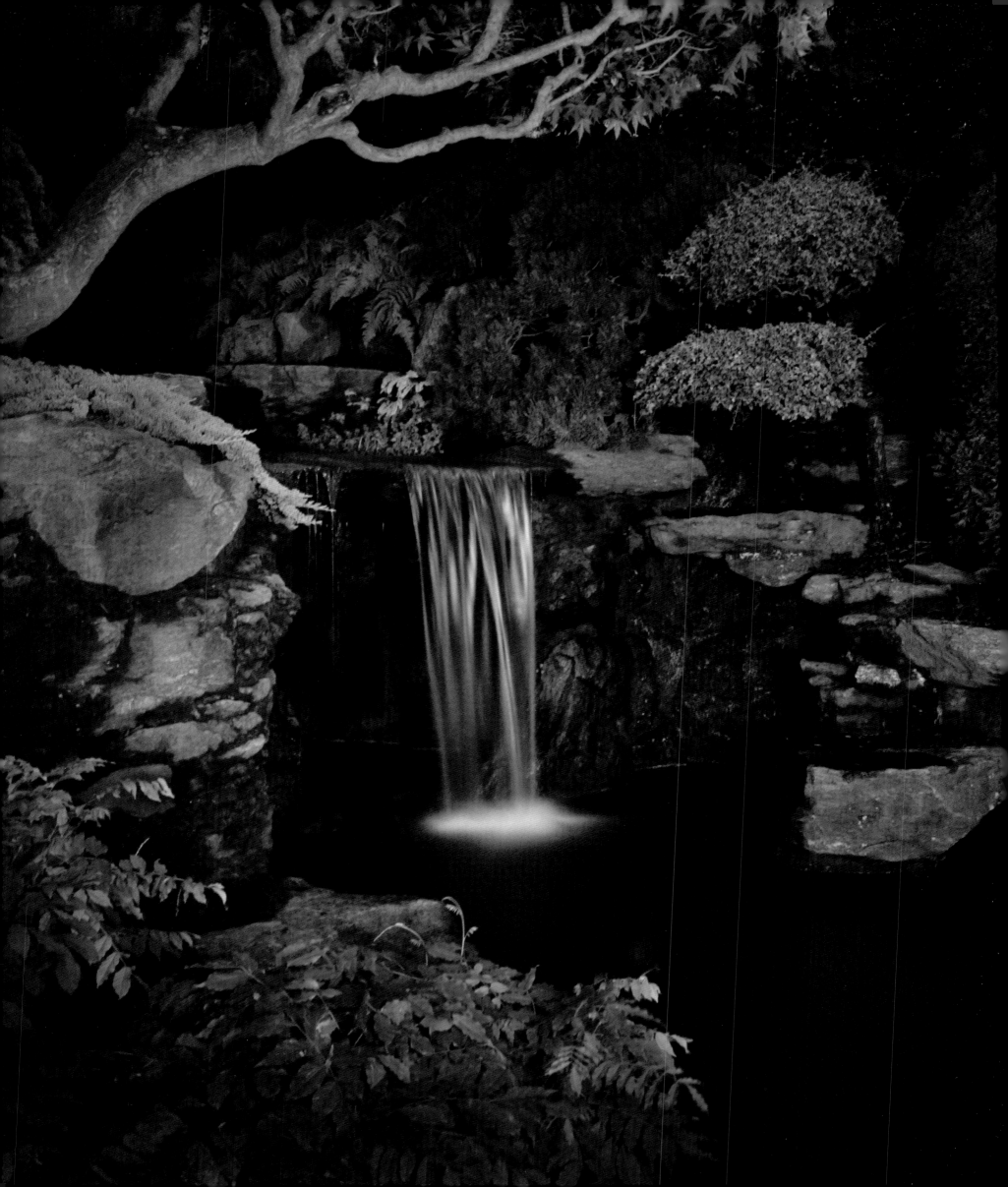

BROOKLYN BOTANIC GARDEN

sweetly scented trees

THE FIRST INKLINGS of Brooklyn's sprawling botanical garden rose out of an ash dump in the center of Brooklyn in 1910. Five years later, legendary Japanese landscape architect Takeo Shiota designed what was to become the first Japanese-style garden constructed in a public space in the United States. The garden presents natural and sculpted trees and shrubs, including evergreens, white pines, American beeches, bald cypresses, and Japanese maples, complemented by collections of Japanese irises, tree peonies, and azaleas. Situated on a hill with winding paths, wooden bridges, and stone lanterns, the garden manifests its Eastern influences in the more than two hundred cherry trees dispersed throughout the grounds. Their glorious blooms take center stage during the Sakura Matsuri Festival held at the end of each April. The Steinhardt Conservatory houses the second-largest public display of bonsai trees outside of Japan; it features as many as a hundred specimens at any given time, with some of the trees in

Opposite and Above: JAPANESE HILL-AND-POND GARDEN

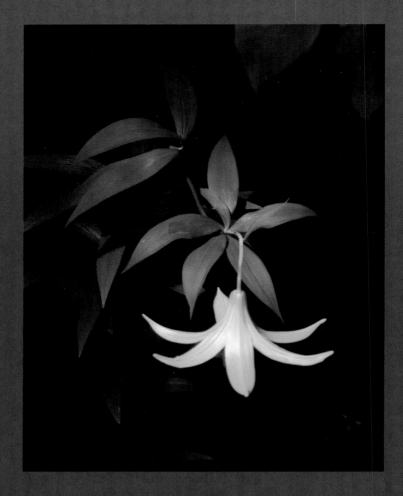

CANADA LILY—*LILIUM CANADENSE*

the collection well over a century old. In 1927, Walter V. Cranford, a construction engineer whose firm built many of Brooklyn's subway tunnels, donated the funds necessary to erect fifteen 50-foot-long rose beds. Today, these beds boast newer plantings of modern roses, ranging from upright hybrid teas and polyanthas to floribundas. First planted in the spring of 1932, the Magnolia Plaza is an elegant formal garden displaying seventeen varieties of these sweetly scented trees, with blooms ranging from white and ivory to pink and purple. In 1955, Brooklyn's Botanic Garden cultivated the first fragrance garden in the nation designed for the sight-impaired where visitors were encouraged to touch and smell the plants. Two decades later, a lovely garden in the English cottage-garden style was transplanted just north of the Fragrance Garden for the exhibition of more than eighty plants referenced in Shakespeare's works. Here, on a sloping bank surrounded by a serpentine wall, lie such finds as monkshood, columbine, blue false indigo, clematis, euphorbia, English holly, rue, pincushion, and skirret, illustrating the garden's successful integration of Eastern and Western traditions. ❈

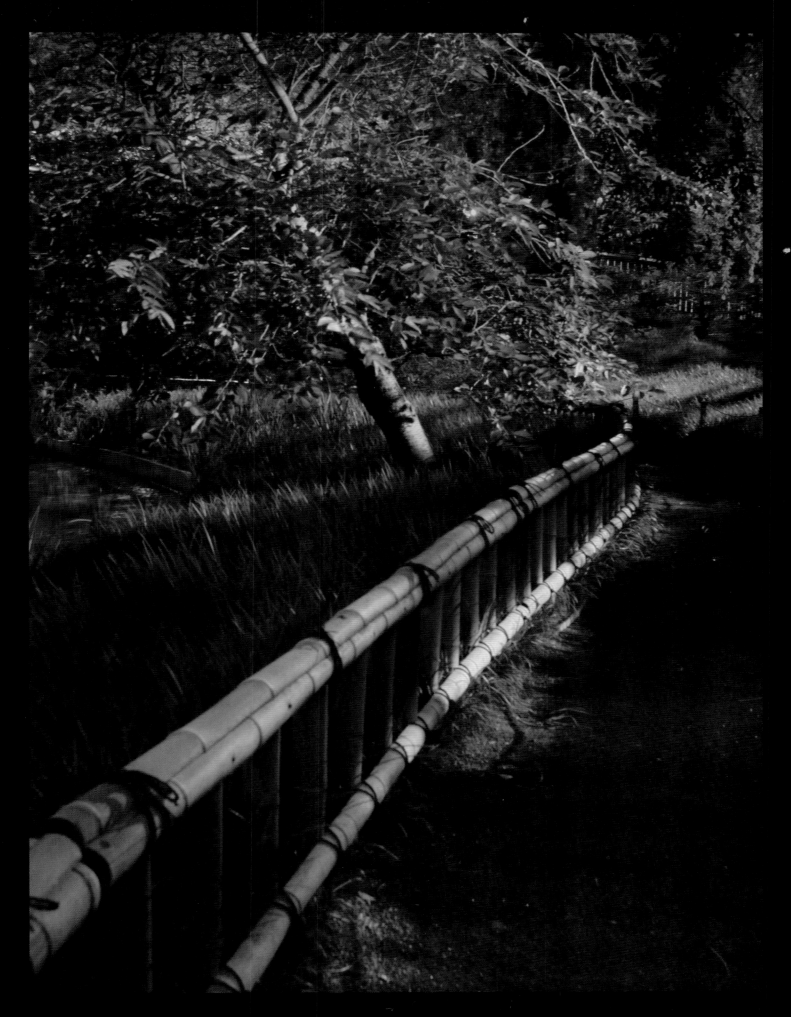

JAPANESE HILL-AND-POND GARDEN

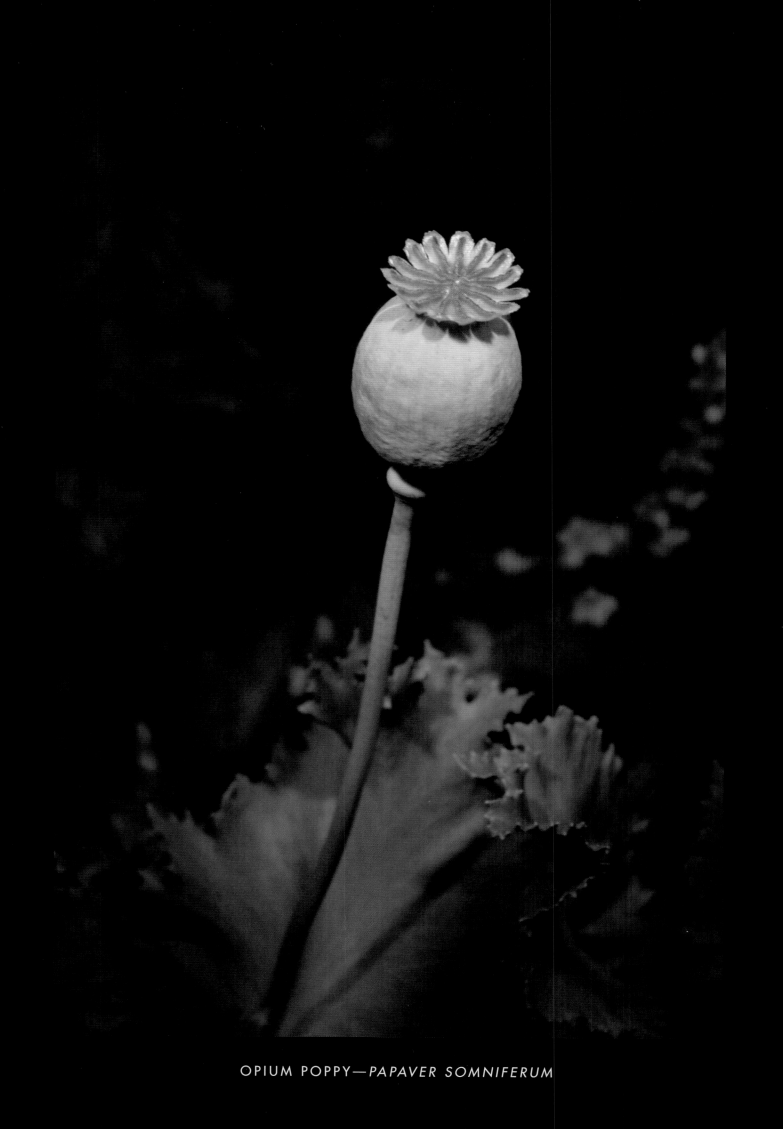

OPIUM POPPY—*PAPAVER SOMNIFERUM*

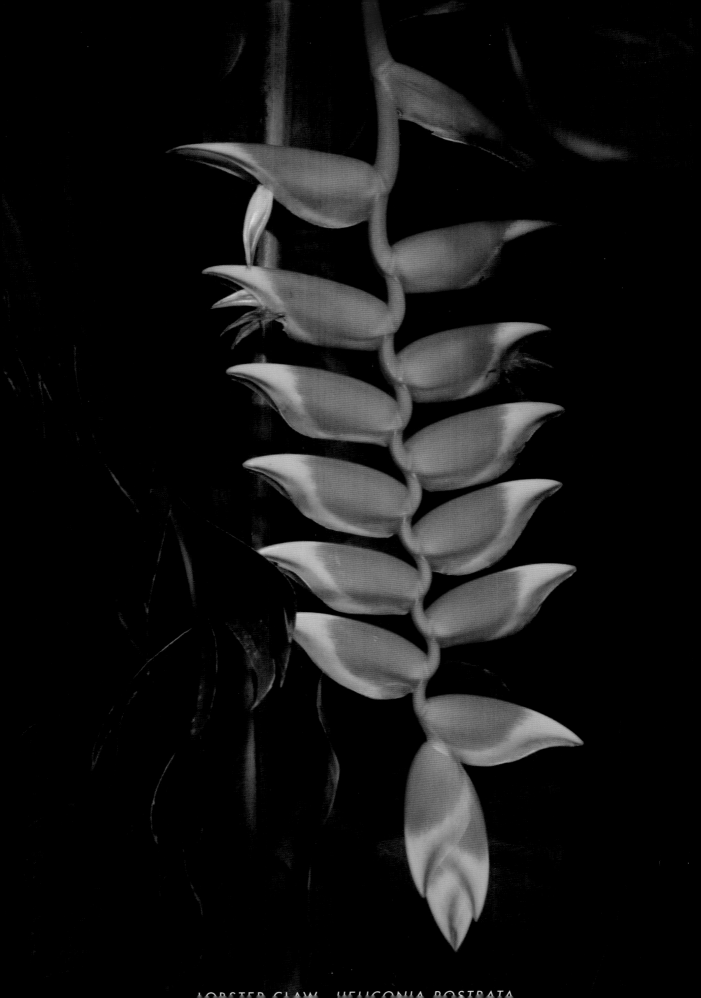

LOBSTER CLAW · HELICONIA ROSTRATA

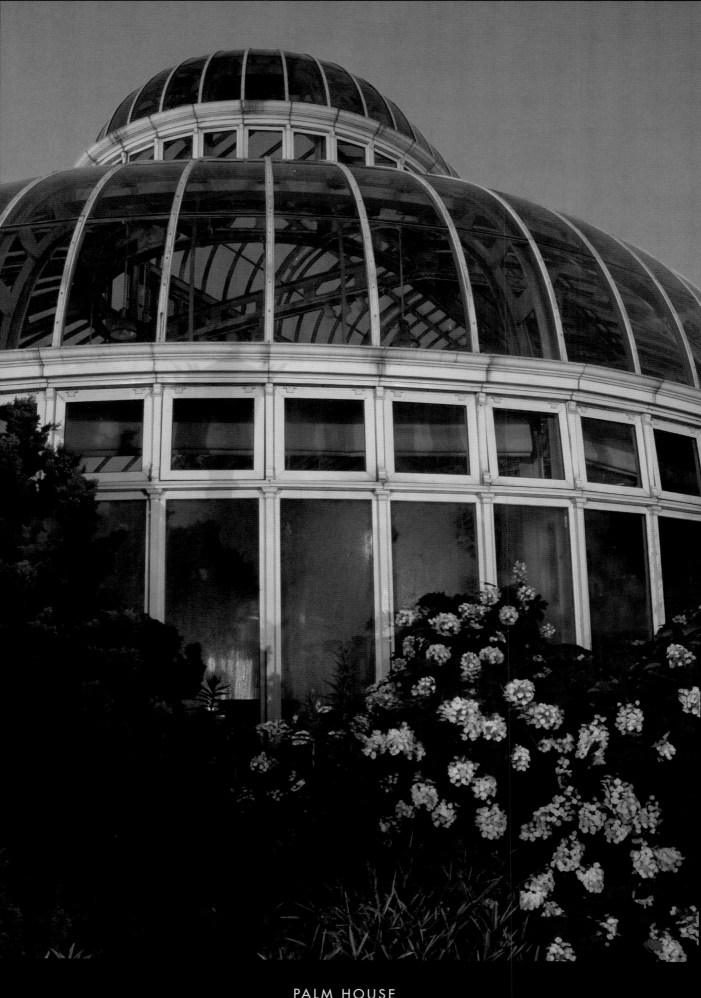

PALM HOUSE

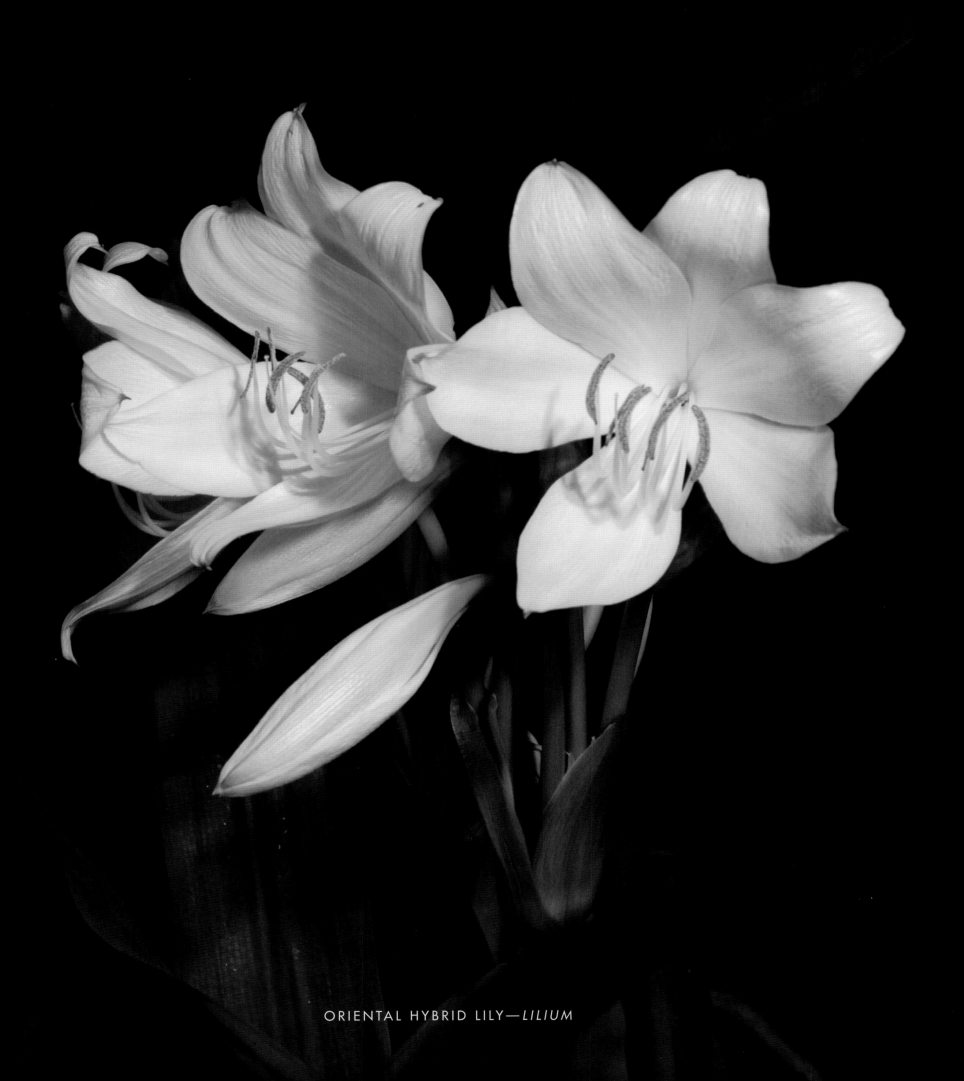

ORIENTAL HYBRID LILY—*LILIUM*

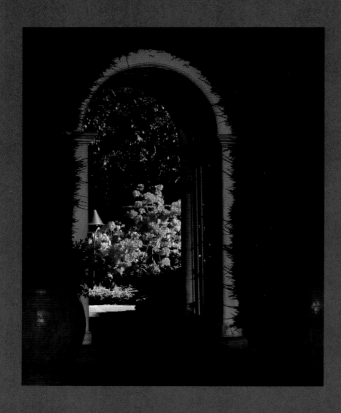

BUTCHART GARDENS

glimpses onto the sea

IN 1904, JENNIE BUTCHART, the wife of a cement-manufacturing pioneer, transformed a quarry in Victoria, British Columbia, into an extended garden for her family's private residence. Since then, the family has been committed to maintaining and developing this fifty-five-acre garden, throughout which examples of the artistry of cement remain. Within the quarry, some fifty feet below a lookout, a sunken garden sits on the edge of a lake, and a path winds its way between beds of annuals set among flowering trees and shrubs that have been planted right up to the quarry's walls. A fountain, created by the Butcharts' grandson, Ian Ross, displays colorful lights and jets that rise seventy feet high, and is lined by a bank of large-flowered Saint-John's-wort and Japanese maples. Two totem poles, carved in 2004 to celebrate the garden's centennial, tower over the entrance to the rose garden, where spectacular rose arches frame a sea of hybrid tea roses, dwarf boxwood hedges, and a flagstone walk

Above and Opposite: ITALIAN GARDEN

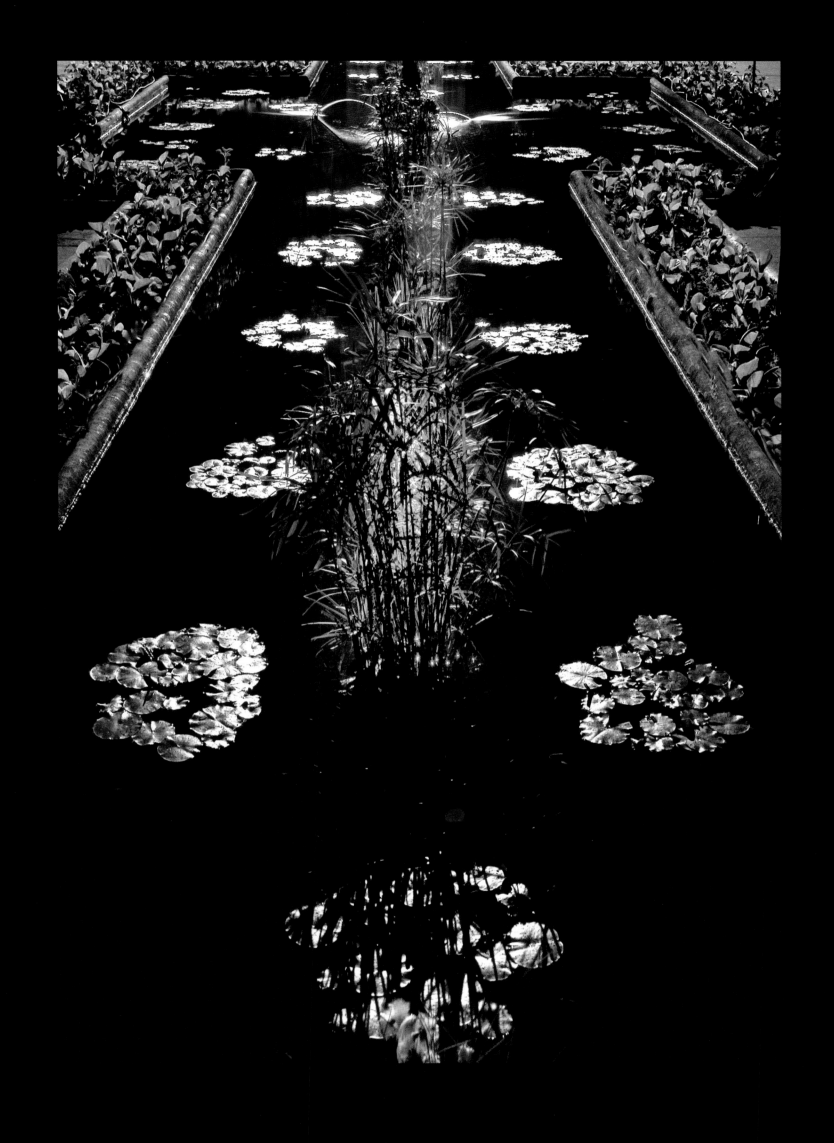

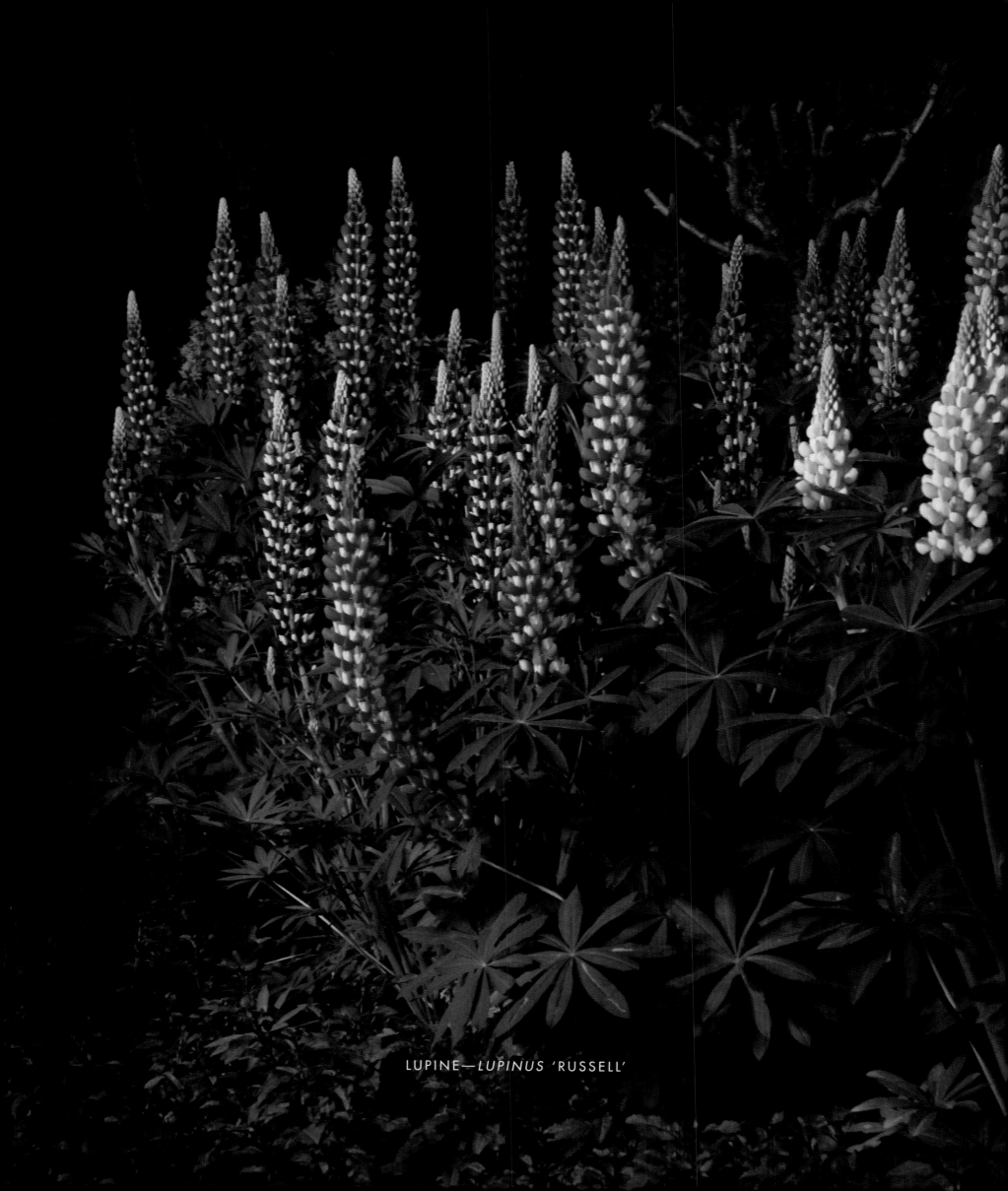

LUPINE—*LUPINUS* 'RUSSELL'

BLUE POPPY—*MECONOPSIS BETONICIFOLIA*

surrounding a wrought-iron wishing well. A fountain of bronze sturgeons (cast in Florence by animal sculptor Sirio Tofanari) heralds the Japanese garden, where visitors can catch glimpses of the sea. Designed with the assistance of Japanese landscaper Isaburo Kishida, the garden presents the rare springtime-blooming Himalayan blue poppy. A star-shaped pond stands before an Italian garden where the original tennis court once stood; today, its cement walls lend support to the garden's beds. Designated a National Historic Site of Canada in 2004, Butchart Gardens is a source of enchantment for visitors year-round. ॐ

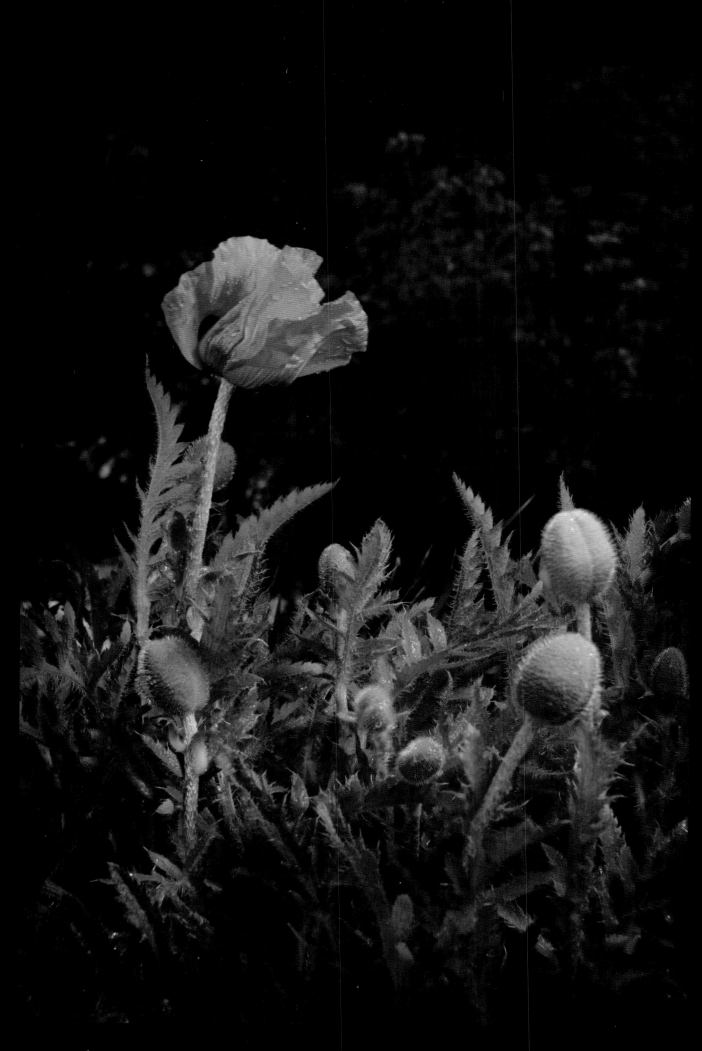

Above: OPIUM POPPY—*PAPAVER SOMNIFERUM* *Opposite:* TOTEM POLE

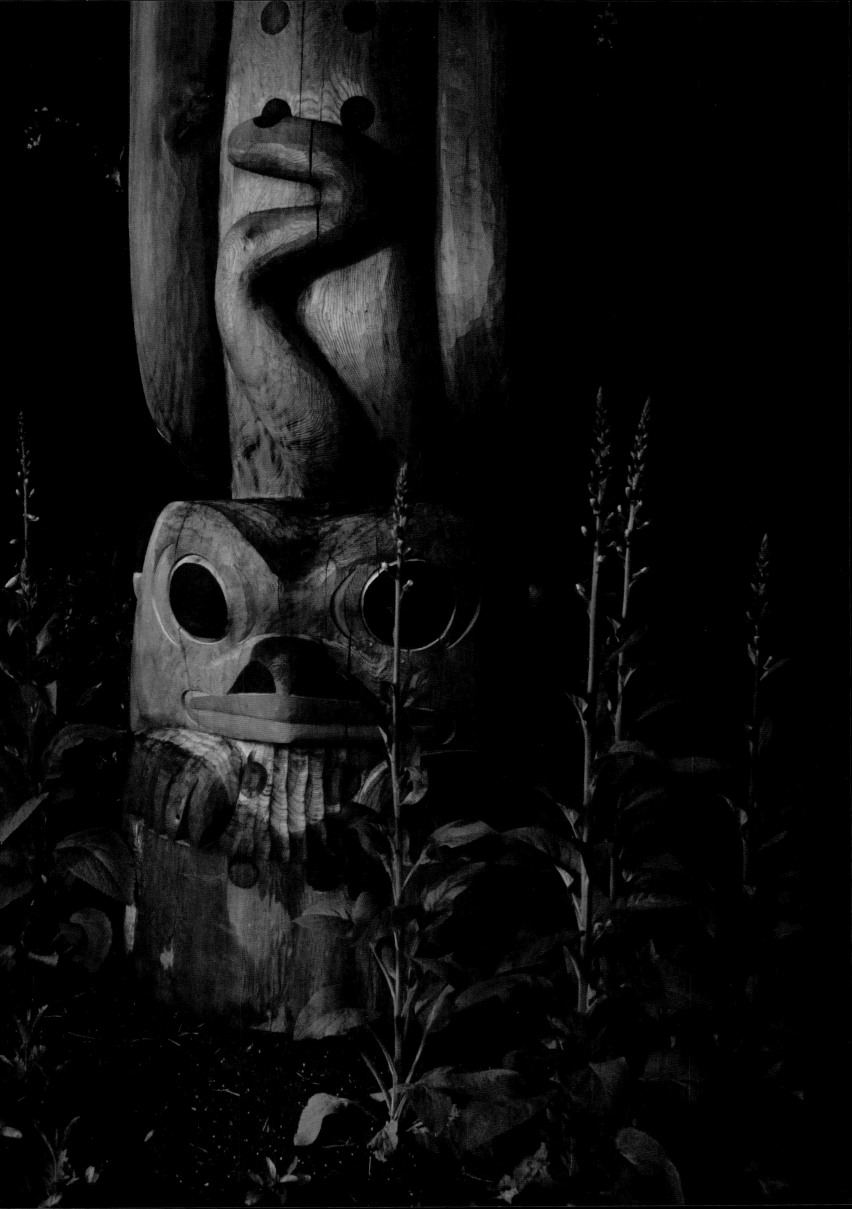

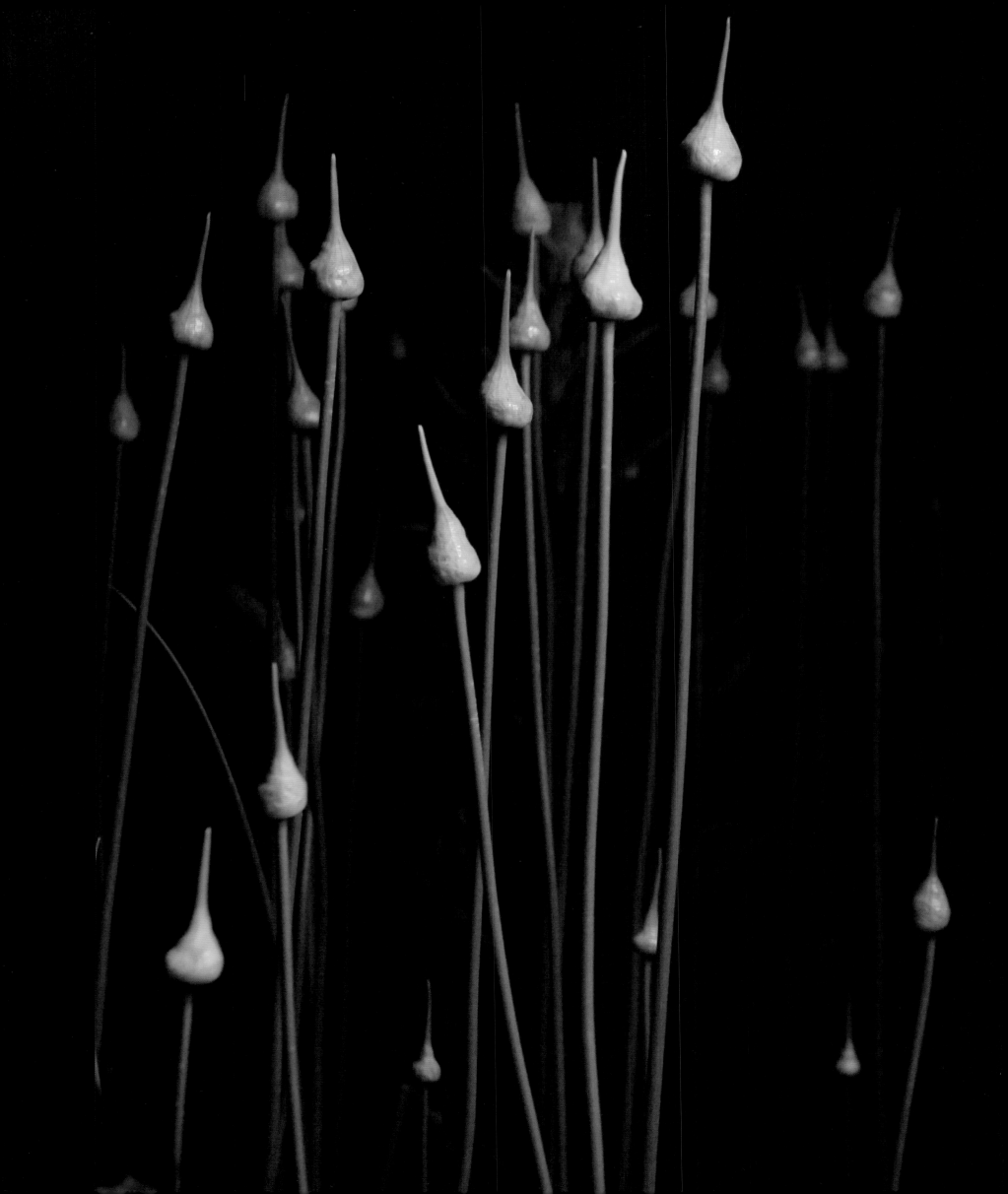

ALL NIGHT HAVE THE ROSES HEARD

THE FLUTE, VIOLIN, BASSOON;

ALL NIGHT HAS THE CASEMENT JESSAMINE STIRR'D

TO THE DANCERS DANCING IN TUNE;

TILL A SILENCE FELL WITH THE WAKING BIRD,

AND A HUSH WITH THE SETTING MOON.

ALFRED, LORD TENNYSON, "MAUD"

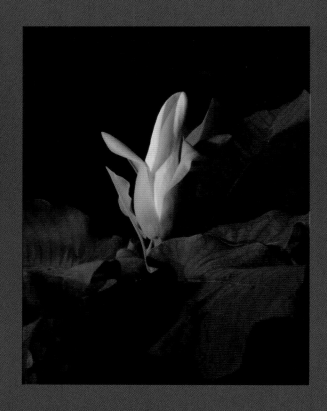

CHICAGO BOTANIC GARDEN

sunset drenched evening

NINE INTERCONNECTED island gardens float within the tranquil waters of the Chicago Botanic Garden. Sacred lotuses, *Nelumbo nucifera*, surround this 385-acre Venetian-style garden dotted with sculptures like *Carolus Linnaeus*, depicting the renowned botanist and founder of binomial nomenclature, and *The Sower*, a classic male figure created by Albin Polasek in 1915. Leading architects John O. Simonds and Geoffrey Rausch designed the master plan, while the central edifice, which houses tropical, temperate, and desert greenhouses, was designed by architect Edward Larrabee Barnes. Visitors to the Heritage Garden, which pays tribute to the botanic gardens of the past, are greeted by a four-quadrant circular space modeled after Europe's first botanical garden in Padua, Italy, followed by displays of the major plant families, cascading sheets of water, and a classic physic garden made up of plants historically known for their medicinal purposes. Artfully created by rosarian William Radler, the rose garden is a

Pages 36–37: ALLIUM—*ALLIUM* *Above:* MAGNOLIA—*MAGNOLIA* 'ELIZABETH'
Opposite: HERITAGE GARDEN

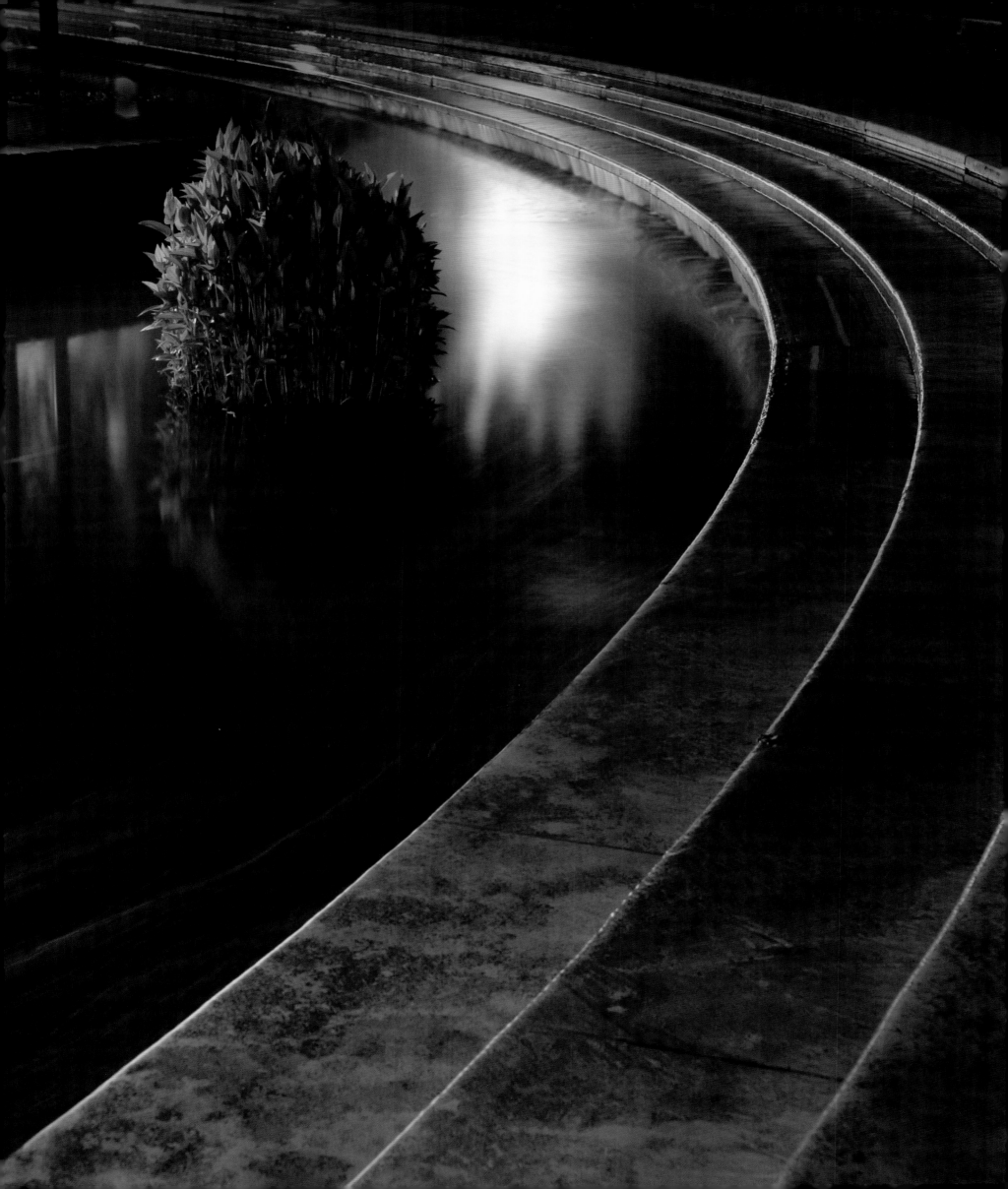

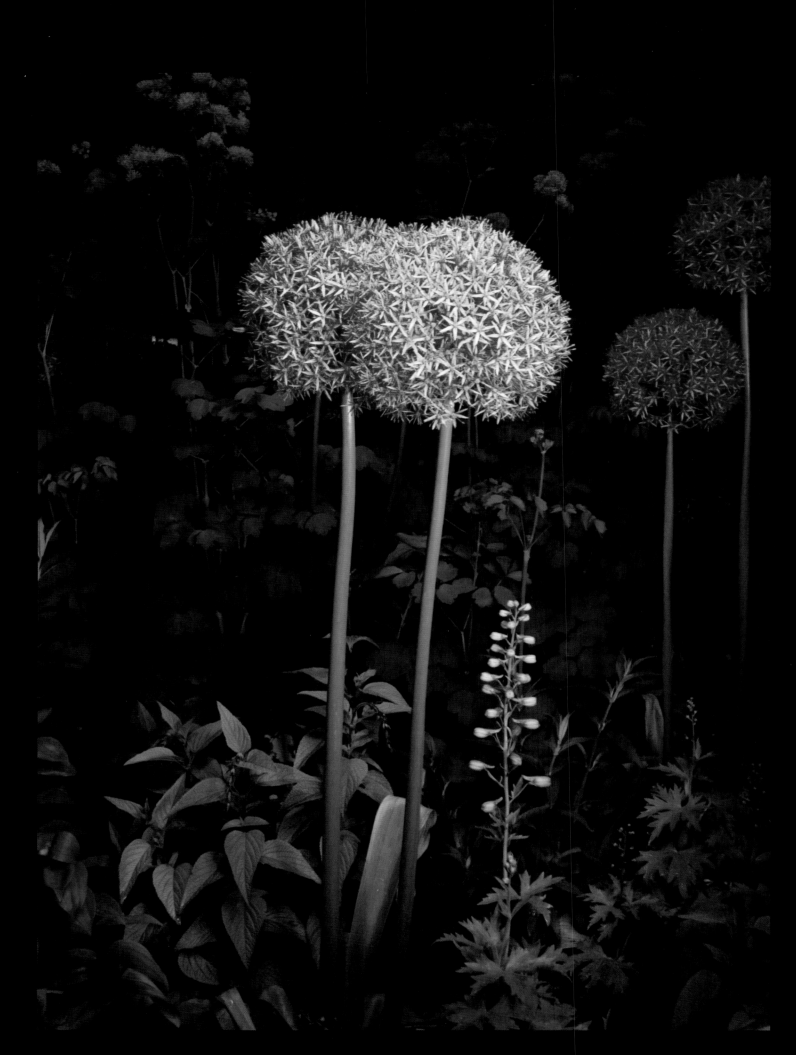

GIANT ALLIUM—*ALLIUM GIGANTEUM* 'GLOBEMASTER'

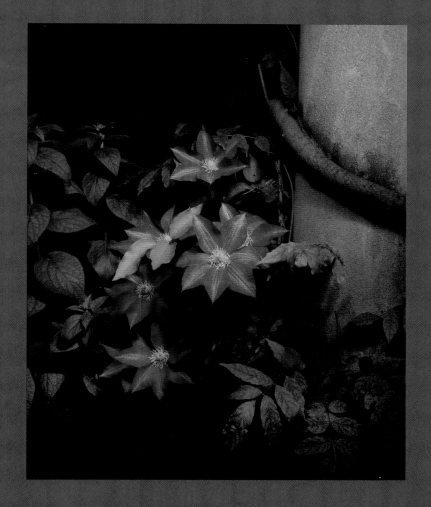

CLEMATIS—*CLEMATIS* 'MRS. CHOLMONDELEY'

dazzling blend of vibrant colors and exquisite perfume. Stone walls shelter six English gardens with flora interspersed among urns, columns, and sitting nooks, representing the history of British garden aesthetics as seen throughout the centuries. Beyond views of waterfalls and meadow gardens, three islands of Japanese gardens fascinate visitors with curving paths exposing gnarled pine trees and colorful branches of willows and Tatarian dogwoods. Across the Arch Bridge sits the sunset-drenched Evening Island, an example of New American garden design featuring a Jens Jensen–inspired council ring tower. The Serpentine Bridge links back to the central island, where a sensory garden and a collection of Illinois' native plants lead visitors to the Fruit and Vegetable Garden, or to the Esplanade, where rows of elms, cone topiaries, and pools of water surround a pavilion. Conceived by Dan Kley, one of the greatest landscape architects of the twentieth century, this aqueous passageway reflects the incredible springtime pageant of crab-apple blooms that has become a hallmark of the Chicago Botanic Garden. ❧

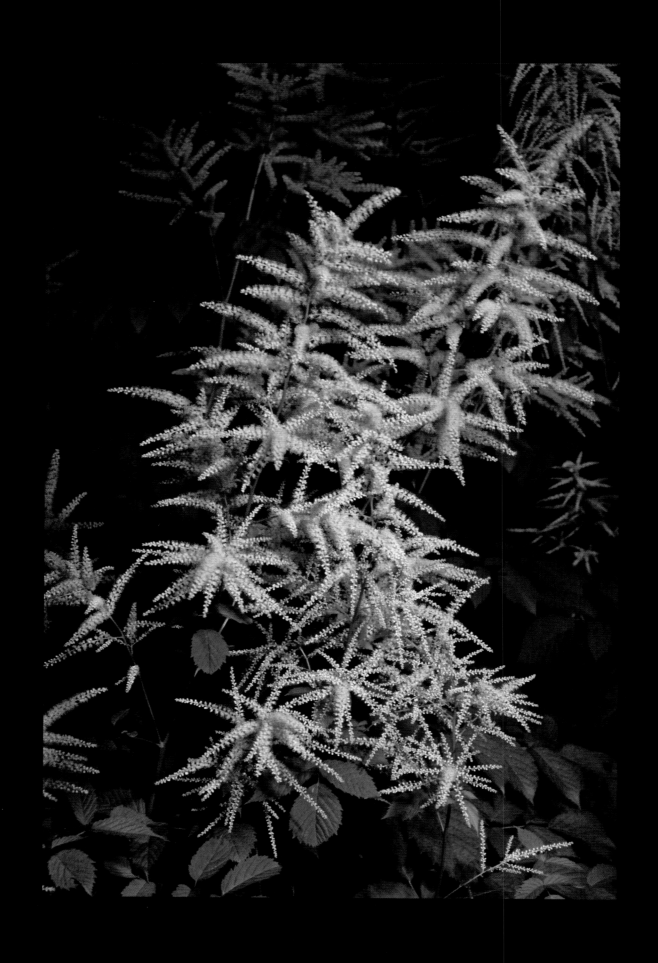

Above: GOAT'S BEARD—*ARUNCUS* *Opposite:* CHINESE PEONY—*PAEONIA LACTIFLORA*

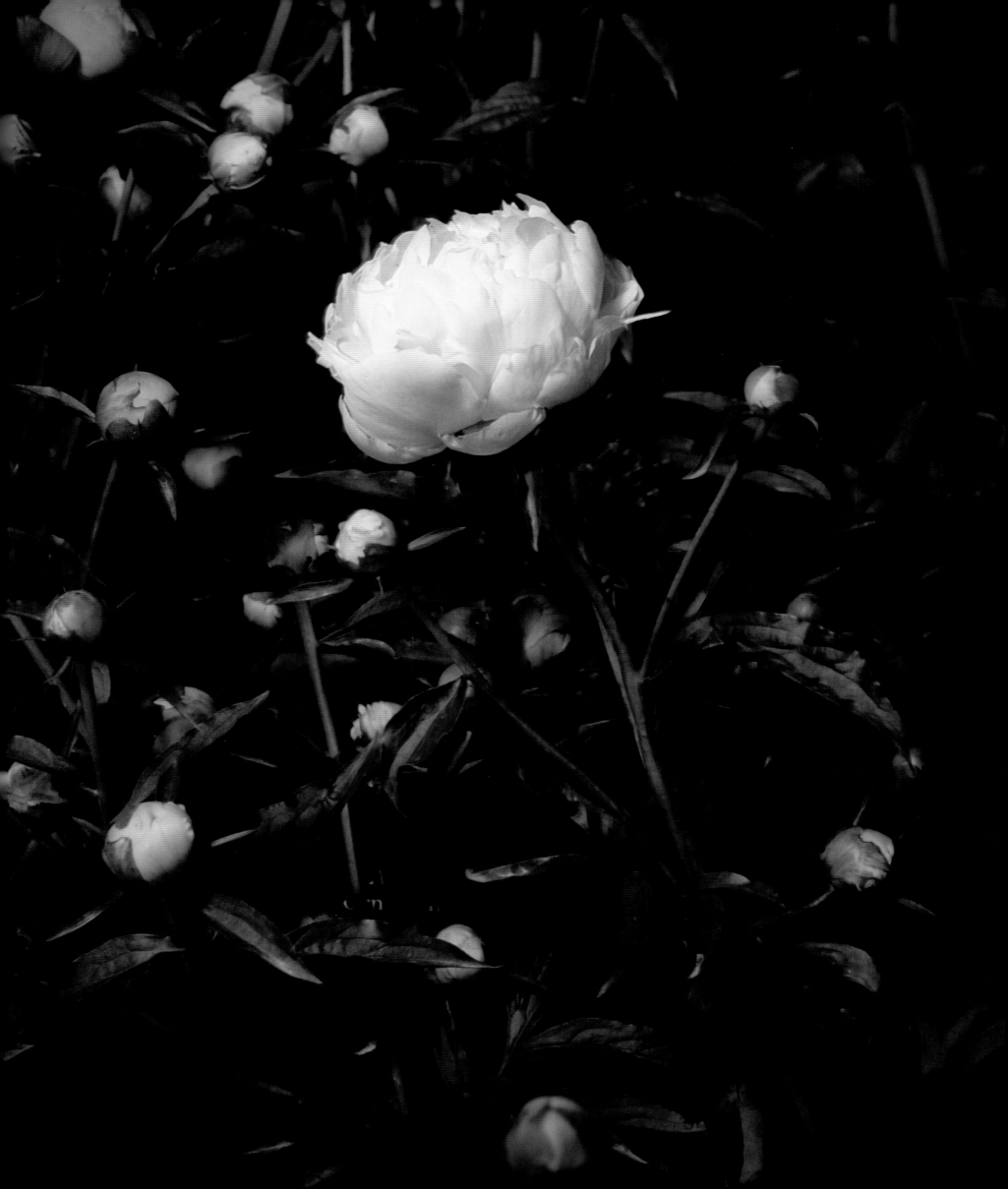

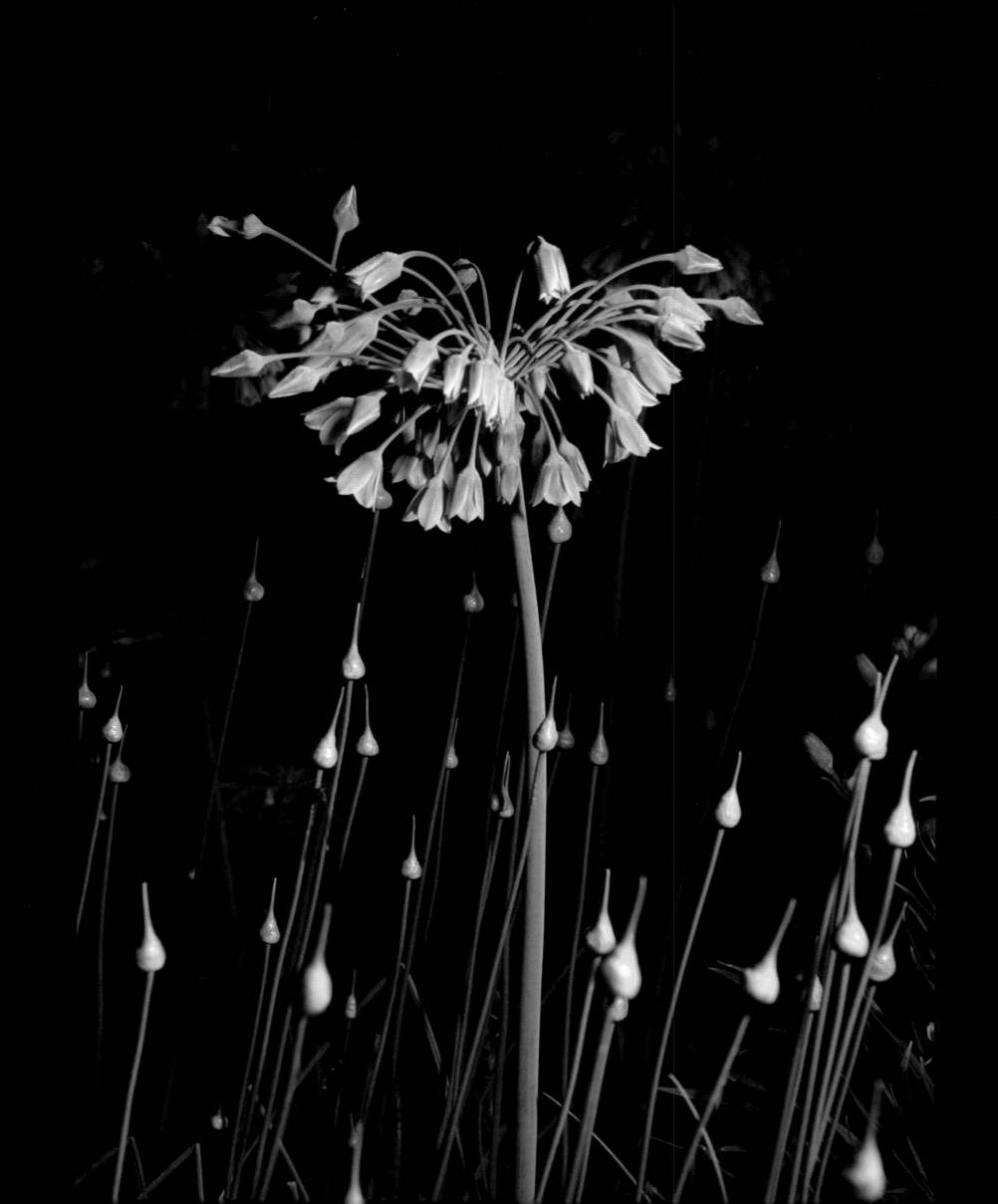

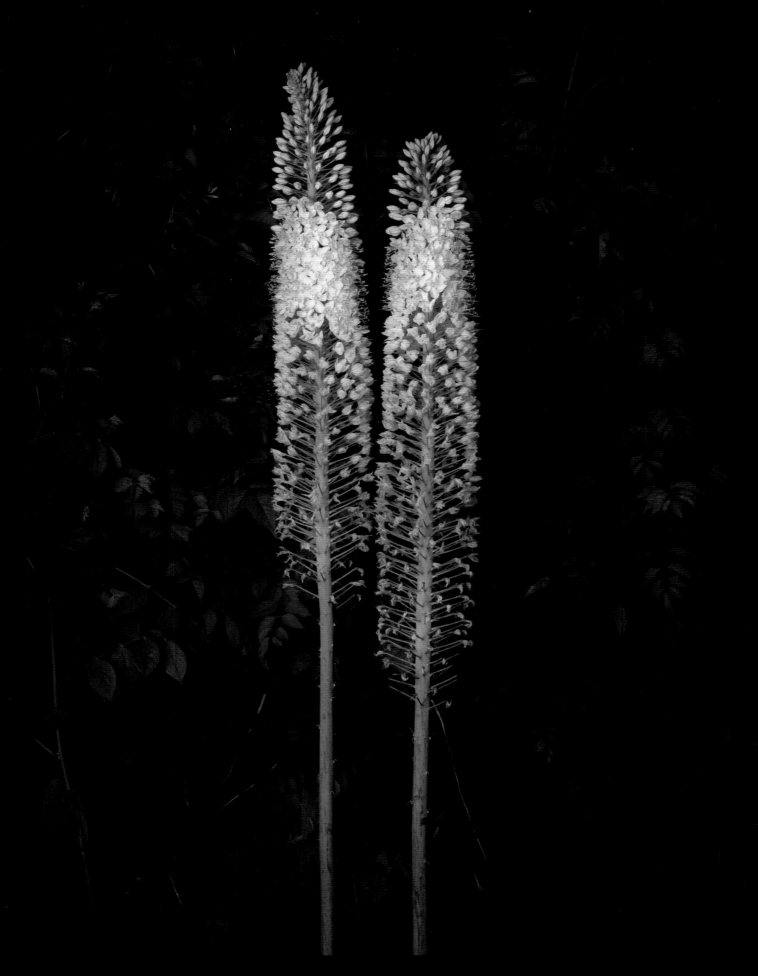

Above: DESERT CANDLE—*EREMURUS AITCHISONII*

Opposite: SICILIAN HONEY GARLIC—*NECTAROSCORDUM SICULUM*

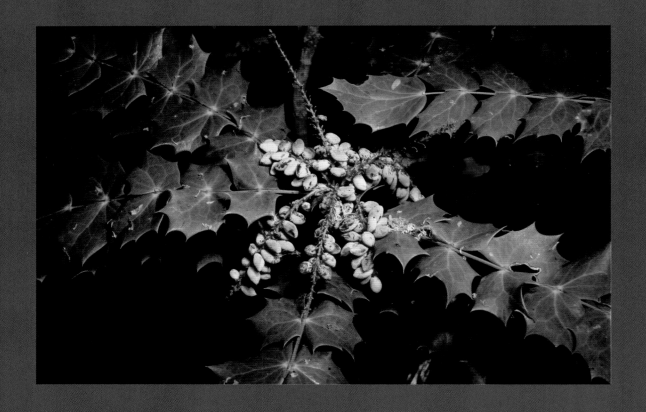

DALLAS ARBORETUM
design within nature

SPRINGTIME IN TEXAS arrives with an explosion of blooms from more than 400,000 bulbs planted in the spectacular Dallas Arboretum show garden. Built on land purchased by the DeGolyer family in the early 1930s, today it houses a varied collection of gardens centered around the family's original garden designed in 1940 by landscape architects Arthur and Marie Berger. A walkway of towering magnolia trees leads from the Spanish colonial homestead to a sunken garden displaying rows of Italian jardinières, and opens up to a sunlit grass court and two gardens conceived by and dedicated to women. Farther on, beyond a gazebo, is a recent addition to the space, an area that includes an octagonal fountain, red cascade-rose trellises, topiary hollies, cubed hedges, and a red- and yellow-leaved barberry hedge in a double-helix configuration. A large, open-air concert stage shoulders a Texas cottage garden filled with bronze wildlife figures, hundreds of perennials, and a

Above: LEATHERLEAF MAHONIA—*MAHONIA BEALEI* *Opposite:* A WOMAN'S GARDEN

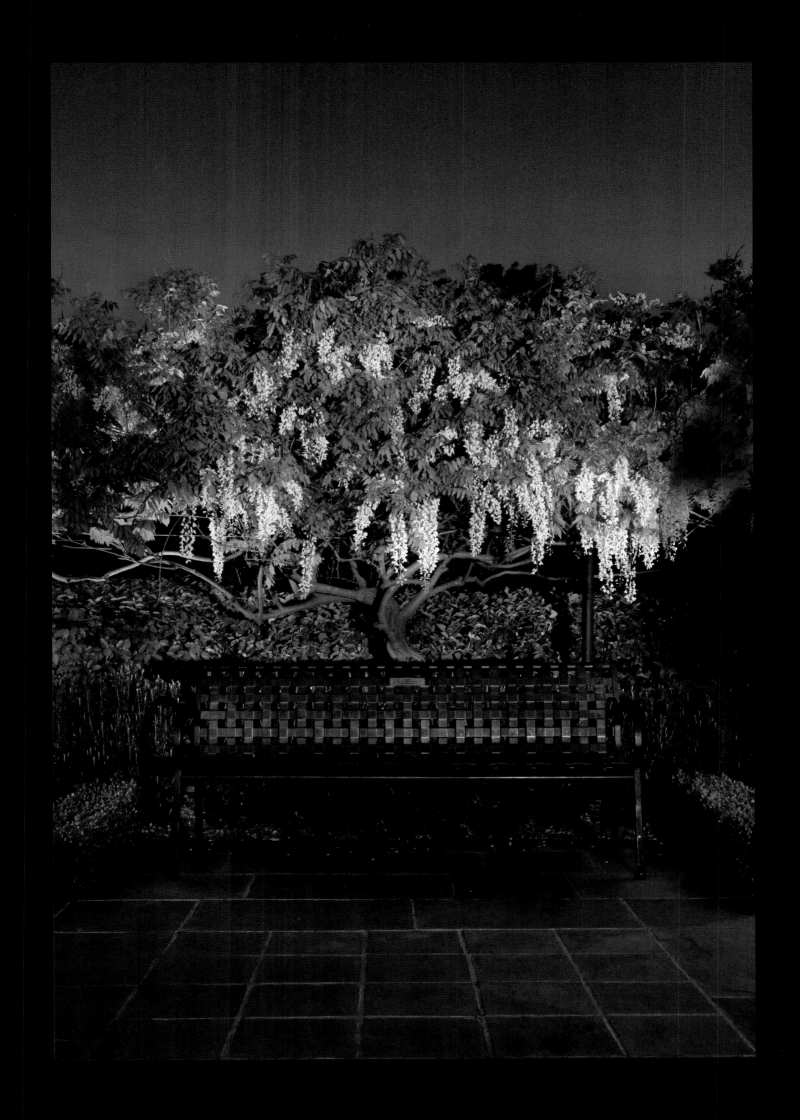

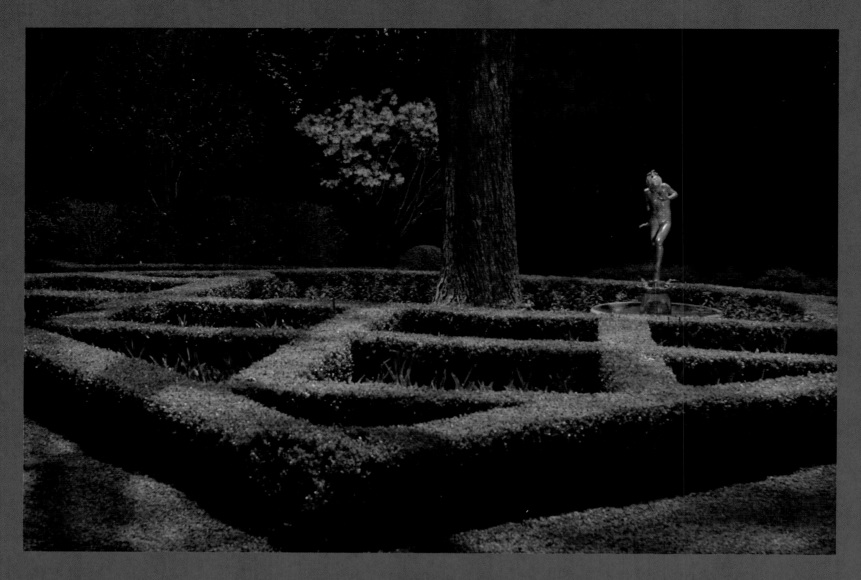

A WOMAN'S GARDEN

falling water curtain set against native limestone walls. The Paseo de Flores, a large path designed by Luis Santana, runs to the other side of the site, where a colorful garden presents a collection of 2,800 azaleas and, depending on the time of year, the rich blooms of daffodils, tulips, dogwood, cannas, caladiums, or chrysanthemums. A vast variety of ferns are accompanied by camellias, witch hazel, and mature trees alongside a rambling brook. A vivid re-creation of a Texas town gives visitors a glimpse of how the pioneers lived, at a time when one's land and gardens were essential resources for survival. Thirteen experimental tree houses, designed by local architects, utilize vast trunks and gnarled branches in playful and innovative ways, demonstrating for visitors the possibilities of design within nature. ✑

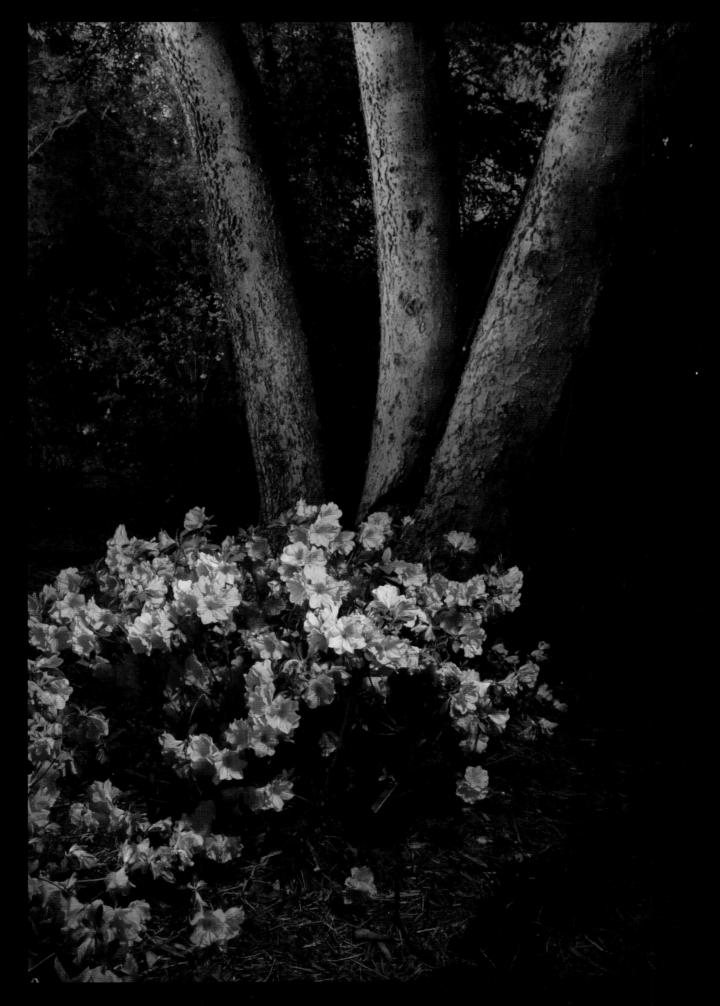

KURUME AZALEA—*RHODODENDRON*

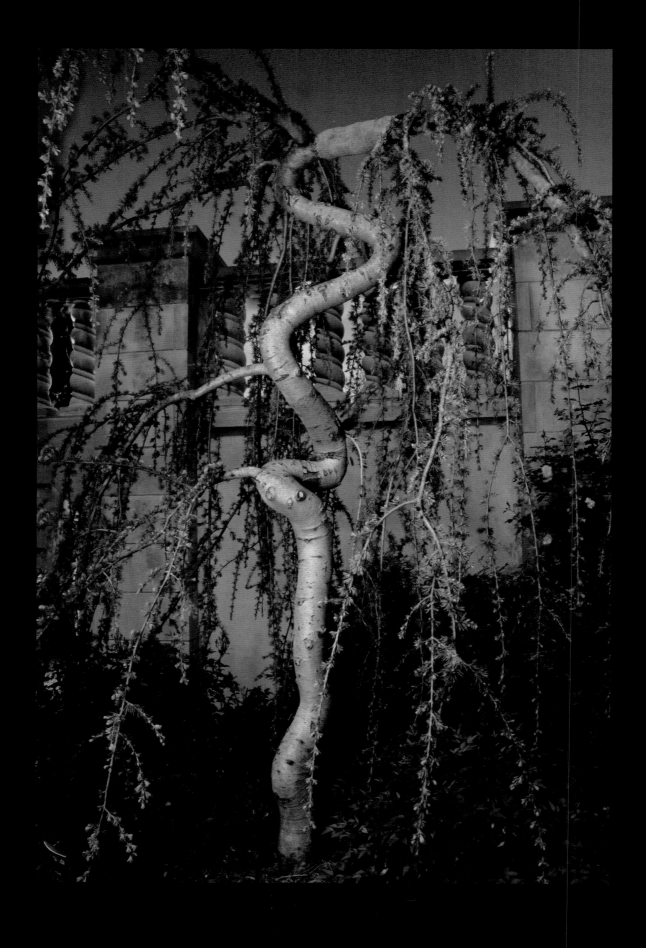

Above: ATLAS CEDAR—*CEDRUS ATLANTICA* *Opposite:* JAPANESE MAPLE—*ACER PALMATUM*
Pages 52–53: TULIPS—*TULIPA*

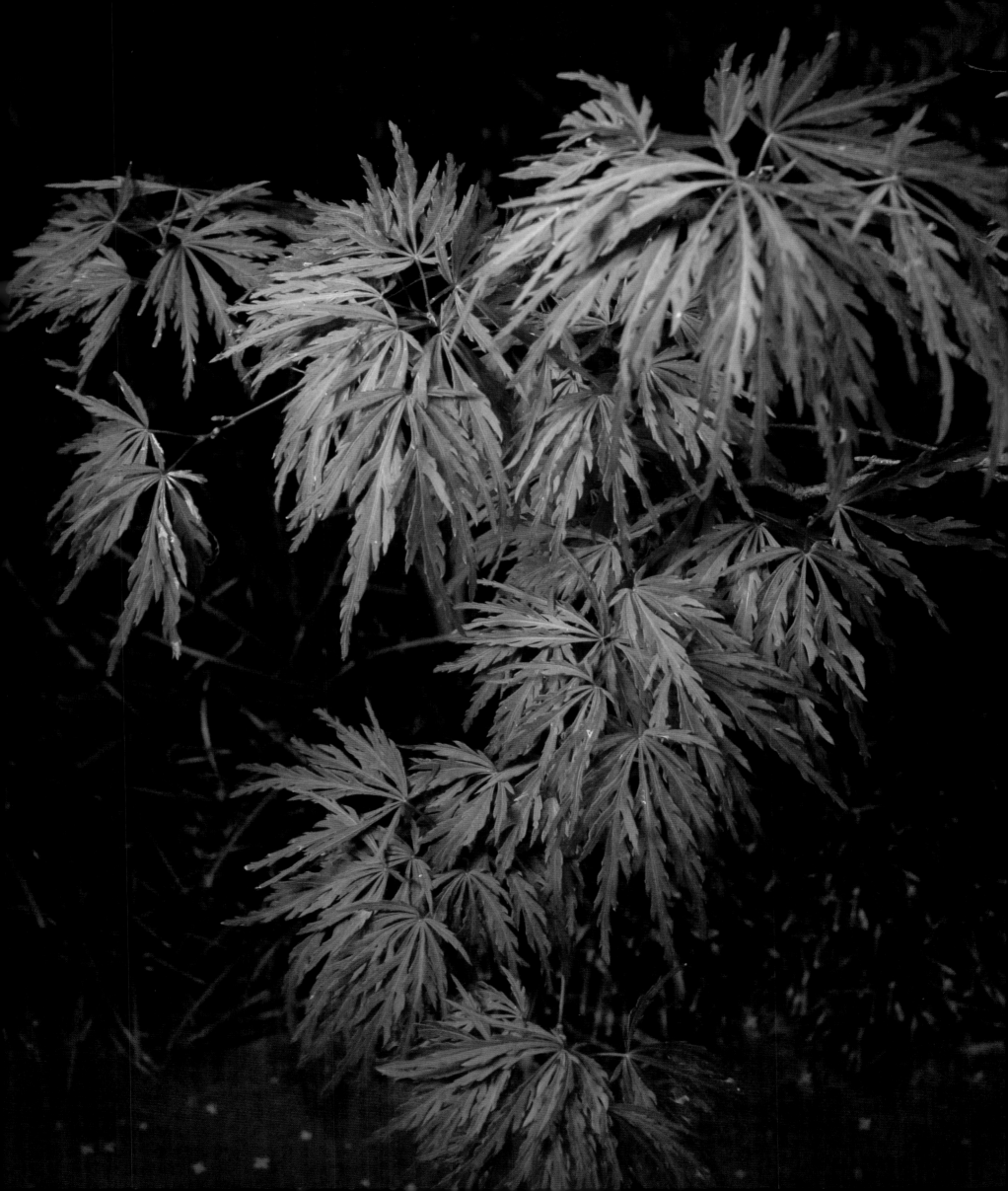

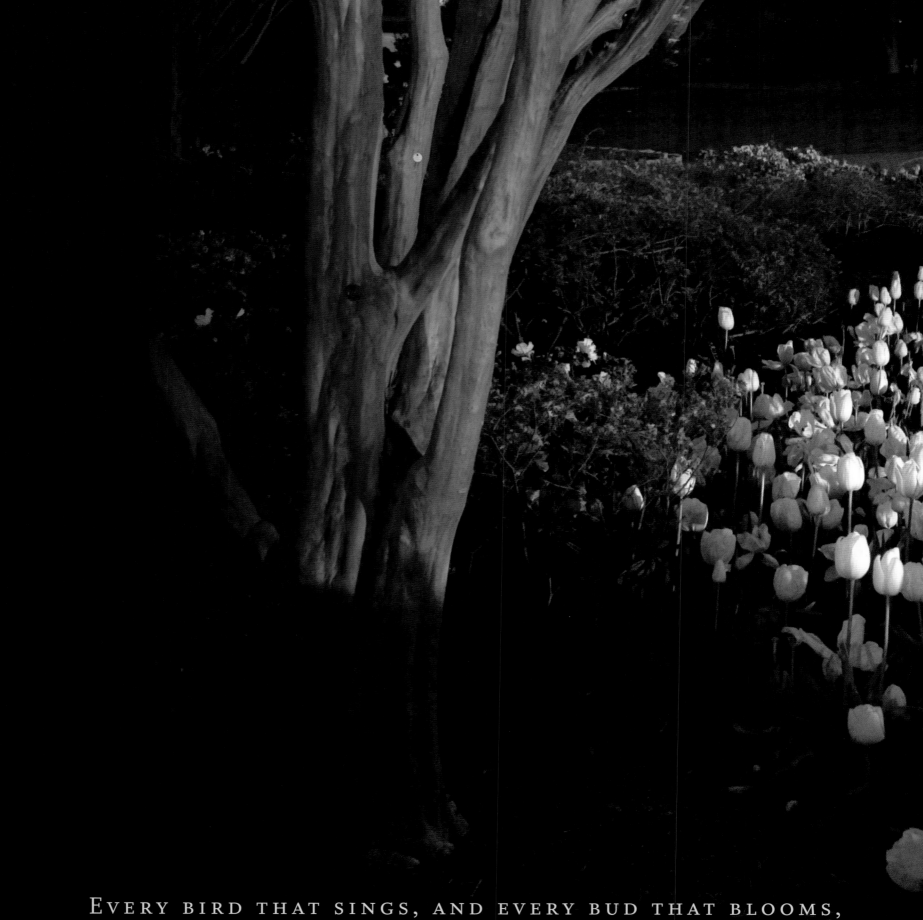

EVERY BIRD THAT SINGS, AND EVERY BUD THAT BLOOMS,

DOES BUT REMIND ME OF THAT GARDEN UNSEEN,

AWAITING THE HAND THAT TILLS IT.

EMILY DICKINSON

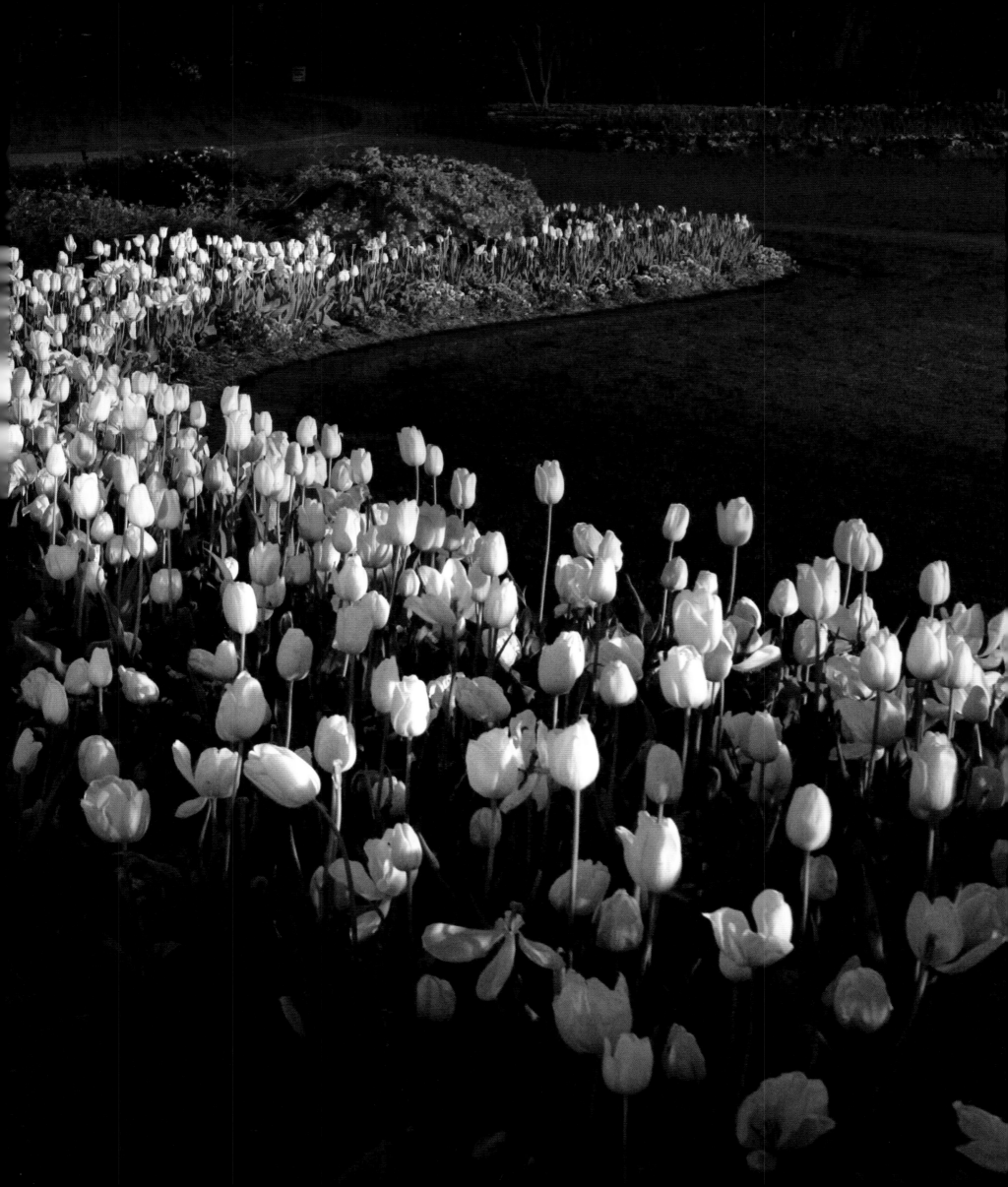

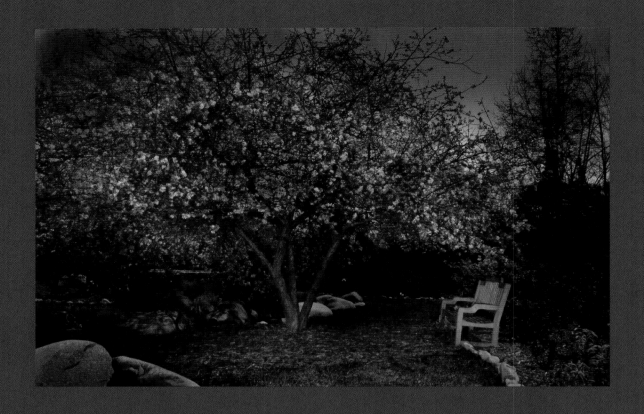

DESCANSO GARDENS

fragrant displays

THE SPANISH WORD *DESCANSO* translates as "restfulness" or "repose," but the history of this

160-acre garden is a dramatic tale that illustrates the conflicted relationship between humans and land.

Situated in Southern California's San Rafael Hills, this area was originally blanketed with live oak and a

chaparral range, and was inhabited by the aboriginal Gabrielino people. But by the eighteenth century,

the land had been claimed by Spanish explorer Gaspar de Portolà for the king of Spain, who, in turn,

gave it to Corporal José María Verdugo as a reward for loyal service. At the end of the nineteenth century,

a contest of ownership began between the state of California and private buyers, and in 1937 a large

section of the original terrain was finally purchased by newspaper magnate E. Manchester Boddy. Boddy

had thousands of camellia trees planted beneath the towering oaks—creating the world's largest

commercial camellia plantation. Descanso Gardens' twenty-acre camellia garden is now North America's

largest, with over thirty-four thousand plants of more than seven hundred species and varieties, many

of which are more than twenty feet in height. In the spring, the intoxicating scent of five hundred lilacs

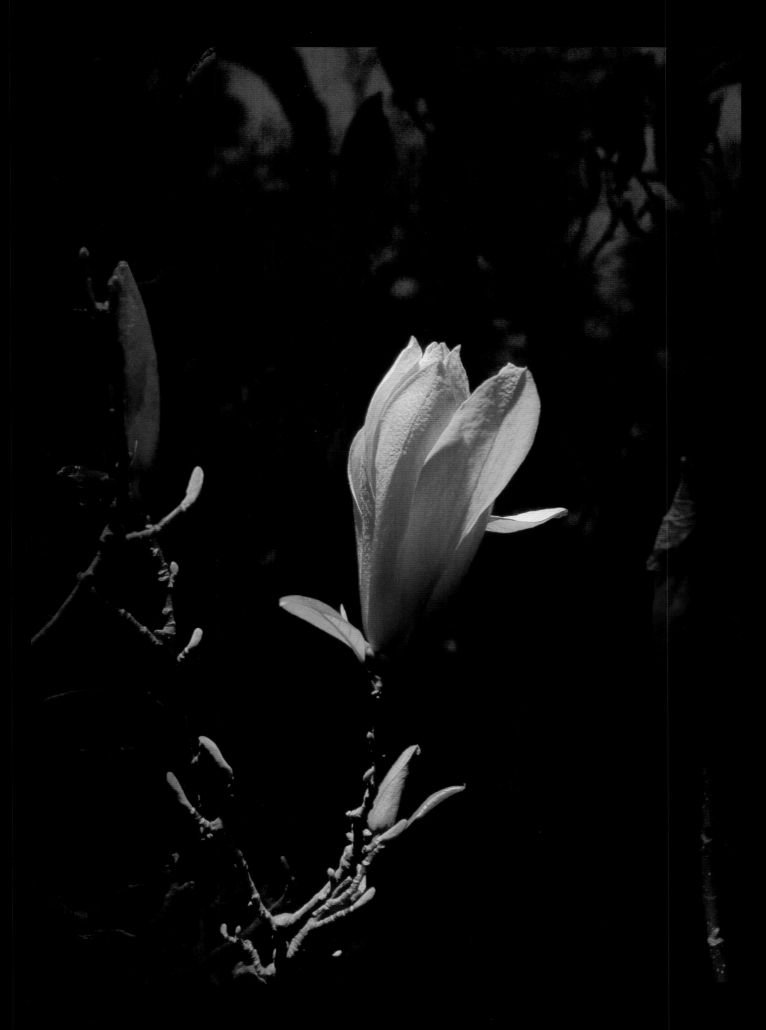

Opposite: INTERNATIONAL ROSARIUM *Above:* LILY MAGNOLIA—*MAGNOLIA LILIIFLORA*

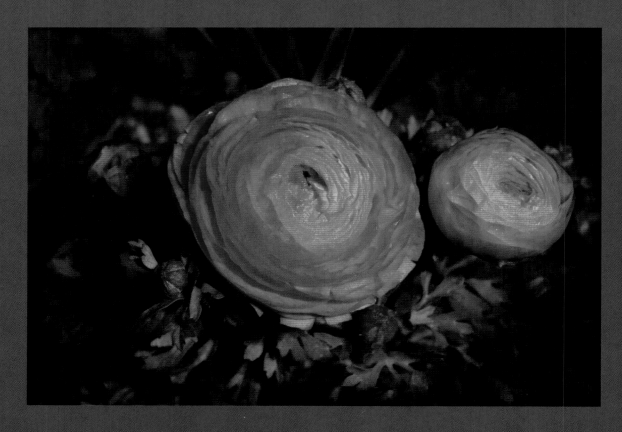

PERSIAN BUTTERCUP—*RANUNCULUS ASIATICUS*

in bloom, including the 'Lavender Lady' developed by the garden's horticulturists, transforms the garden. Descanso's Japanese Garden features a stunning collection of Japanese maples, azaleas, and bamboo, complemented by a lovely raked rock garden. For more insight into Japanese culture, visitors can explore the Full Moon Tea House, with its blue tile roofing imported from Japan, and a *minka*, a structure resembling a Japanese farmhouse. The California Garden was designed in 1959 by famed horticulturist Theodore Payne. A celebration of Southern California's natural heritage, this garden is set amid the sunbathed chaparral hillside, with paths that meander through sage scrub, Matilija poppies, manzanitas, and other native wildflowers. A five-acre garden of more than three thousand roses represents centuries of horticultural history from around the world. Alongside the rosarium lies an iris garden with 1,500 varieties—the largest of its kind in California. Boddy's elegant twenty-two-room mansion, designed by architect J. E. Dolena, is situated on a hill near the mountain stream that provides fresh spring water to the gardens, a constant reminder of the land's fruitful history. ℘

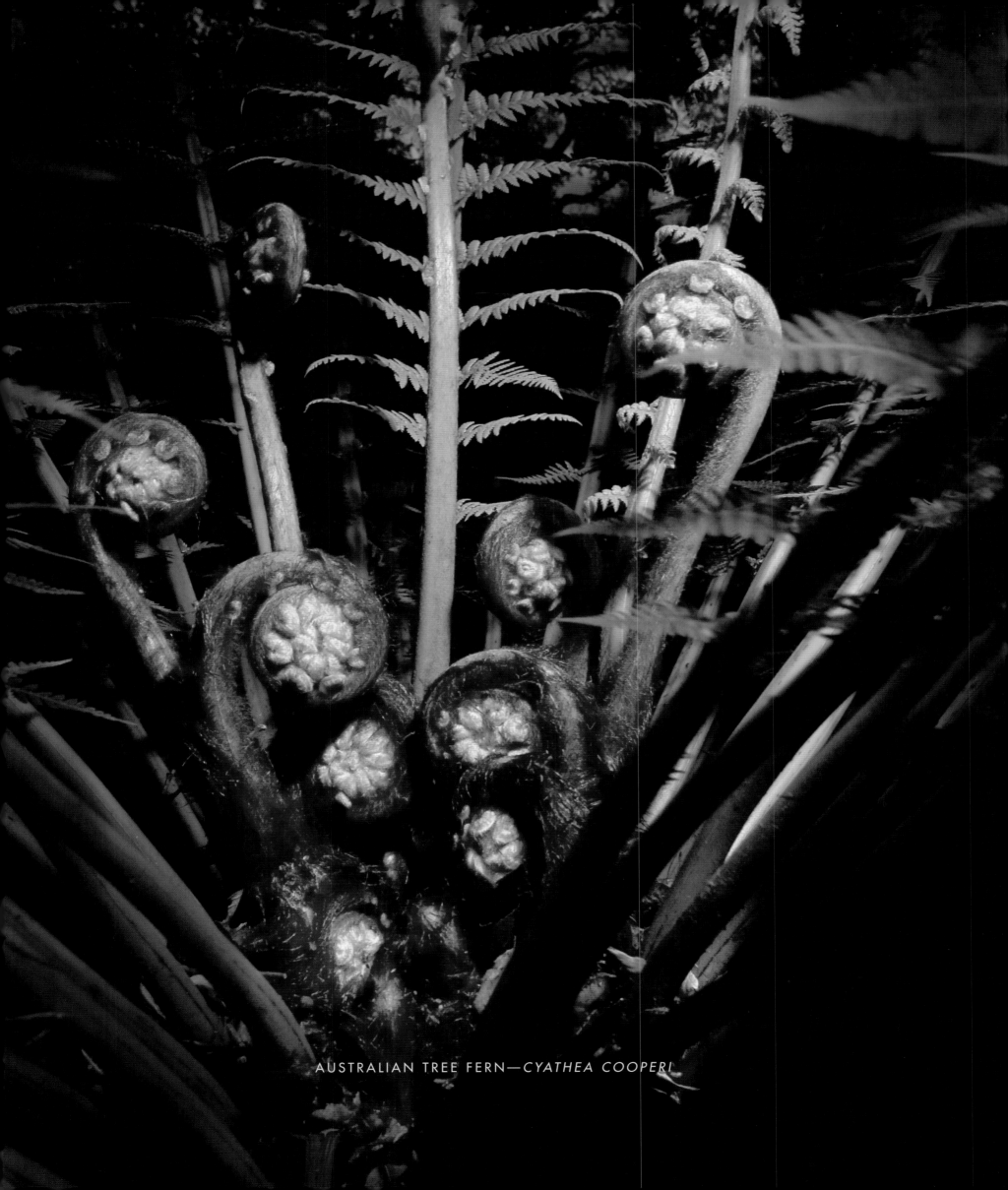

AUSTRALIAN TREE FERN—*CYATHEA COOPERI*

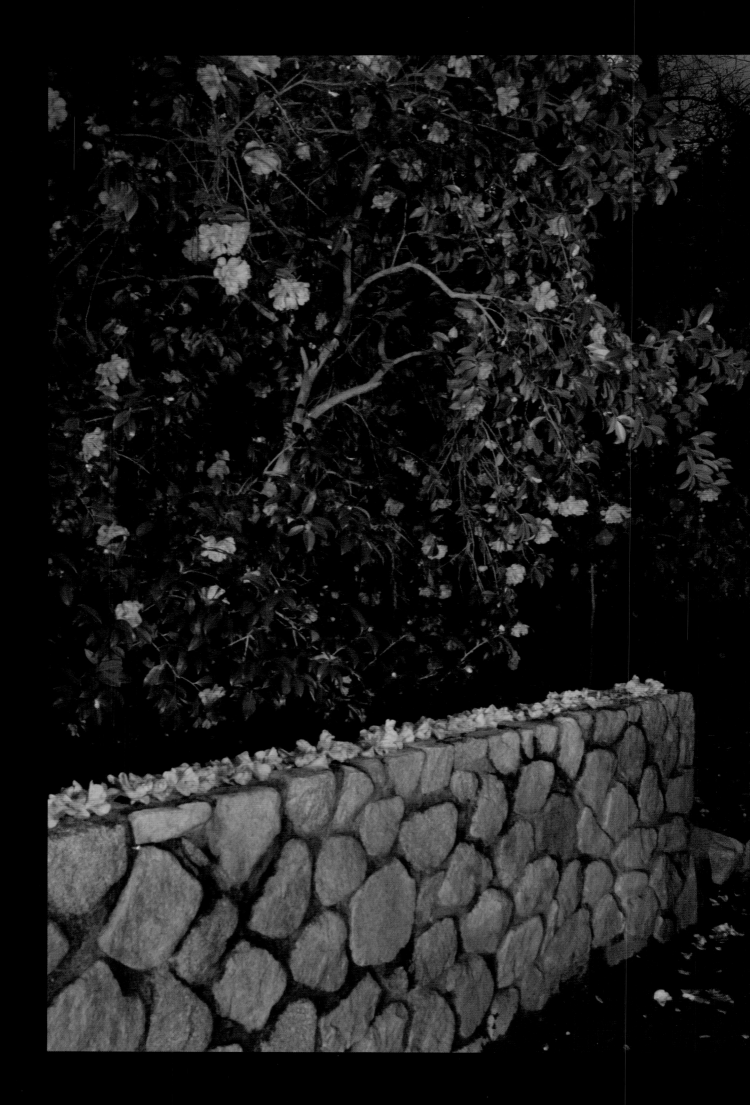

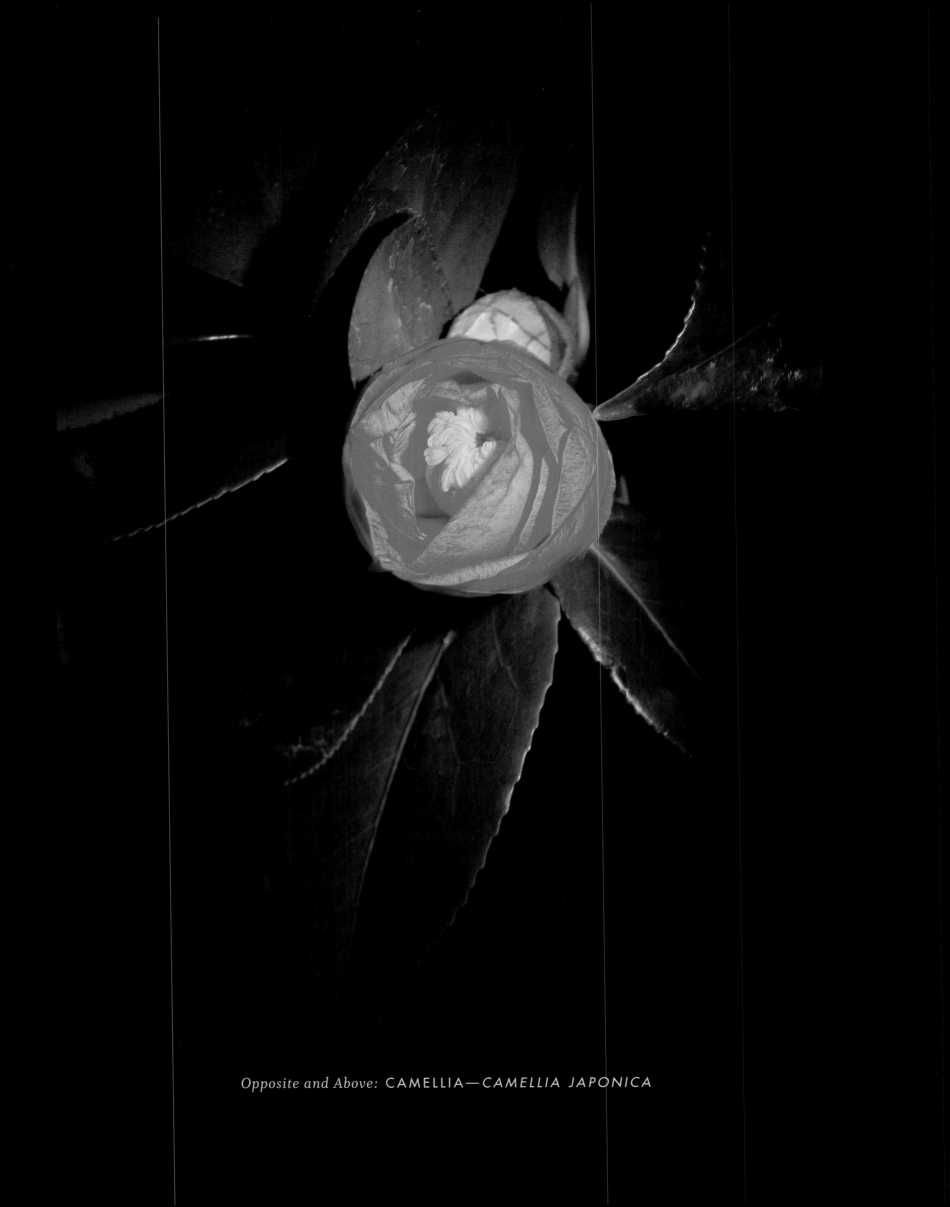

Opposite and Above: CAMELLIA—CAMELLIA JAPONICA

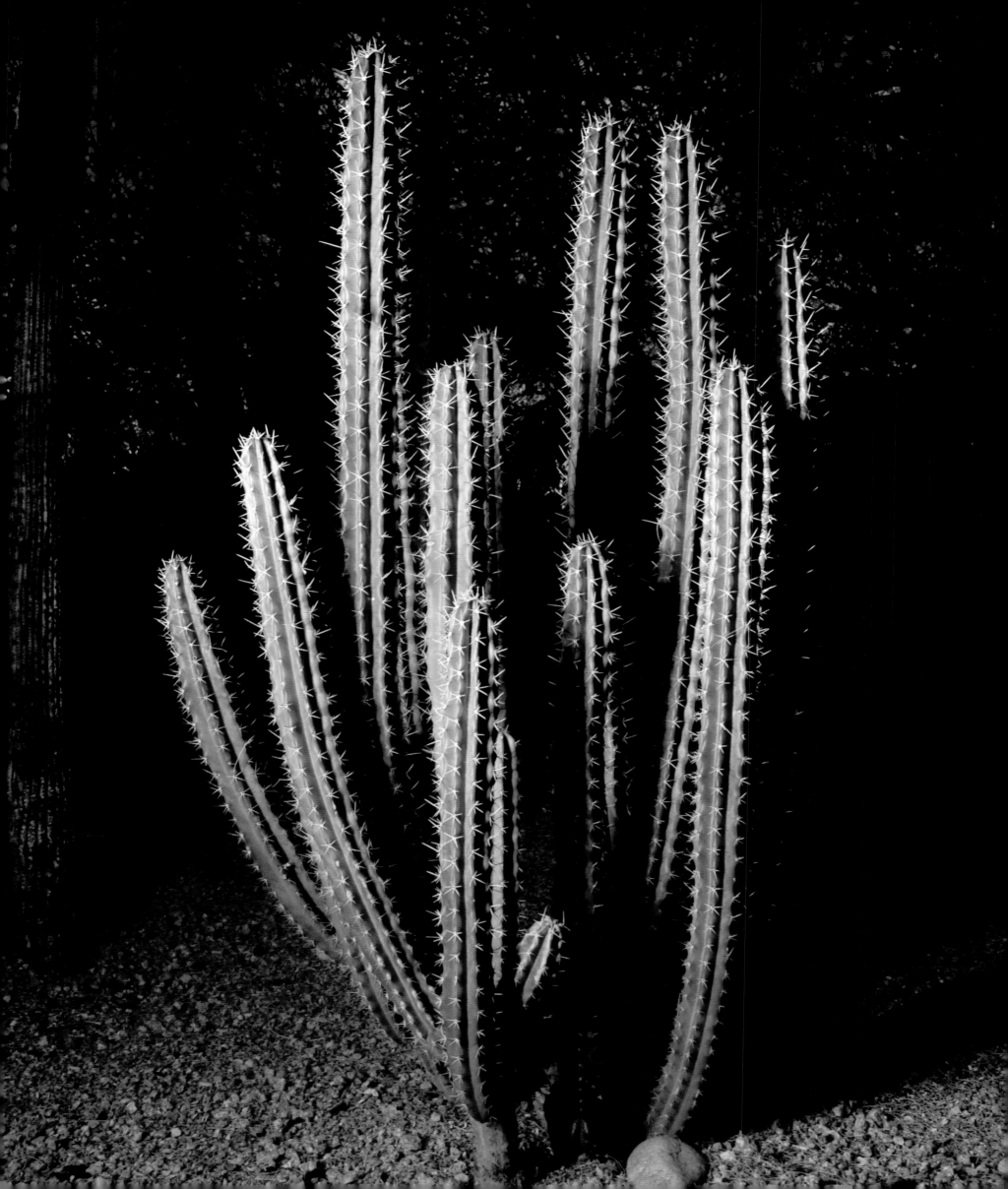

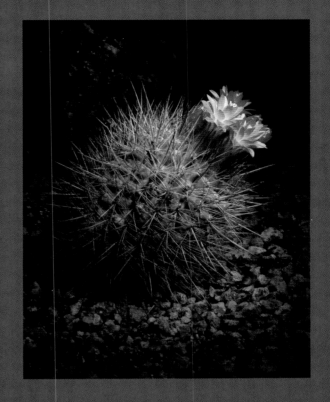

DESERT BOTANICAL GARDEN

a desert oasis

DOVES BY DAY and owls by night fly freely among the red, orange, and magenta blooms of 139 threatened and endangered desert-plant species cultivated by the Desert Botanical Garden. Established in 1939 through efforts led by Gertrude Divine Webster, the world's finest collection of desert plants is located in the metropolitan area of Phoenix, Arizona, amid the red buttes of Papago Park. The garden's oldest plantings are found along the main trail of this sandy park, the Desert Discovery Trail, which takes a circular route through a sun-warmed palette of soft green hues that change texture and form from one turn to the next. From here, the Wildflower Trail leads off to display colorful gardens designed to attract hummingbirds and butterflies. Beyond the Cactus and Succulent Houses, another trail leads to areas that focus on the plants and people of the Sonoran Desert. Hispanic and native crop gardens create a desert oasis while a forest of saguaro cacti towers above spiny clusters

Opposite: PITAYA—*STENOCEREUS STELLATUS* *Above:* QUISQUITO—*ERIOSYCE SUBGIBBOSA* SUBSP. *CASTANEA*

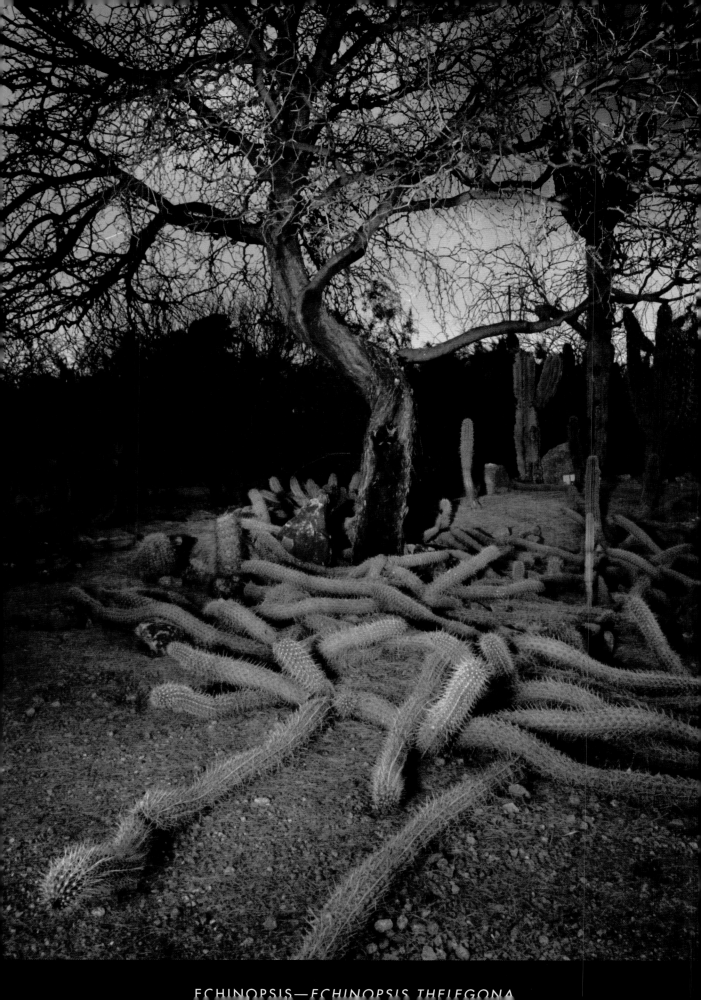

ECHINOPSIS—ECHINOPSIS THELEGONA

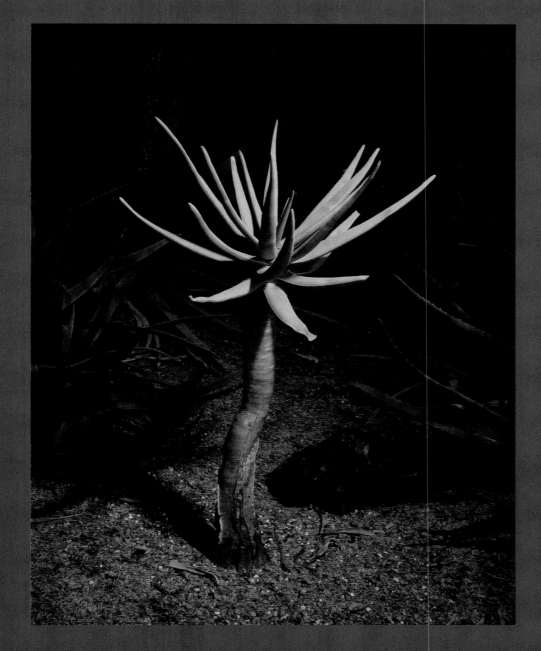

QUIVER TREE—*ALOE DICHOTOMA*

of golden barrels. The Nature Trail opens up dramatic vistas of distant mountains as trilling verdins and cooing doves make lilting conversation in the background. A final trail educates visitors on desert life with examples of desert landscaping and plots of vegetable and herb gardens. The Desert House Exhibit is an experimental house designed to showcase water- and energy-saving devices suitable for harmonious desert living. All around, whiptail lizards rustle about on the desert floor, and bats and moths pollinate dazzling night-blooming cacti, making the fifty-acre Desert Botanical Garden a true urban oasis. ∞

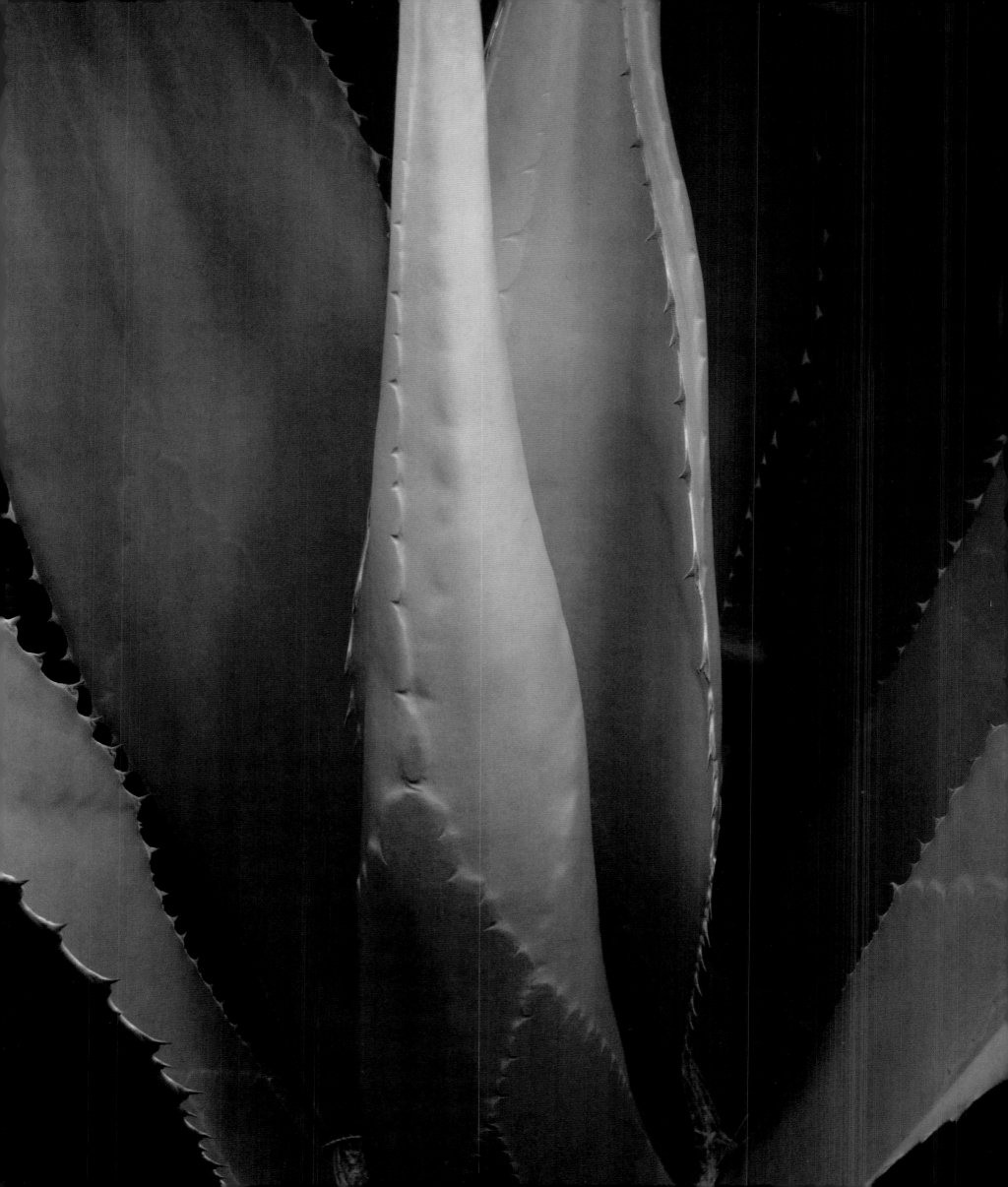

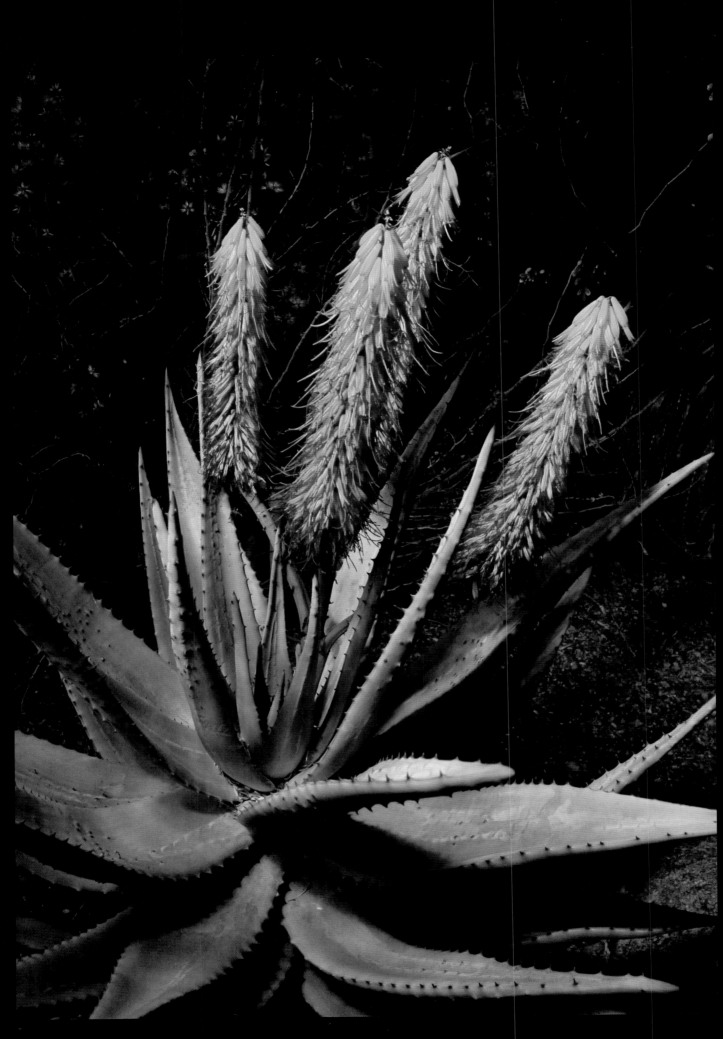

Opposite: NEW MEXICO AGAVE—*AGAVE NEOMEXICANA* *Above:* CAPE ALOE—*ALOE FEROX*

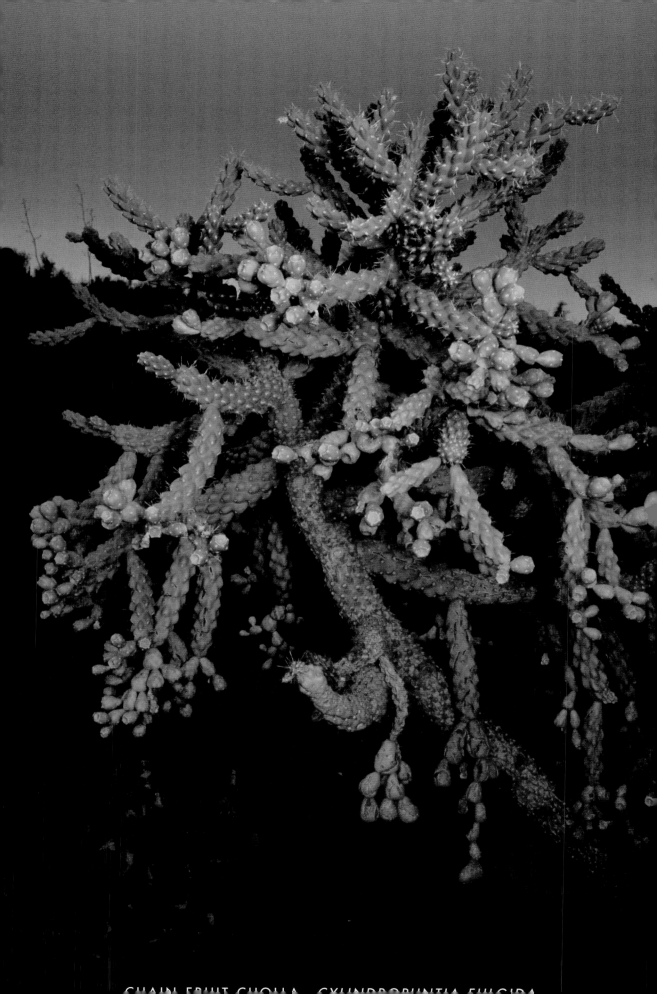

CHAIN-FRUIT CHOLLA · CYLINDROPUNTIA FULGIDA

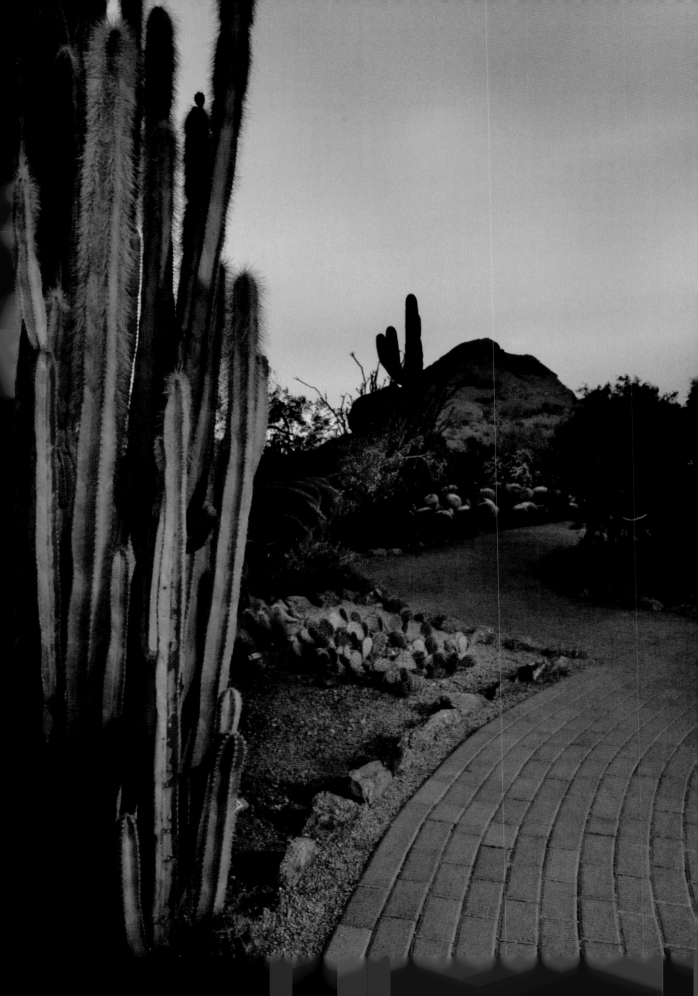

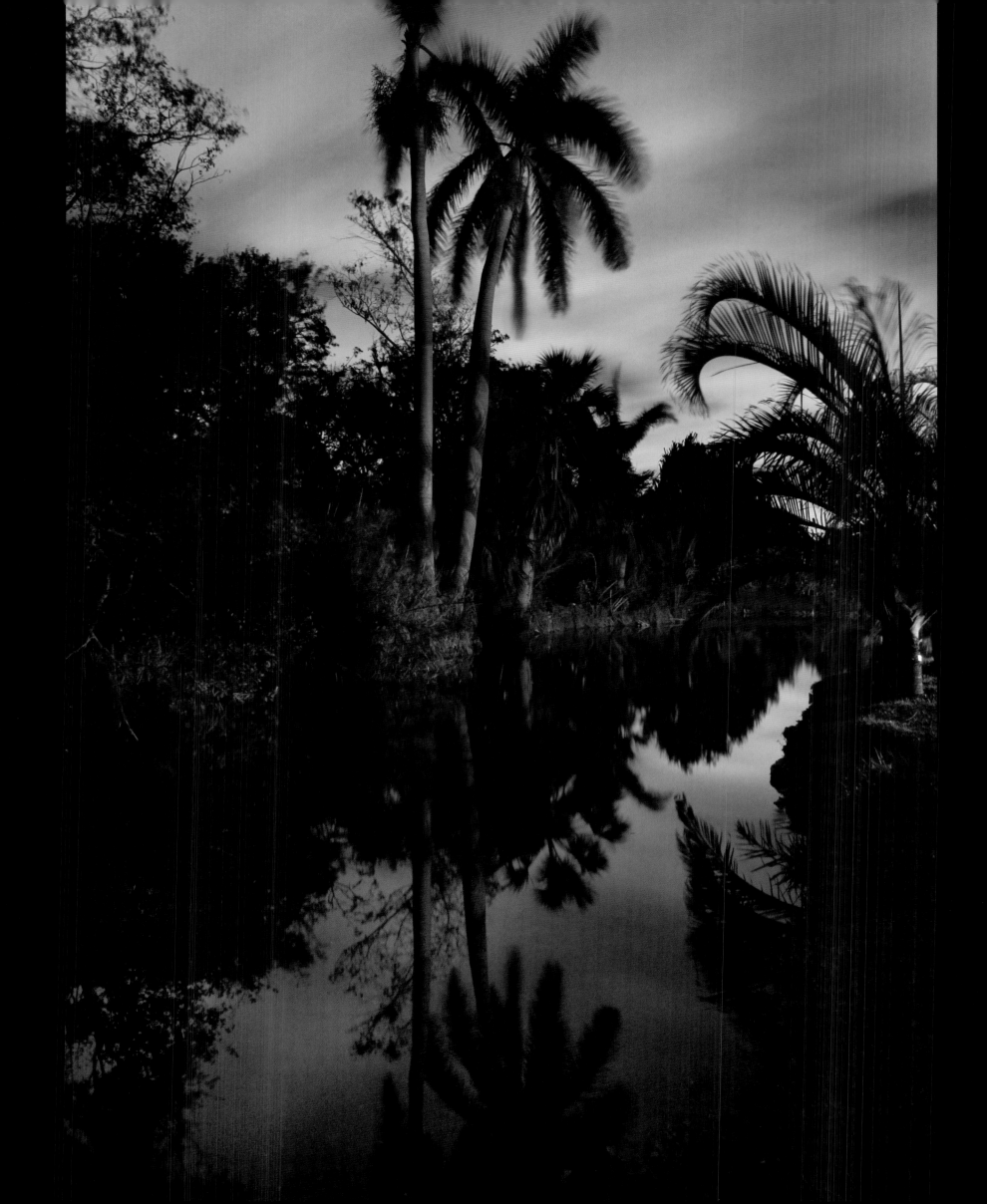

FAIRCHILD TROPICAL BOTANIC GARDEN
hints of vanilla

IN 1938, PLANT EXPLORER and botanist Dr. David Fairchild, with the help of landscape architect William Lyman Phillips, transformed a series of glades and lagoons into what is now Miami's Fairchild Tropical Botanic Garden. This semiformal garden has one of the largest collections of tropical plants in the world, featuring over 193 genera of more than 400 identified palm species and one of the world's most diverse collections of cycads (palms that are threatened with extinction). A two-acre rain forest features plants of the American tropics, including buttressed trunk trees; woody vines, or lianas, that can grow up to a foot in diameter; epiphytes; and a variety of heliconias from South and Central America. Rare species native to South Florida and the Puerto Rican archipelago inundate the garden with exotic scents and delight visitors with their unusual appearance: the giant baobab tree's pendant white flowers, the giant Amazon water lily in the Sibley Amazonica Pool, the nodding blooms of

Opposite: HAMMOCK LAKE *Above:* BROMELIAD—*AECHMEA*

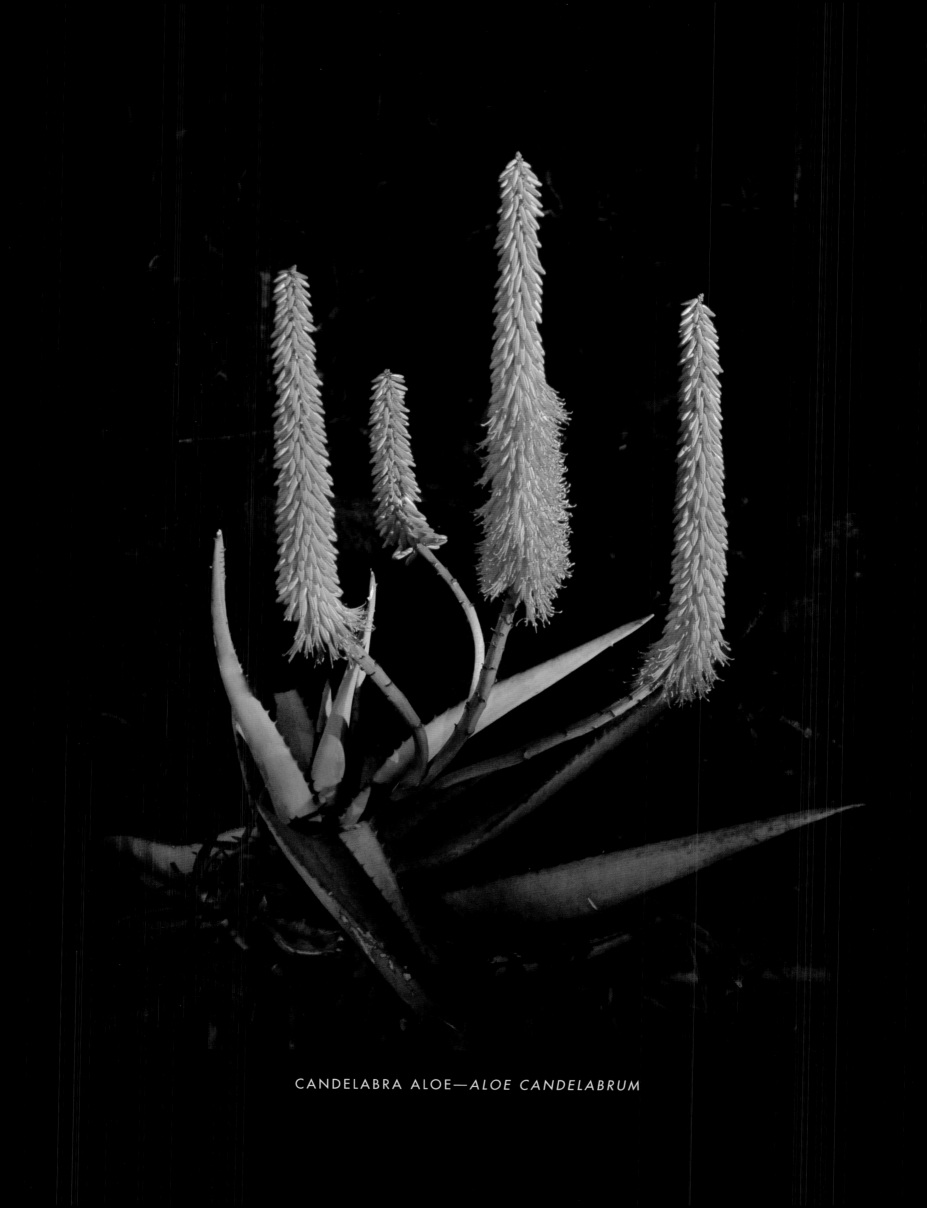

CANDELABRA ALOE—*ALOE CANDELABRUM*

BROMELIAD—*AECHMEA* 'BLUE TANGO'

Dombeya within the Tropical Flower Garden, and the ivory flowers of the Mexican tuberose (a bulbous relative of the agave plant sacred to the Aztecs). A stream winds through an adjacent conservatory containing the Tropical Fruit Pavilion, the first of its kind in the United States to display exotic species from Borneo, the Amazon, Indonesia, Thailand, and several other corners of the Earth. This internationally significant collection possesses more than 450 cultivars of superior equatorial fruits, including canistels, jackfruits, mamey sapotes, lychees, longans, durians, mangosteens, rambutans, and sapodillas. The Fairchild Herbarium is the largest in the region, with more than 165,000 plant specimens of flora from Florida, the Bahamas, and the Caribbean Basin, and palms and cycads from across the globe. With alligators swimming in its lagoons, great grey owls hunting in its glades, and raccoons searching for the remnants of fallen fruits, this Southern garden is a flourishing shelter for plants and animals alike. ✒

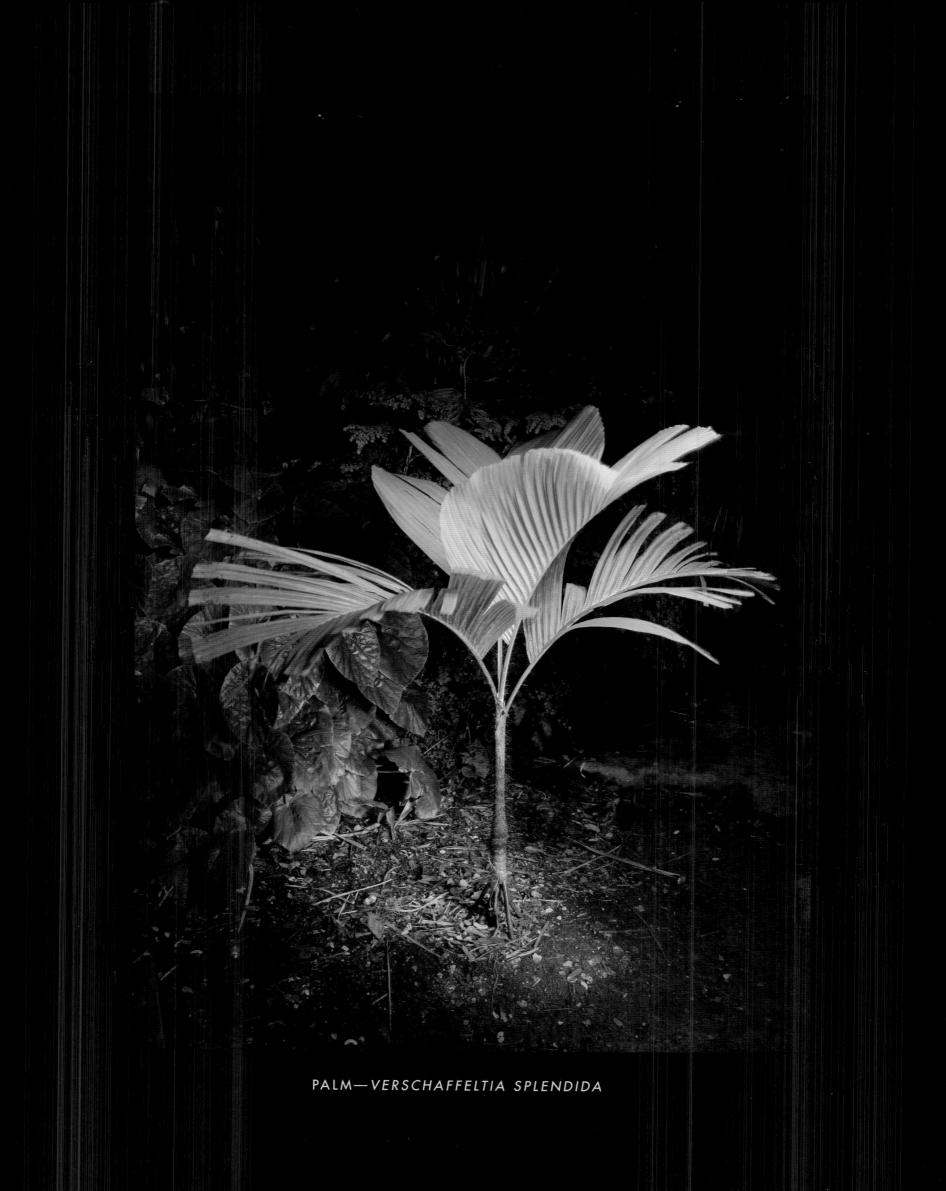

PALM—VERSCHAFFELTIA SPLENDIDA

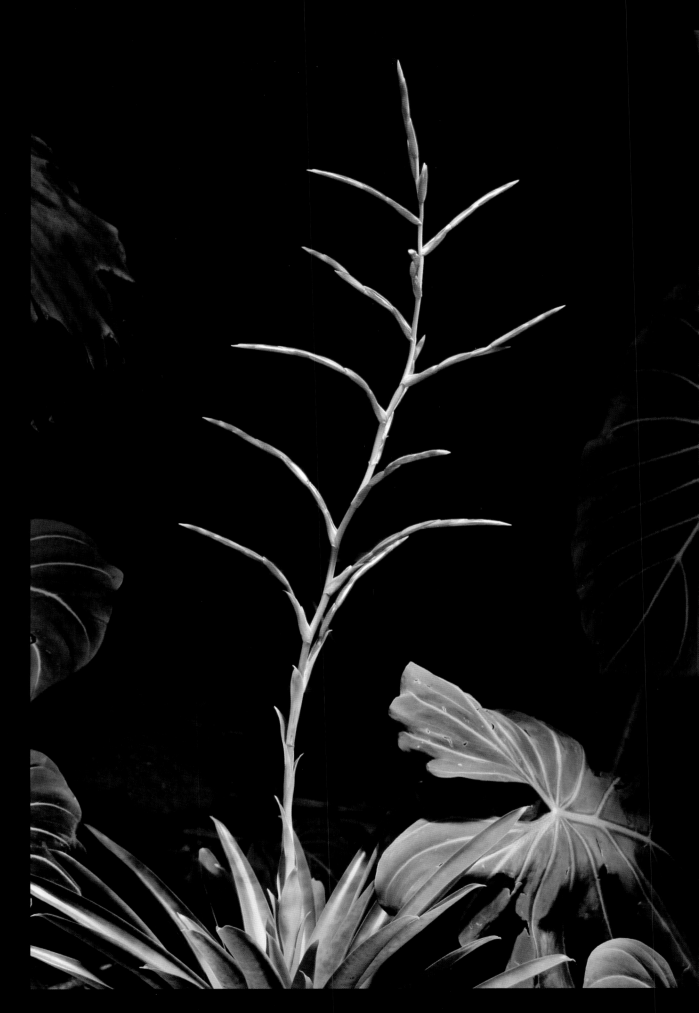

BROMELIAD—*VRIESEA NEOGLUTINOSA*

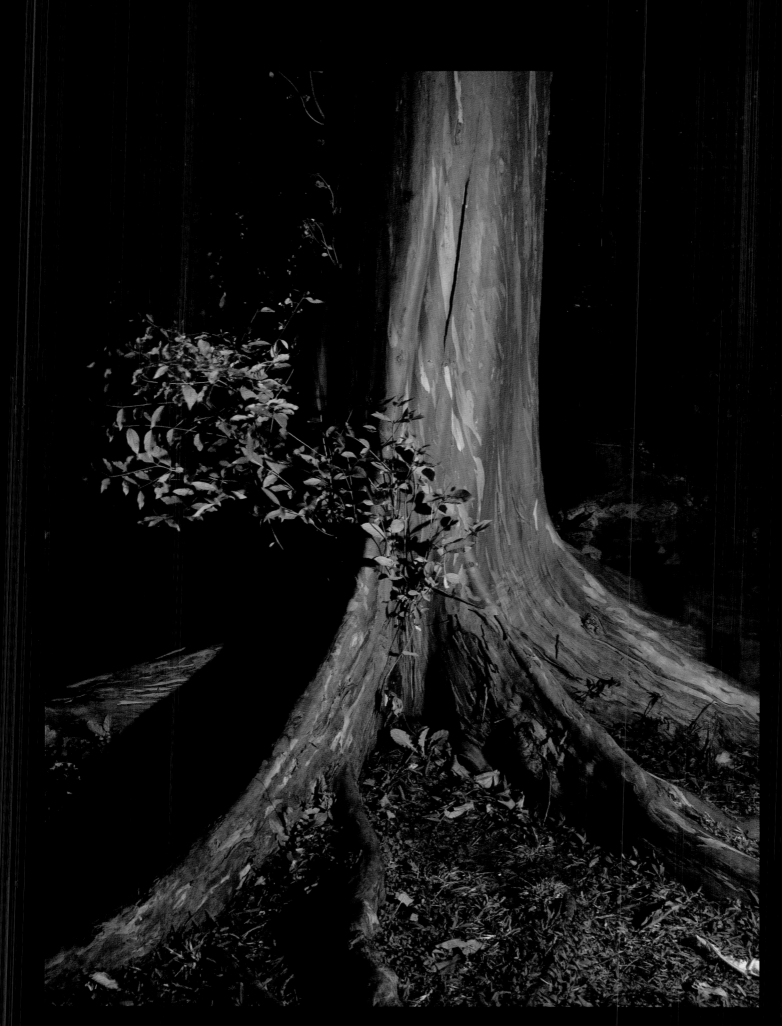

Above: RAINBOW EUCALYPTUS—*EUCALYPTUS DEGLUPTA* Opposite: PALM—*PSEUDOPHOENIX VINIFERA*

Pages 76–77: GIANT WATER LILY—*VICTORIA AMAZONICA*

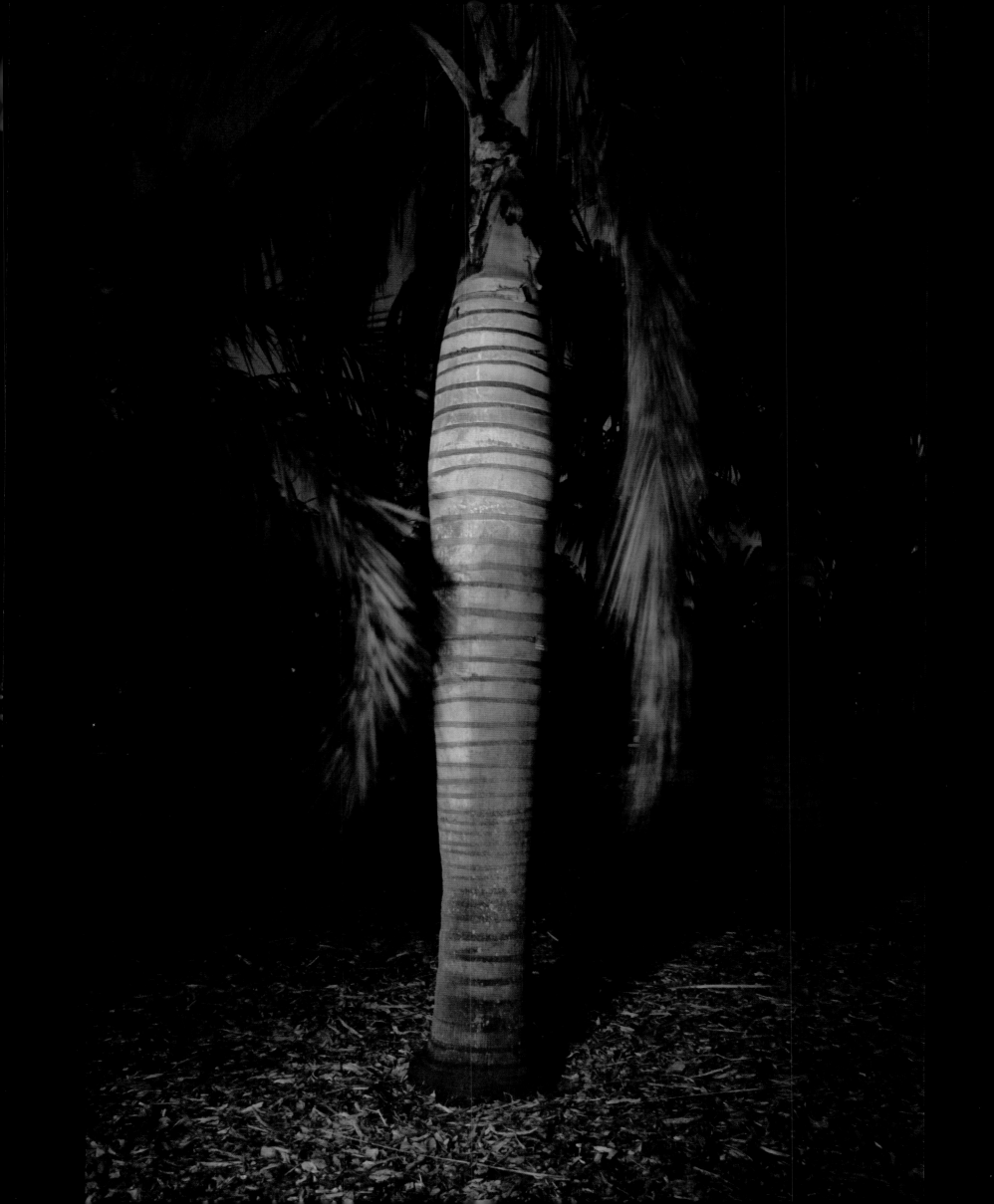

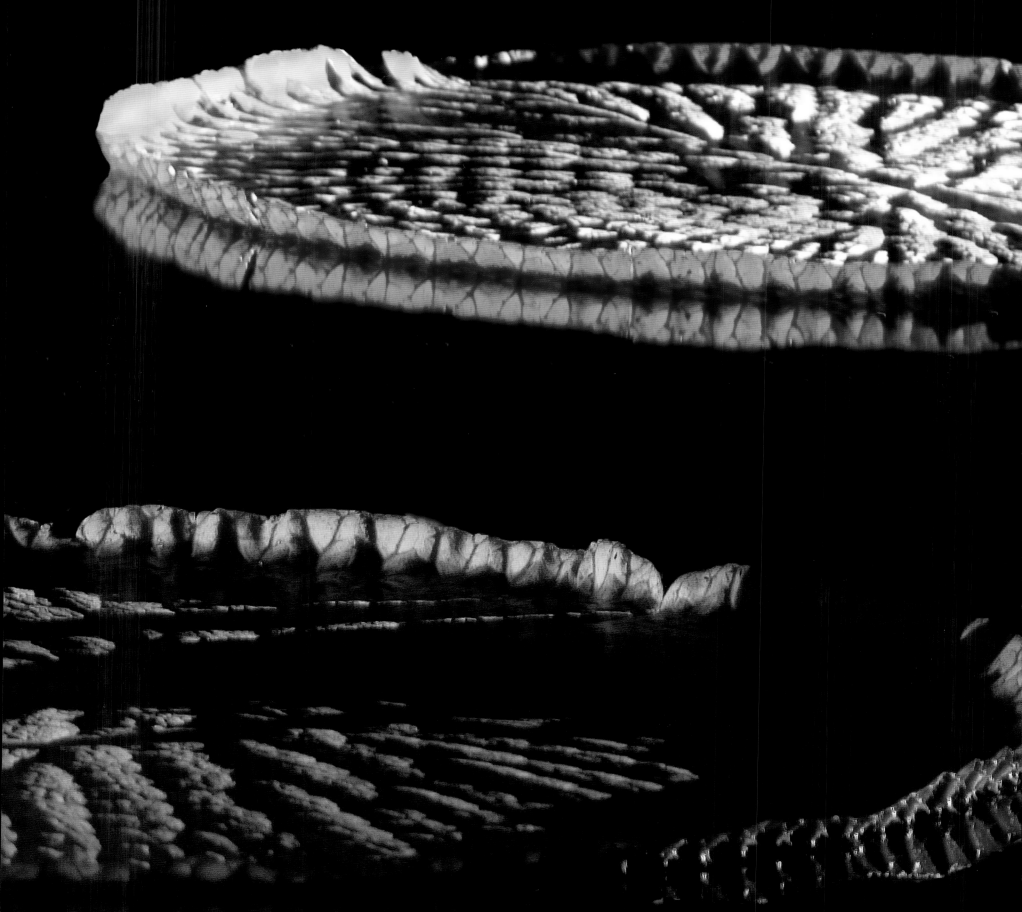

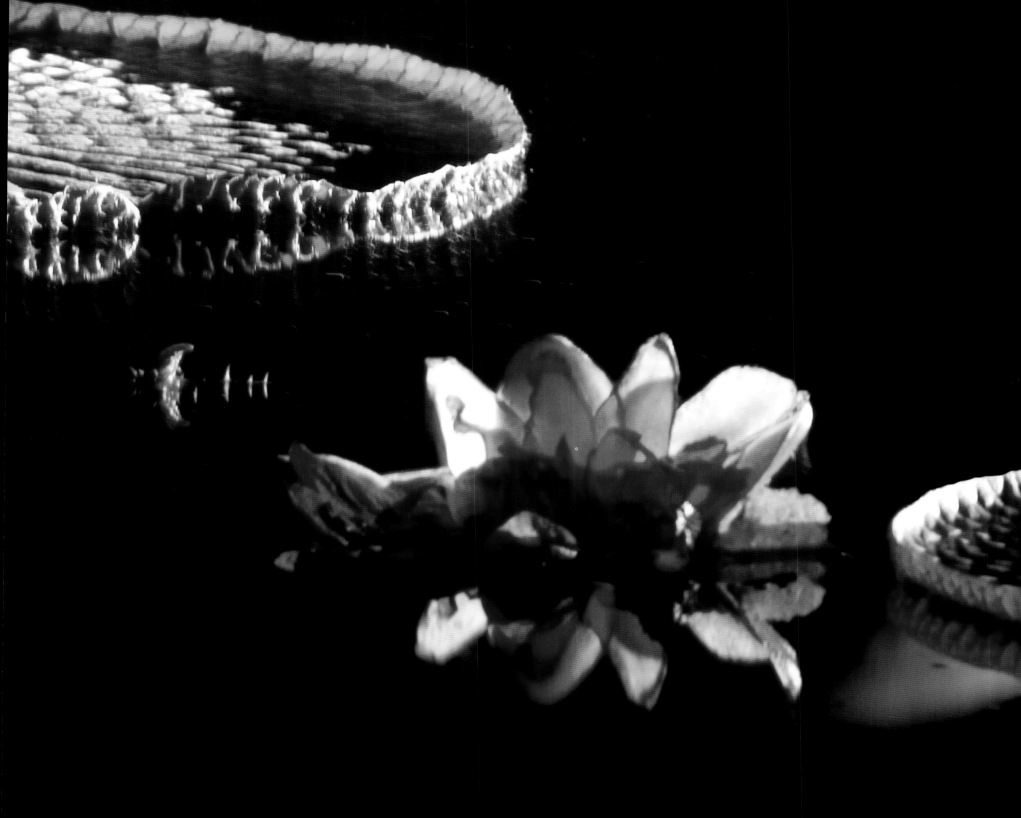

MY GARDEN, WITH ITS SILENCE AND PULSES OF FRAGRANCE

THAT COME AND GO ON THE AIRY UNDULATIONS,

AFFECTS ME LIKE SWEET MUSIC...

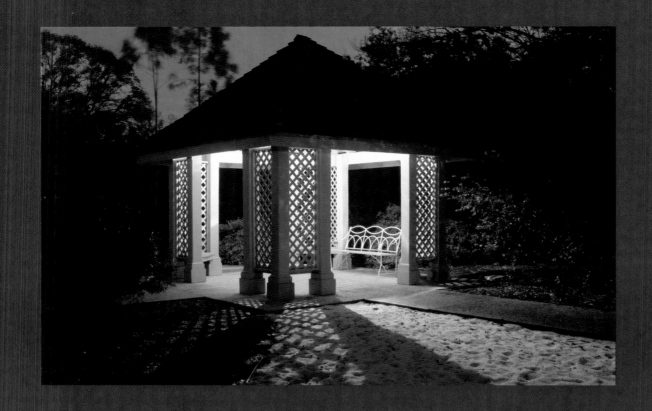

HARRY P. LEU GARDENS

under the majestic oak

WITHIN THE SHADOW of the world-famous theme parks of Orlando, Florida, beneath 200-year-old towering oak trees draped in Spanish moss, lies a small fifty-acre plot steeped in mid-nineteenth-century history. Purchased in 1936 by Harry P. and Mary Jane Leu and donated to the City of Orlando in 1961, the Harry P. Leu Gardens began as a collecting ground for plants the couple gathered while on their travels. The gardens offer a boardwalk and gazebo overlooking Lake Rowena and three native species of mangroves, water lilies, and, where the Tropical Stream Garden meets the lake, pickerel weeds, red swamp hibiscuses, giant leather ferns, arrowheads, and arrowroots. The adjacent Wetland Garden features live oaks, red maples, and bald cypress trees that shelter palmettos, coral beans, sea grapes, spider lilies, horsetails, spiderworts, and various ferns. The Tropical Stream Garden is home to many exotic fruits, including bananas, papayas, passion fruits, star fruits, mangos, guavas, and lychees, as well as various

Above: ROSE GARDEN *Opposite:* ROSE—ROSA 'OLD ROSE'

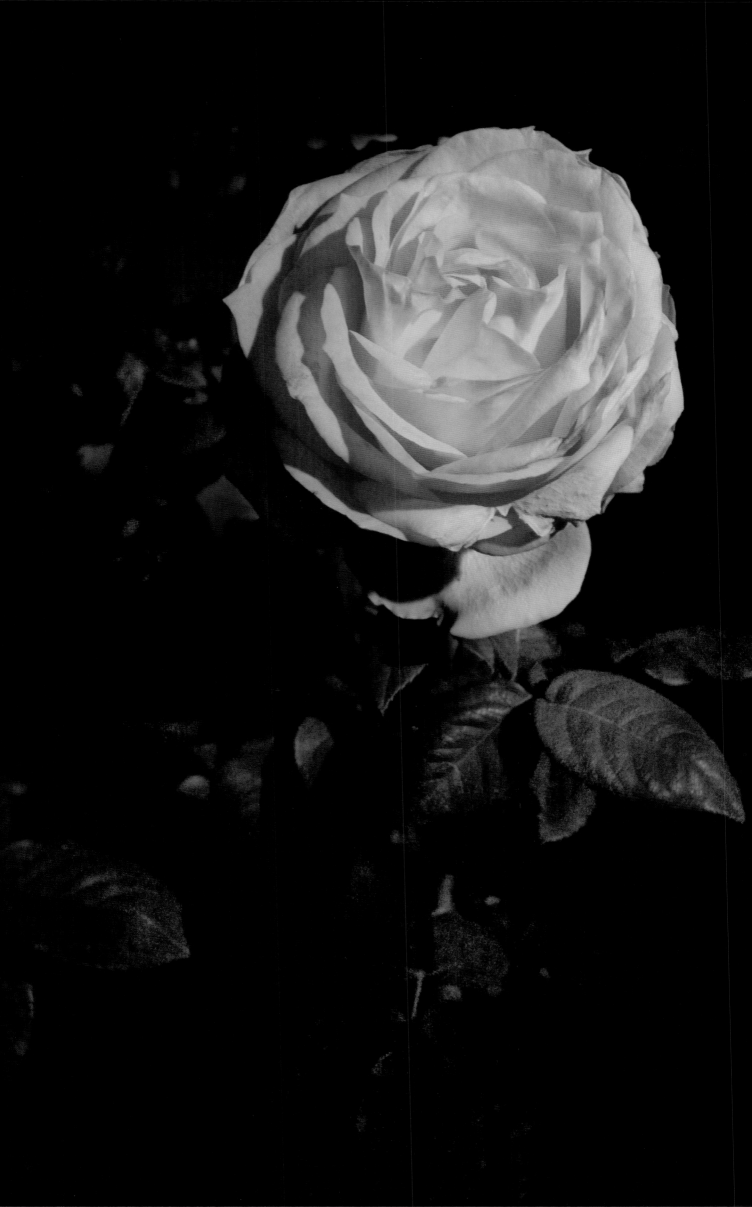

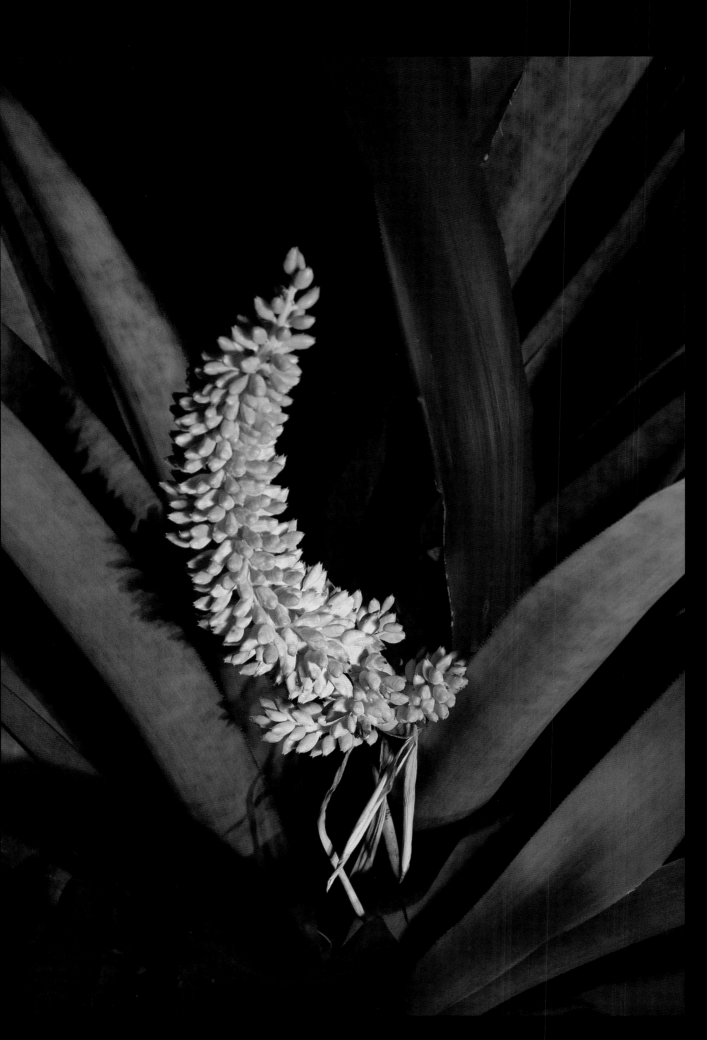

ALOE—*ALOE*

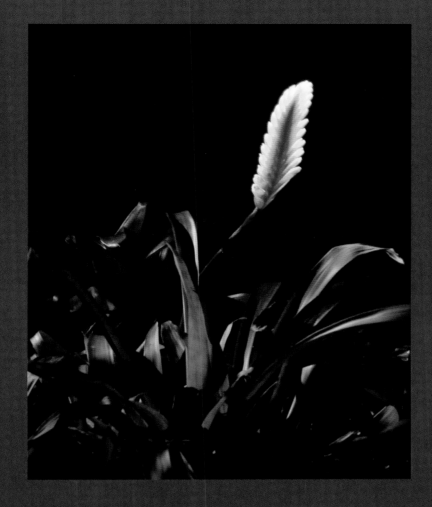

BROMELIAD—*VRIESEA*

tropical plantings, such as birds-of-paradise, gingers, tree ferns, palms, and flowering vines. Alongside

the lake, under majestic canopies of oak, sweet gum, and pine found in the North and South Woods, the

camellia trees' waxy flowers bloom in hues of red, pink, white, and even a rare yellow throughout

the winter months. The Leu Camellia Collection is one of the largest outdoor collections of camellias in

the United States, with twenty-five different species, including the common camellia, *Camellia sasanquas*,

and the *Camellia sinensis* (tea plant), some present when the Leus acquired the area and others drawn from

various locations throughout the world. Mary Jane's Rose Garden is the largest formal rose garden in

Florida, exhibiting a selection of roses well suited to central Florida's steamy climate and known for

their resistance to disease, including the hybrid tea, grandiflora, English, Bermuda mystery, and shrub

roses. With a butterfly garden displaying more than one hundred different nectar and larval plants,

and a bird garden that provides fruits, insects, and water to hummingbirds, this spectacular botanical

oasis remains one of Florida's main attractions.

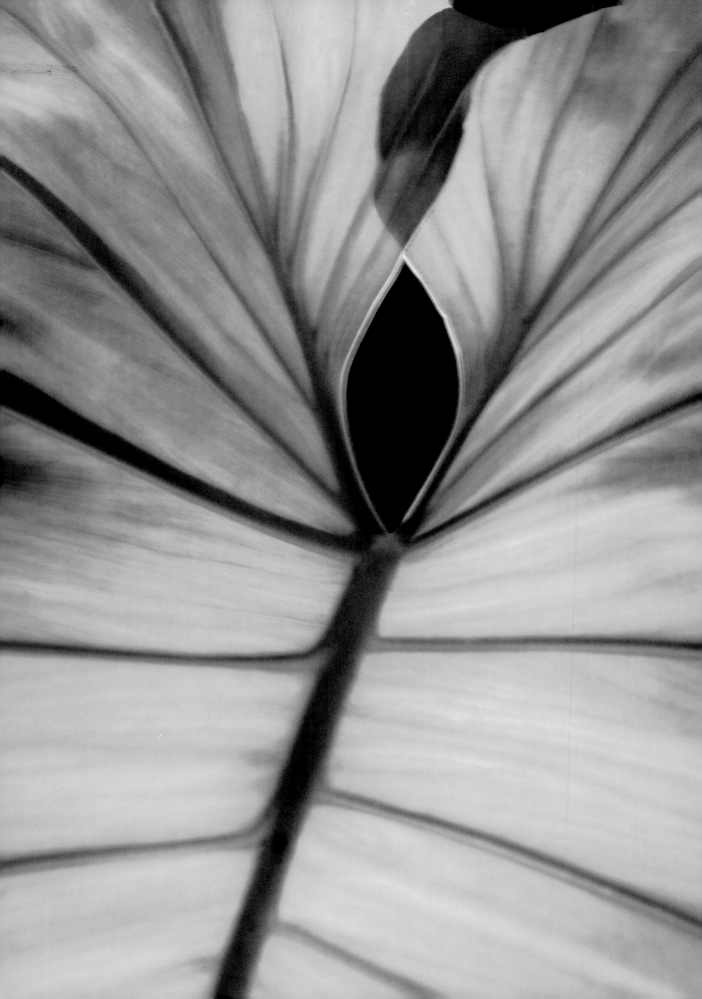

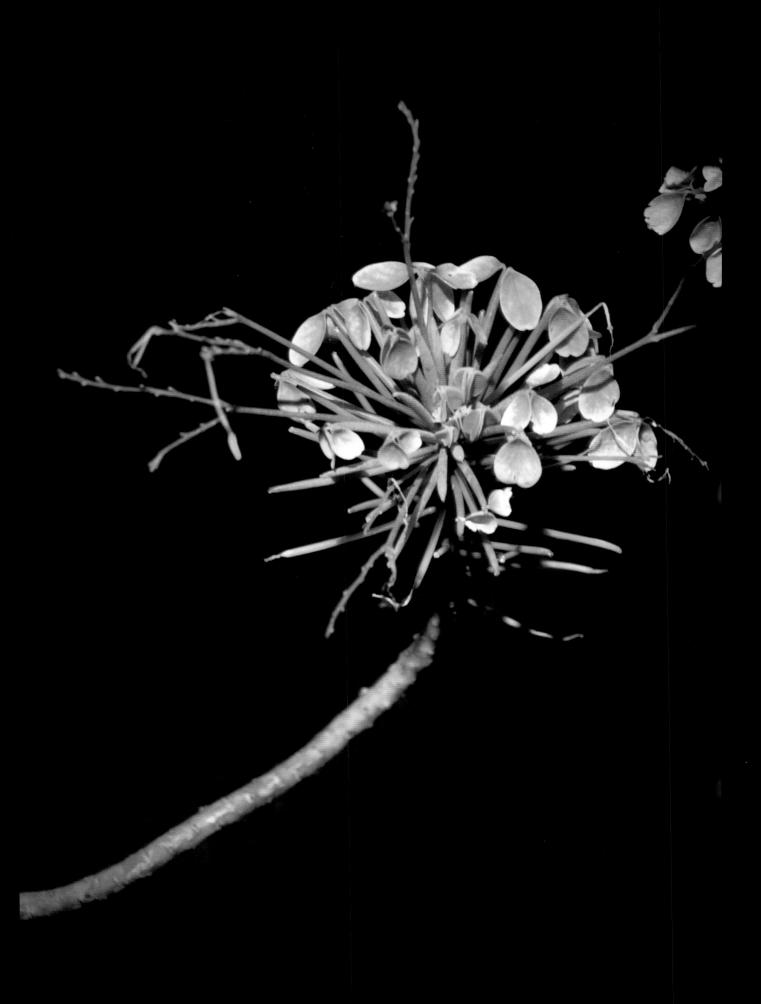

Opposite: PHILODENDRON—*PHILODENDRON* *Above:* OXALIS—*OXALIS HERRERAE*
Pages 84–85: CALADIUM—*CALADIUM*

I LOOK UPON THE PLEASURE WE TAKE IN A GARDEN

AS ONE OF THE MOST INNOCENT DELIGHTS

IN HUMAN LIFE.

CICERO

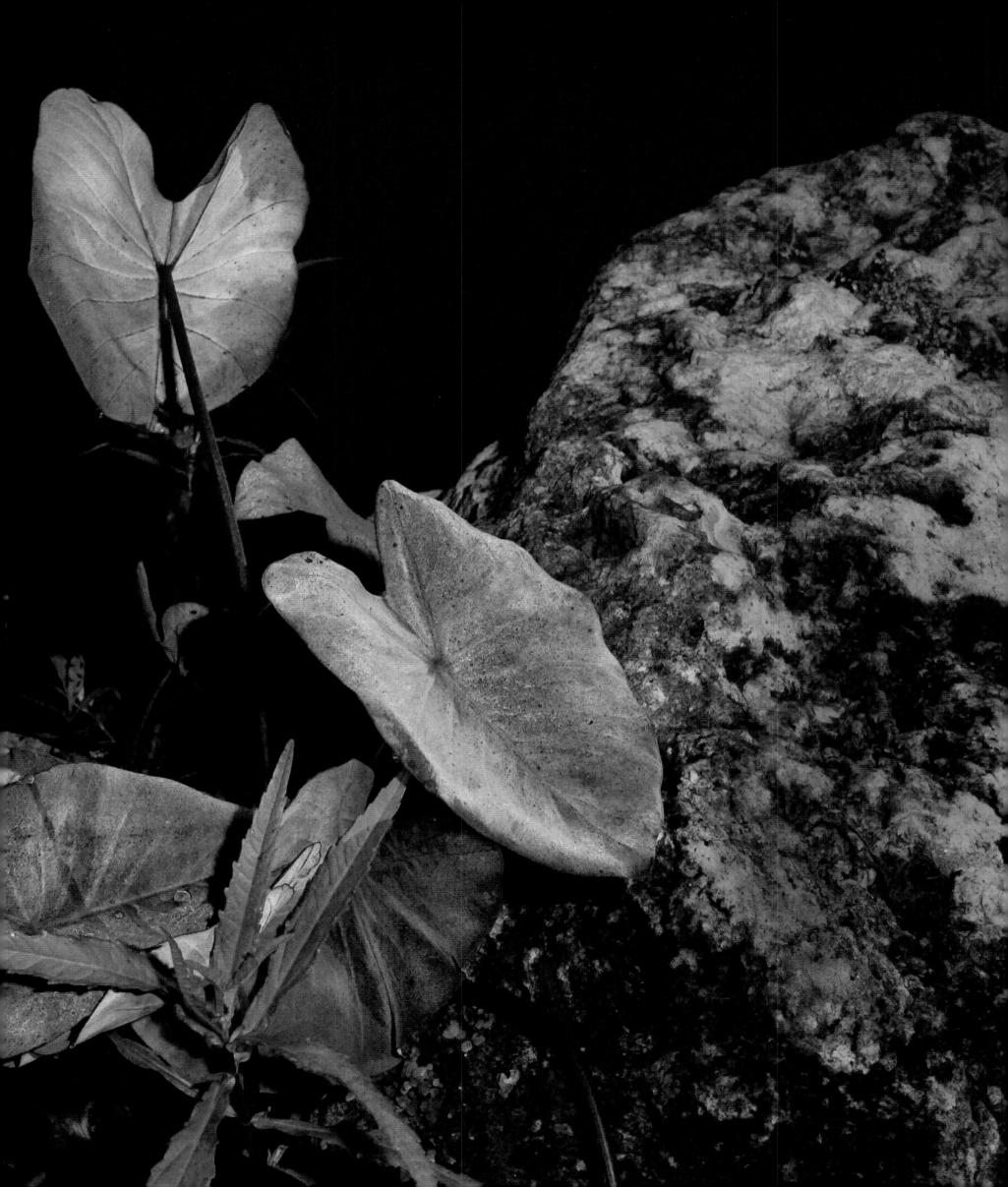

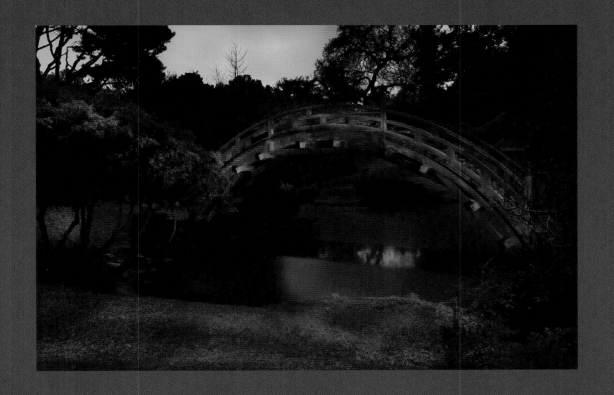

HUNTINGTON BOTANICAL GARDENS

the dream place

IN 1903, THREE YEARS AFTER he had moved to Los Angeles, H.E. Huntington purchased the beautiful San Marino Ranch, a working orange grove that he came to call "the dream place." Here, on the scarp of the Raymond Hill Fault, which stretches from South Pasadena to Arcadia, Huntington worked for twenty-four years to amass botanical, artistic, and literary treasures for an institution dedicated to knowledge. Laid out around an extensive art gallery, a library, and a Victorian-style conservatory, the Gardens' fifteen thousand plants flourish in the Mediterranean climate of Southern California. Built by Huntington around a 1.5-acre lake, the Chinese Garden includes camellias, pines, and lotuses set against a backdrop of mature California oaks. True to traditional practices, it is carefully situated in a northern orientation to the San Gabriel Mountains and displays carved stones from China, five hand-carved stone bridges, a stream, and a canyon waterfall. Located beside natural springs that emerge from the fault,

Opposite: BOOJUM TREE—*FOUQUIERIA COLUMNARIS* *Above:* JAPANESE GARDEN

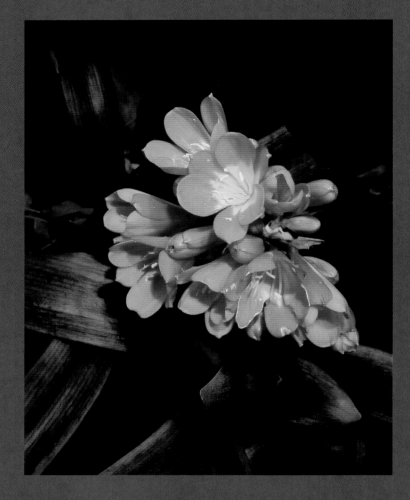

CLIVIA—*CLIVIA MINIATA*

various ponds offering lily pads, bamboo, swamp irises, dwarf papyruses, and water hyacinths surround a bronze sculpture of St. Francis of Assisi by Huntington's daughter-in-law, Clara. A children's garden centers around the four elements, and features the Rainbow Room, Fragrance Garden, and Fog Grotto, as well as a topiary volcano, sonic pool, water bells, marble jets, magnetic sand, and pebble chimes. In winter, the south-facing slope is one of the warmest areas in the garden, allowing for a jungle garden and an informal subtropical garden with plantings loosely organized according to geographical location, from Asia to Mesoamerica. These include tee cotton, which produces the longest and highest quality fibers of any cotton; *Mimosa polycarpa* var. *spegazzinii*, one of the "sensitive" plants whose leaves fold up when touched; sausage trees, with their nectar-filled maroon flowers; and forest fever trees, whose bitter leaves and bark make a tea that is said to be effective against malaria. Today, Huntington's 207-acre estate continues to inspire visitors, showcasing his literary and artistic treasures alongside the extensive gardens. ❧

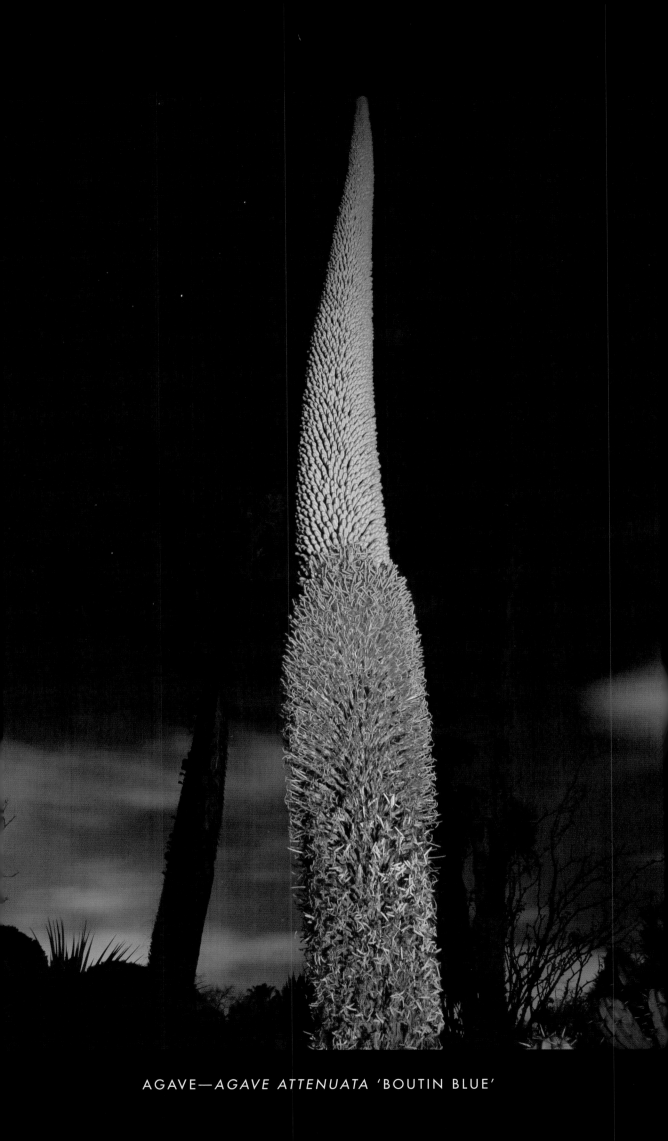

AGAVE—*AGAVE ATTENUATA* 'BOUTIN BLUE'

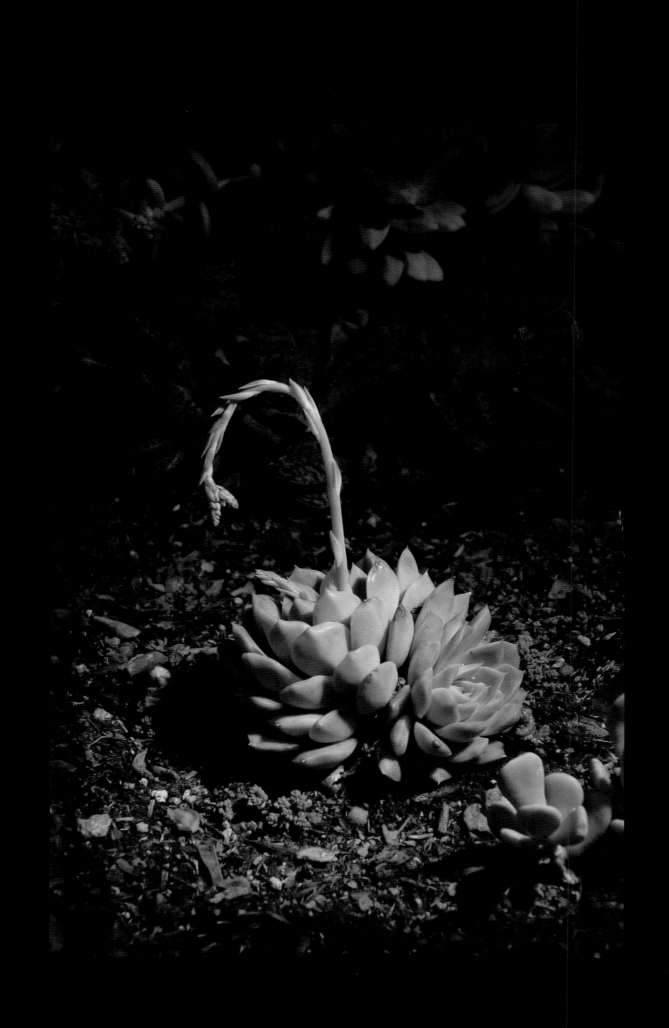

HEN AND CHICKS—*ECHEVERIA ELEGANS*

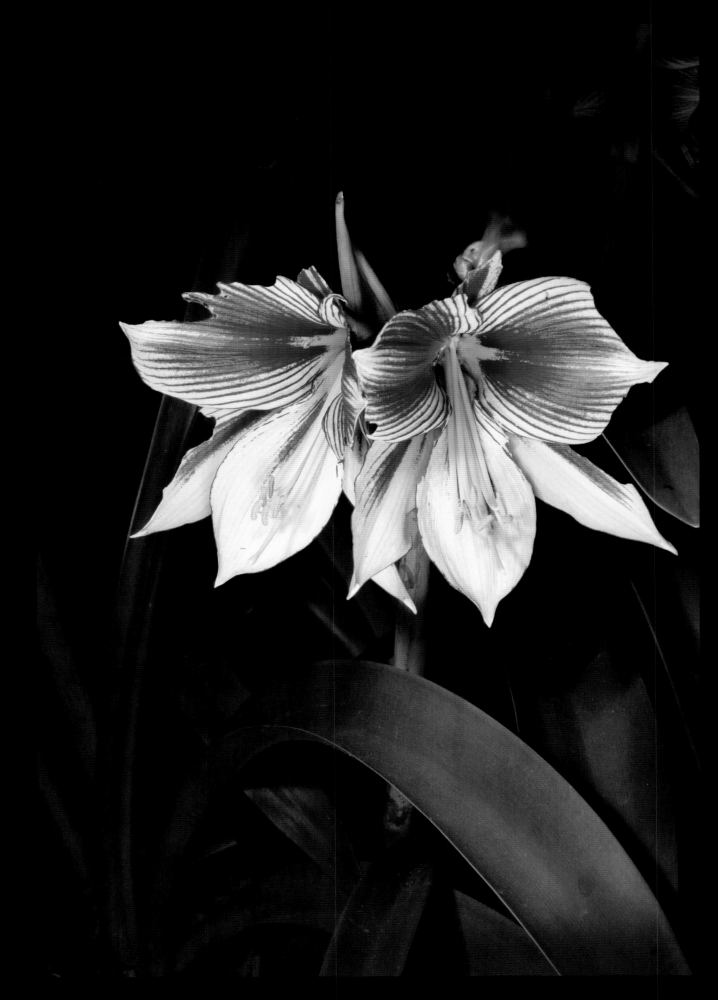

BUTTERFLY AMARYLLIS—*HIPPEASTRUM PAPILIO*

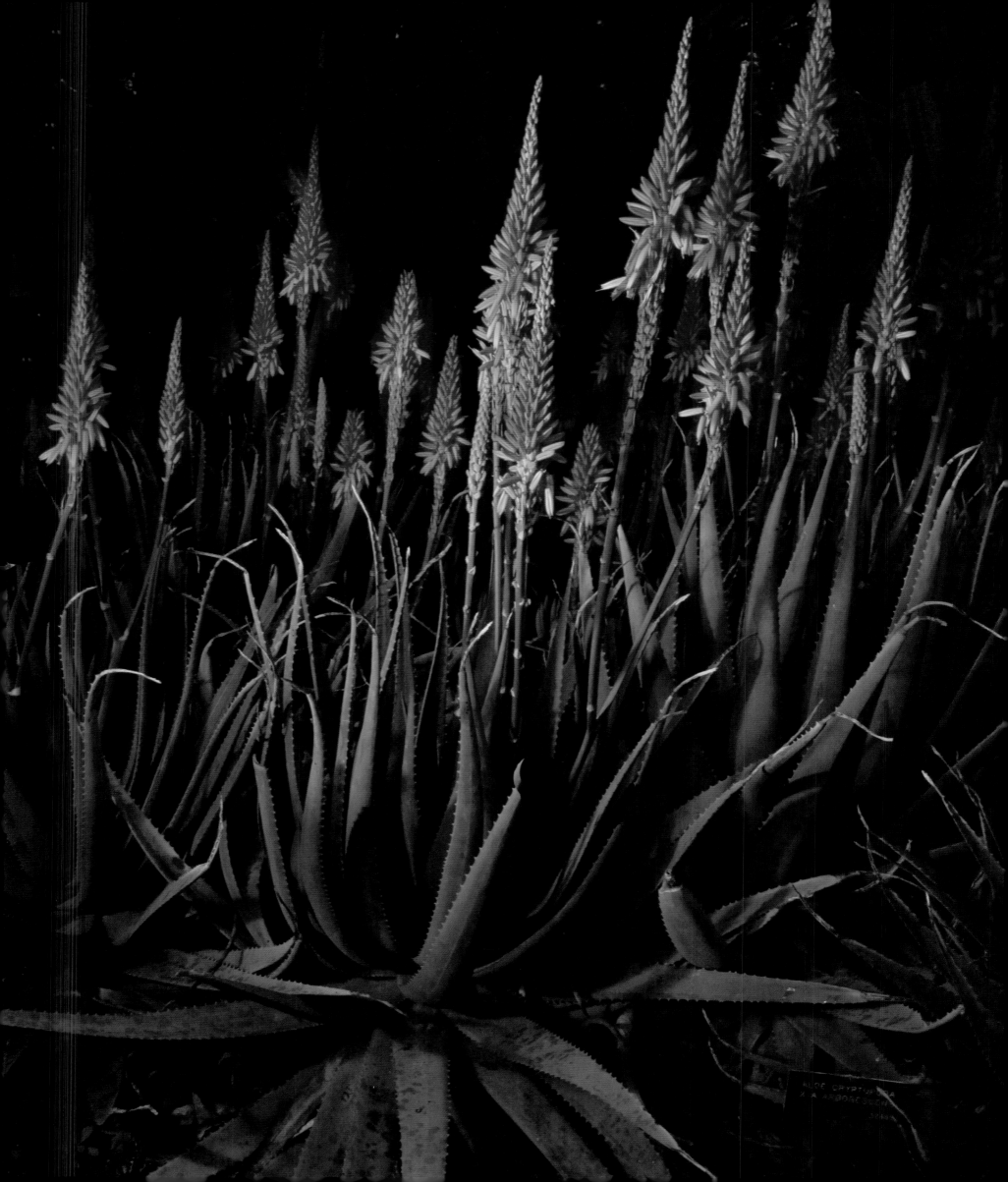

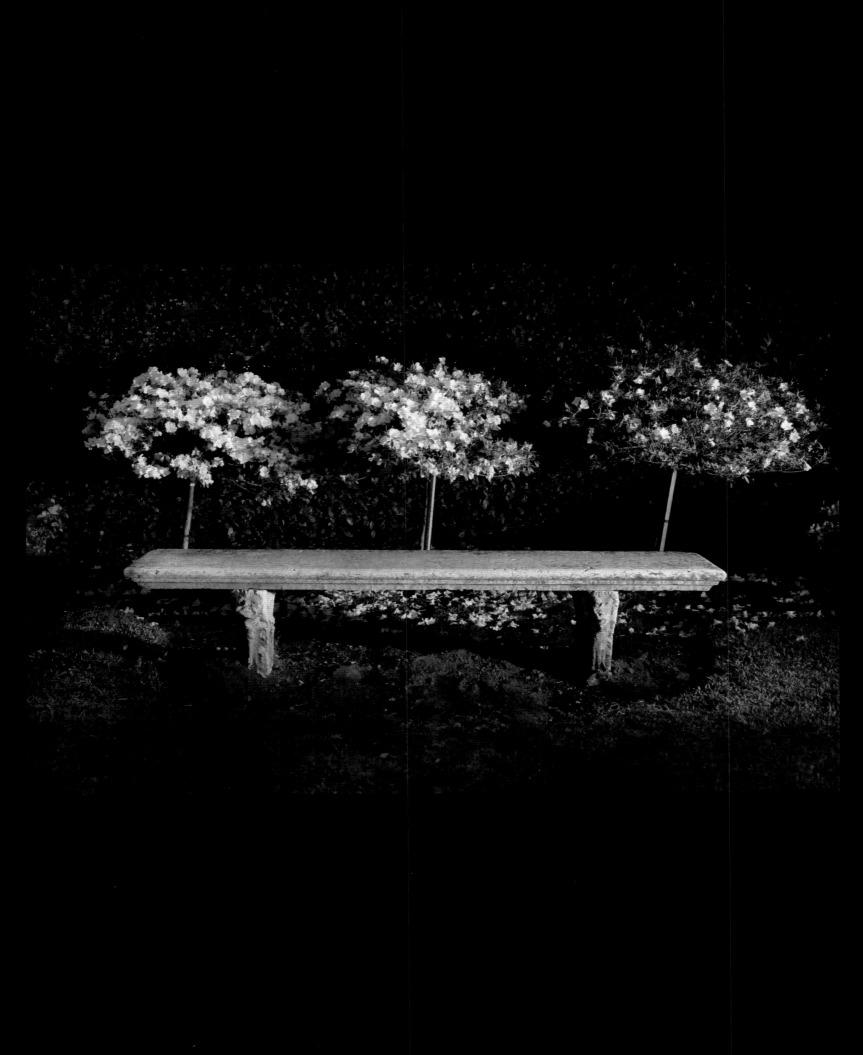

Opposite: YELLOW ALOE—*ALOE CRYPTOPODA* *Above:* NORTH VISTA SCULPTURE GARDEN

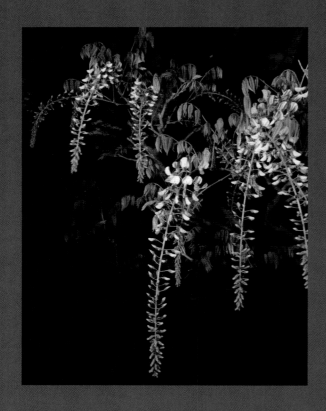

LONGWOOD GARDENS

water for reflection

WITH OVER 1,000 ACRES of woodlands, meadows, and cultivated land, and twenty indoor

gardens, Longwood Gardens features 11,000 types of plants and more fountains than any other garden

in the United States. Located in Philadelphia, the area was originally inhabited by the native Leni

Lenape tribe and was purchased in 1906 by Pierre du Pont, an industrialist, conservationist, farmer,

designer, impresario, and philanthropist who sought to conserve the forest. During his travels as a

young adult, du Pont witnessed spectacular expositions that planted the seed in his mind for the

creation of a fountain garden that would combine western European design and American electrical

knowledge. He began with a 600-foot-long flower-garden walk in 1907, and today, Longwood Gardens

boasts two fountain gardens, an outdoor theatre built around a fountain, and a dozen or so smaller

individual fountains spread throughout the space. The Main Fountain Garden is set on a spectacular

five-acre spread, its highest jet rising 130 feet, with ten thousand gallons of water recirculating each

minute through 380 fountainheads, scuppers, and spouts. During the summer-long festival of

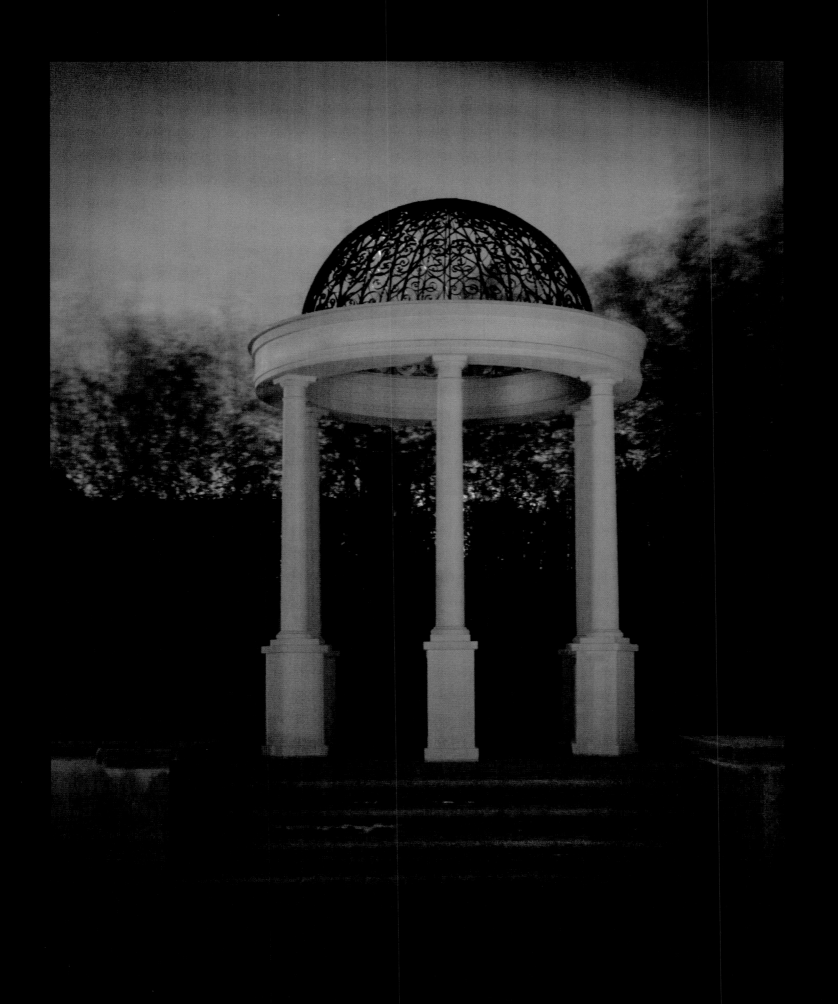

Opposite: CHINESE WISTERIA—*WISTERIA SINENSIS* *Above:* LOVE TEMPLE (CARYOPTERIS ALLÉE)

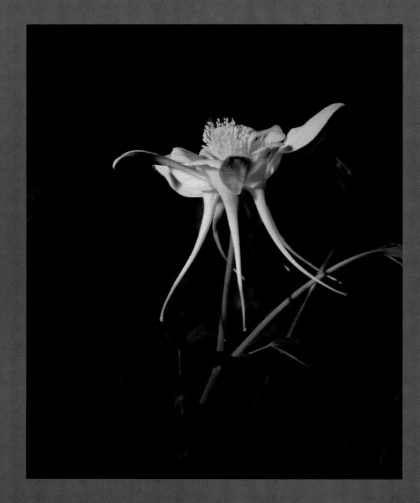

WESTERN RED COLUMBINE—*AQUILEGIA ELEGANTULA*

fountains, the water is illuminated by 674 multicolored lights in a computer-controlled extravaganza set to music. A massive conservatory was built in 1919, and, following numerous renovations and expansions, currently houses a ballroom, a music room, and a pipe organ. The Main Conservatory offers a stately greenhouse orangery featuring flowers, bulbs, and foliage ranging from creeping figs and birds-of-paradise to an old *Rhaphiolepis*. An exhibition hall has a sunken marble floor that is usually flooded with a few inches of water, enabling Australian tree ferns to thrive and accentuating seasonal displays that include oleander, crape myrtle, marguerite, and petunia. While the West Conservatory is made up of an endless assortment of greenhouses, including gardens dedicated to bonsais, orchids, ferns, roses, and acacias, the new East Conservatory complex, inspired by Moorish, French, and modernist influences, creates a parklike setting with a waterfall for permanent plantings of Mediterranean and subtropical flora. The construction of a giant analemmatic sundial and 61-foot-tall Chimes Tower within the outdoor gardens typifies Longwood's successful marriage of gardening arts and technology. ॐ

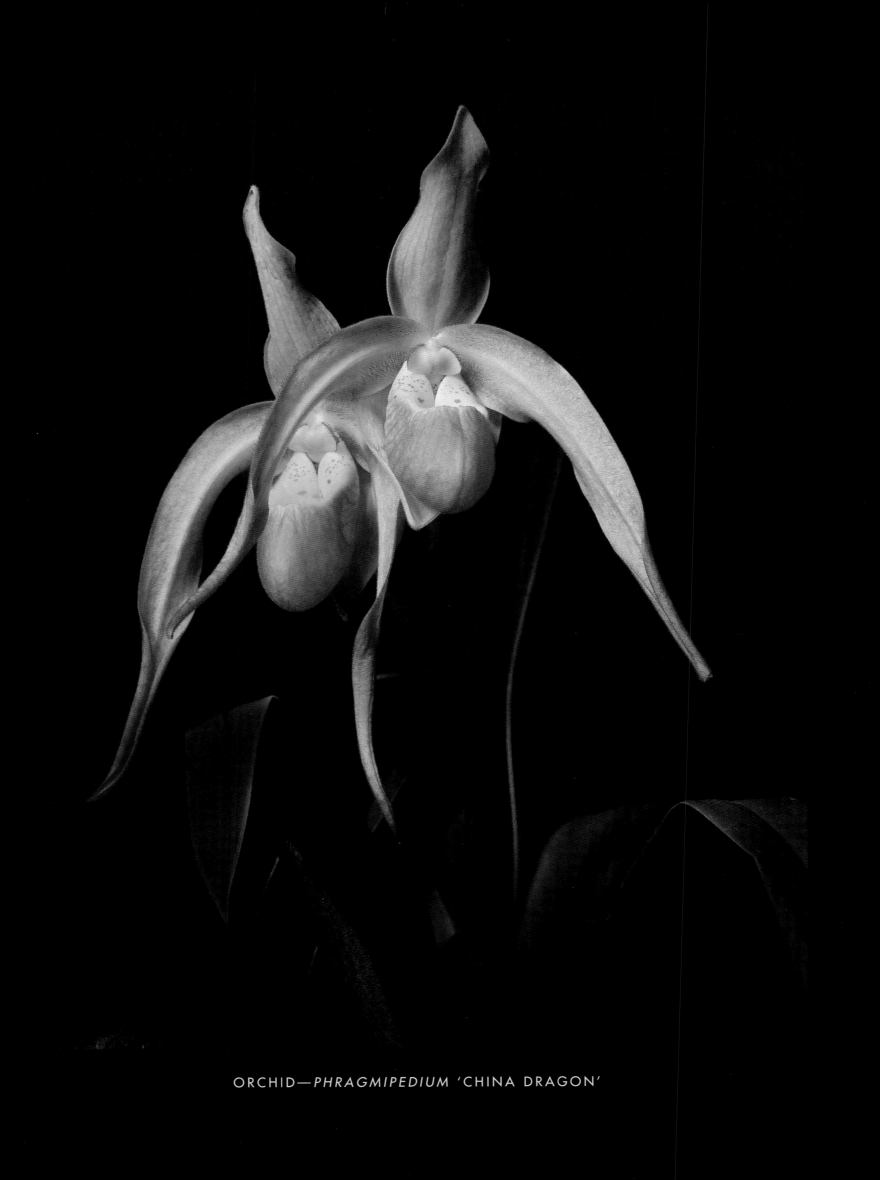

ORCHID—*PHRAGMIPEDIUM* 'CHINA DRAGON'

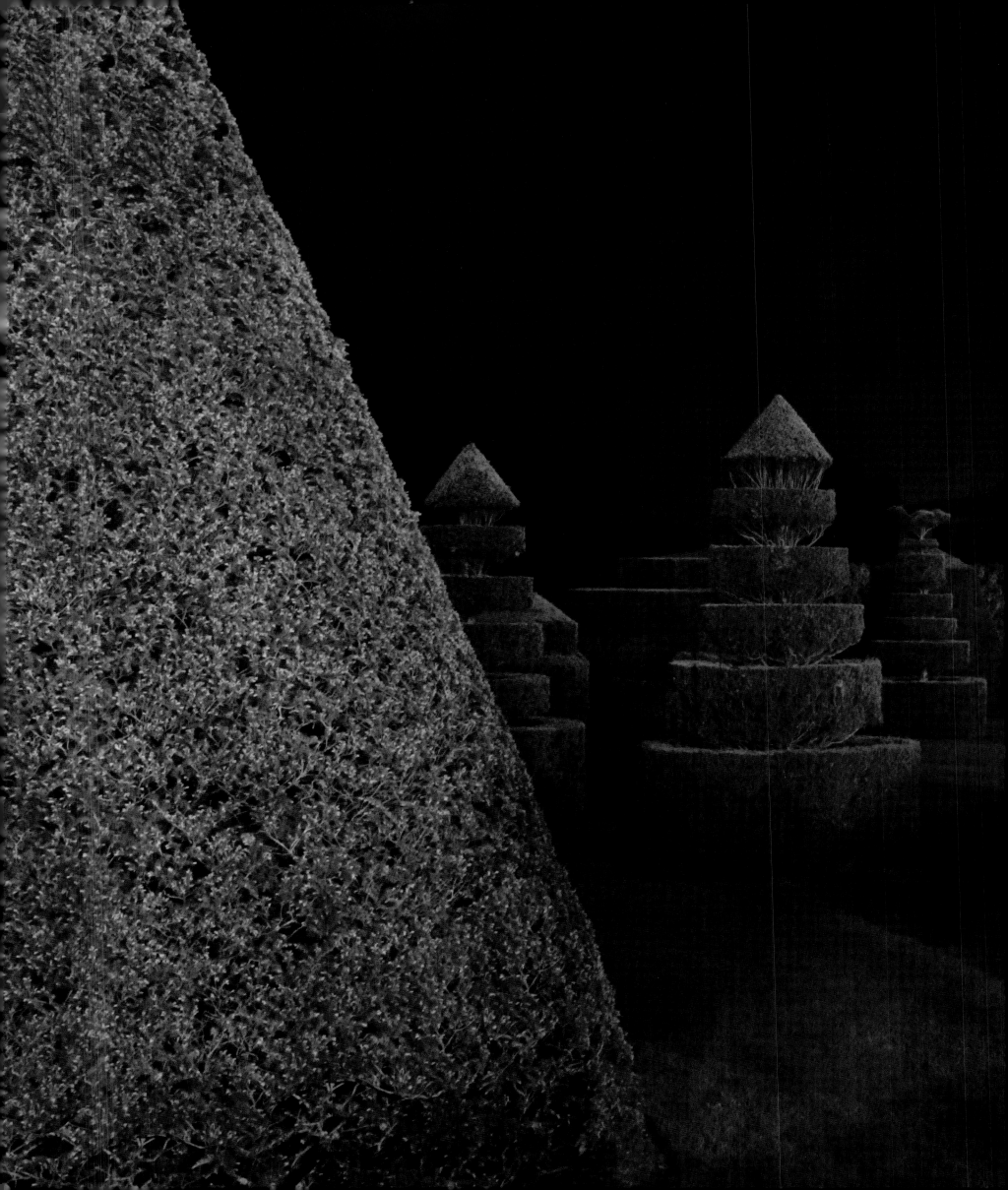

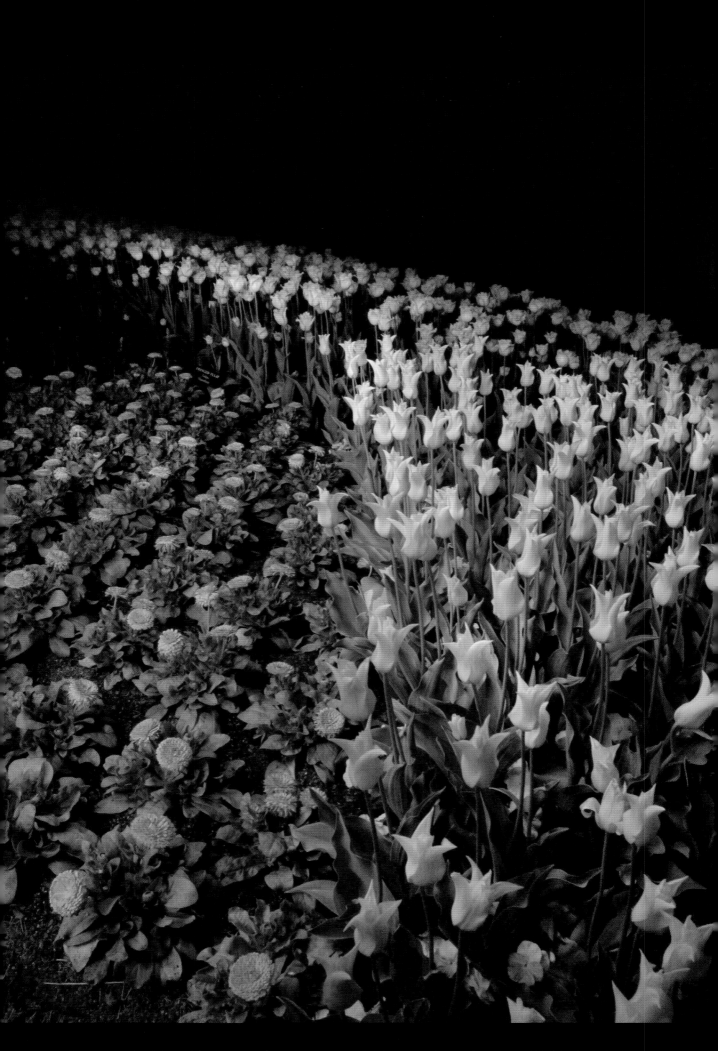

Opposite: YEW—*TAXUS* *Above:* MARIGOLDS & TULIPS—*TAGETES & TULIPA*

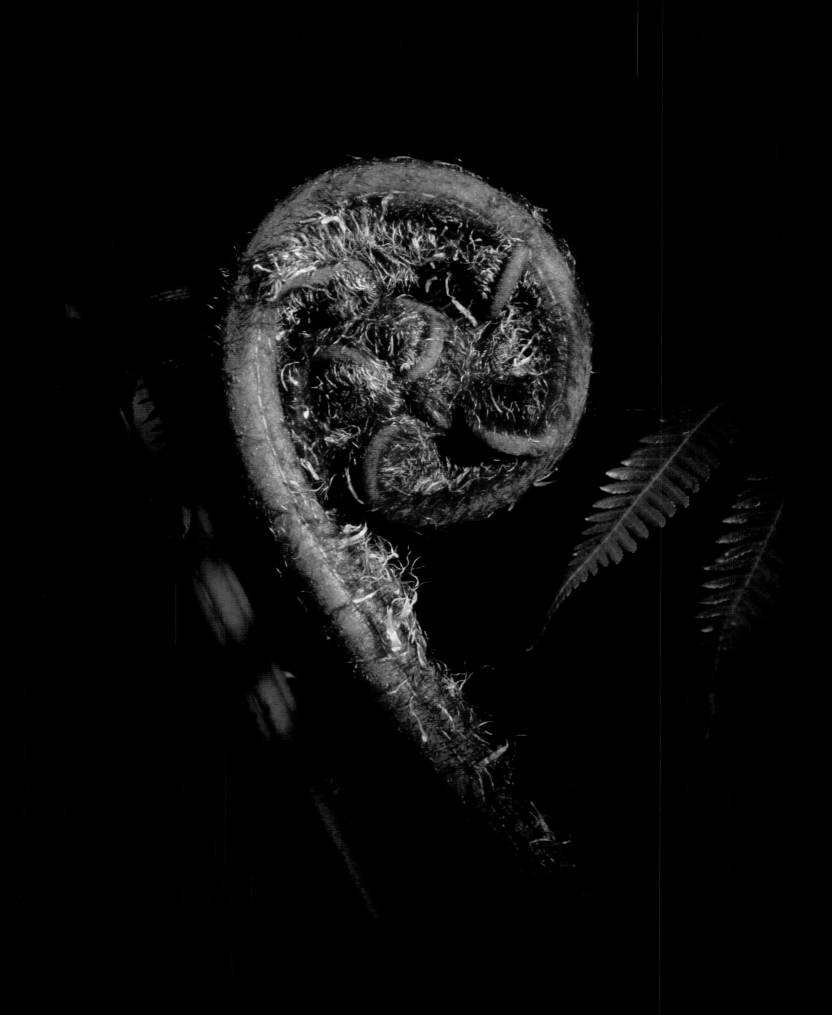

Above: TREE FERN—*CYATHEA* *Opposite:* PITCHER PLANT—*SARRACENIA MOOREANA*

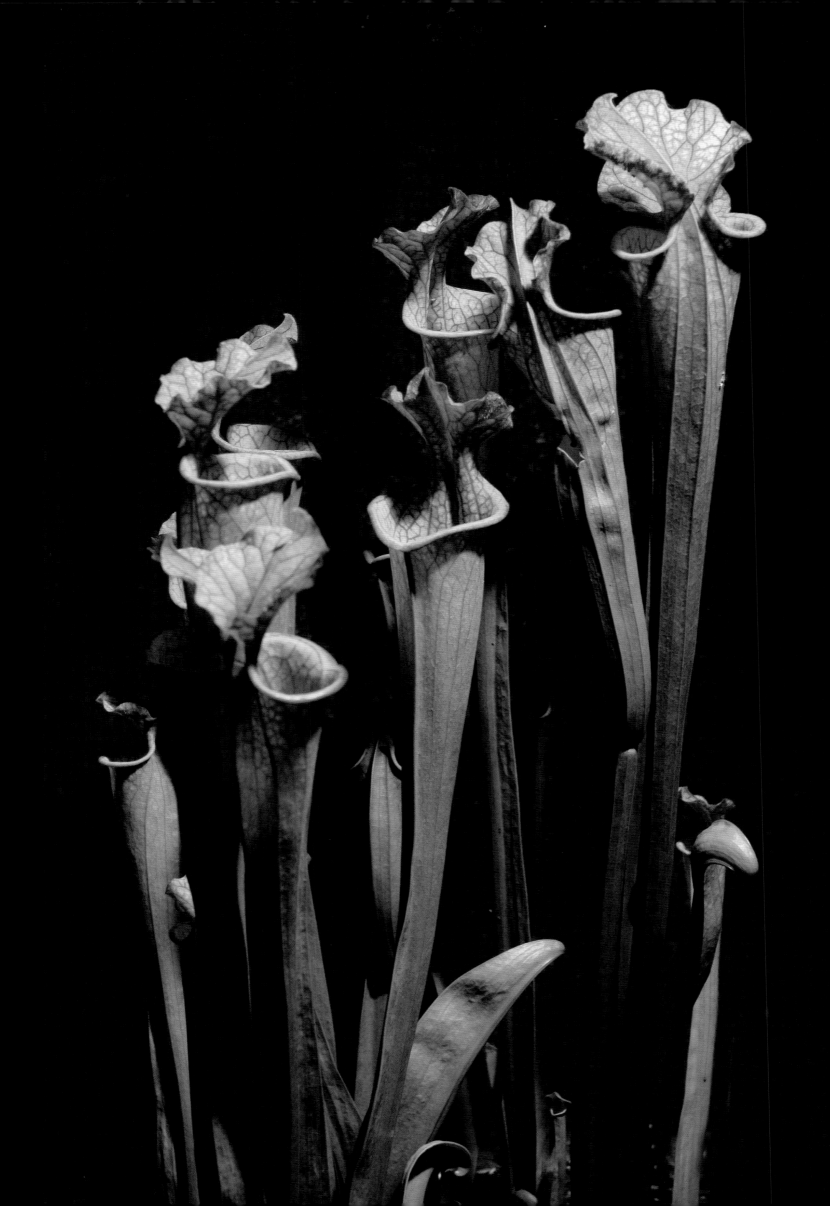

MISSOURI BOTANICAL GARDEN

harmony and peace

AN EIGHTEEN-YEAR-OLD Englishman named Henry Shaw arrived in St. Louis, Missouri, in 1819. Before his fortieth birthday, he had amassed a fortune that allowed him to retire and purchase the site that would become the Missouri Botanical Garden. With the encouragement of Dr. George Engelmann, one of the great eighteenth-century American botanists, and the assistance of Asa Gray, a Harvard botanist, and Sir William Hooker, director of London's Royal Botanic Gardens at Kew, the garden opened in 1859. Today, this National Historic Landmark is the oldest botanical garden in the United States, and a center for botanical research and science education. Covering over half an acre is the Climatron Conservatory, a seventy-foot-high geodesic dome designed in 1960 by the St. Louis architectural firm Murphy and Mackey. The tropical setting of the conservatory allows a variety of animals, including red-eyed tree frogs, saffron finches, and silver-beaked tanagers, to roam freely among several pools of water, waterfalls, and over 1,200 species of plants, including orchids and epiphytes, and banana, cacao, and coffee trees. North of the Climatron, the Shoenberg Temperate House has seven distinct gardens with

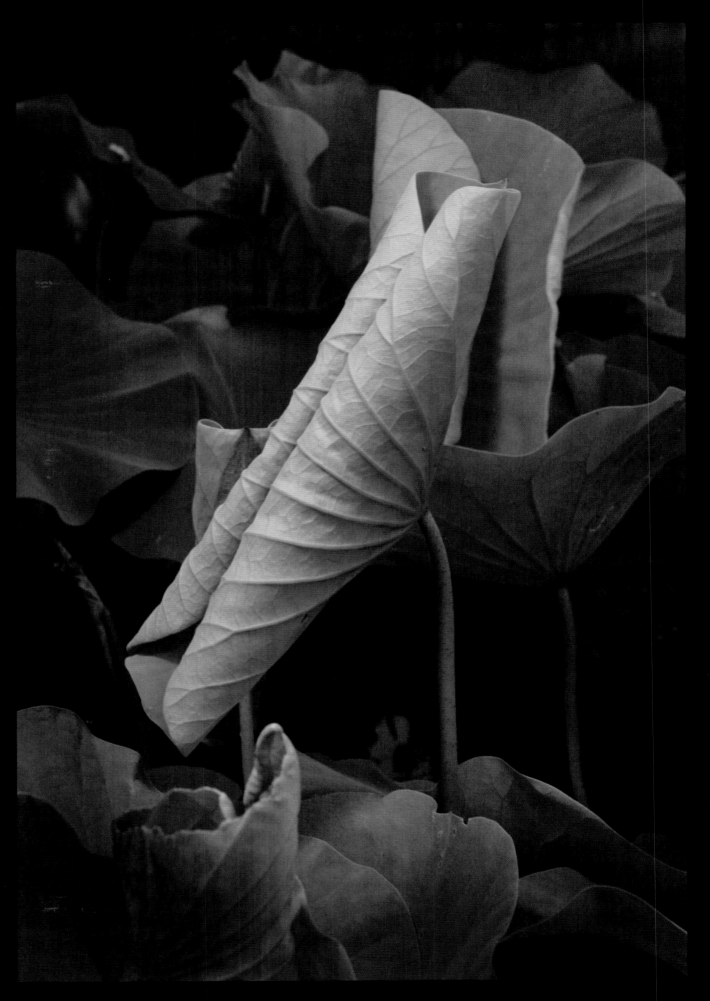

Opposite: APHELANDRA—*APHELANDRA LEONARDII* *Above:* AMERICAN LOTUS—*NELUMBO LUTEA*

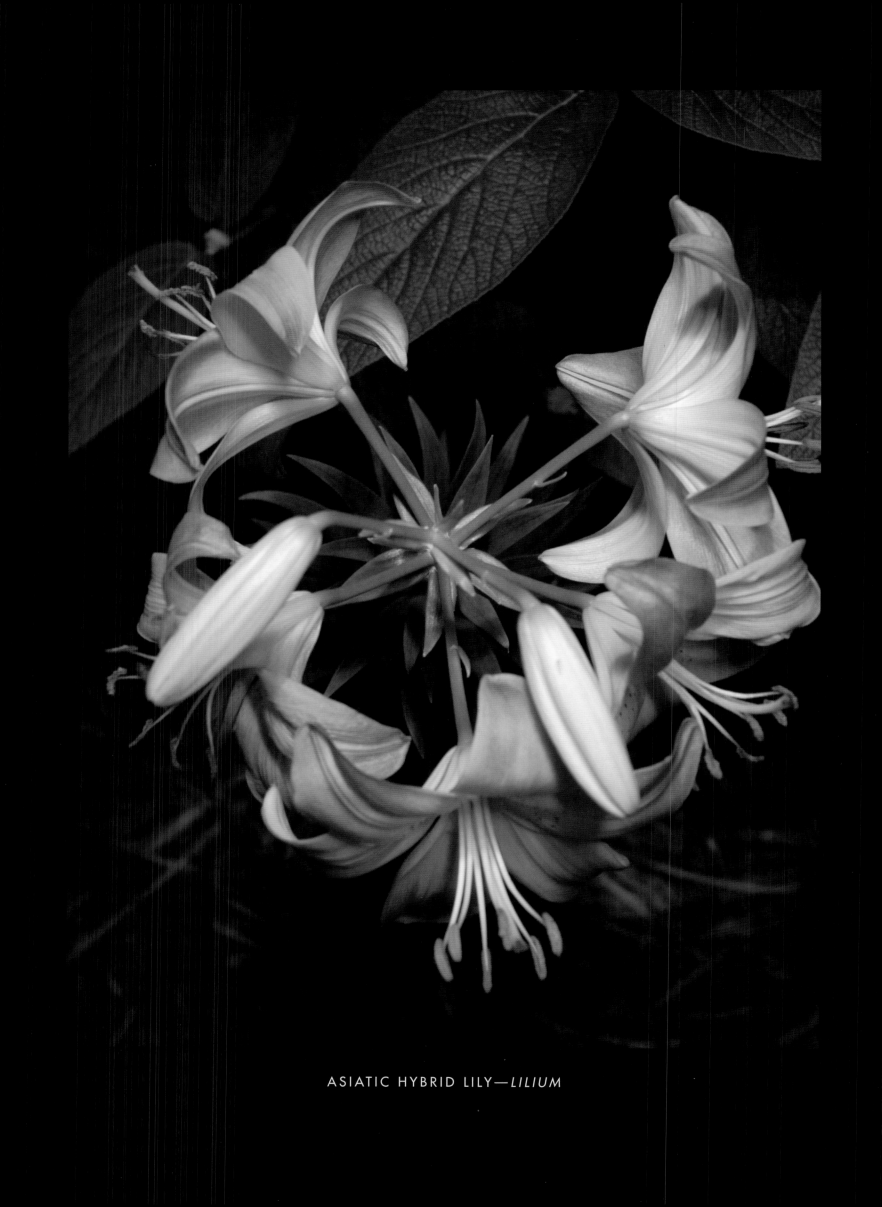

ASIATIC HYBRID LILY—*LILIUM*

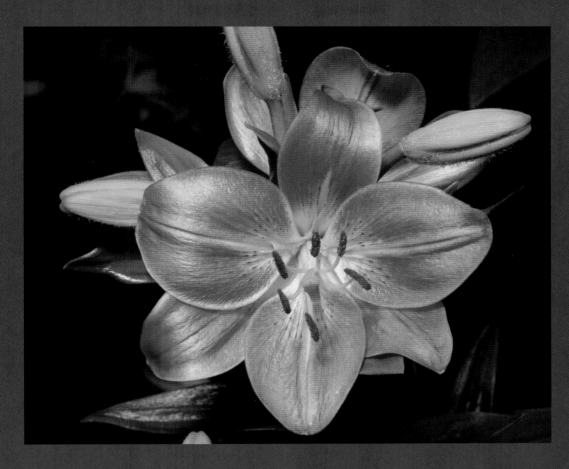

ORANGE LILY—*LILIUM BULBIFERUM*

such plants as figs, grapes, pomegranates, laurel, and numerous herbs and spice plants, along with an entire area dedicated to carnivorous plants. Built by Shaw in 1882, the Linnean House is the oldest continuously operating greenhouse conservatory west of the Mississippi. It houses an array of camellias, including the tea-producing *Camellia sinensis* and the extremely rare yellow-flowering *Camellia chrysantha*, alongside fragrant olive trees and several types of jasmine. Outside, the largest traditional Japanese garden in the Western Hemisphere, designed by Koichi Kawa, presents cherry blossoms, azaleas, chrysanthemums, peonies, and lotuses spread out among waterfalls, streams, stone lanterns, and a raked gravel garden. The Chinese garden, created in honor of the sister-city relationship between St. Louis and Nanjing, features an authentic Chinese pavilion, a bridge, and a moon gate, accented by traditional stones, carvings, and water features designed by architect Yong Pan. Home to seventy-nine acres of horticultural display and one of the six largest herbariums in the world, the Missouri Botanical Garden is a true urban oasis.

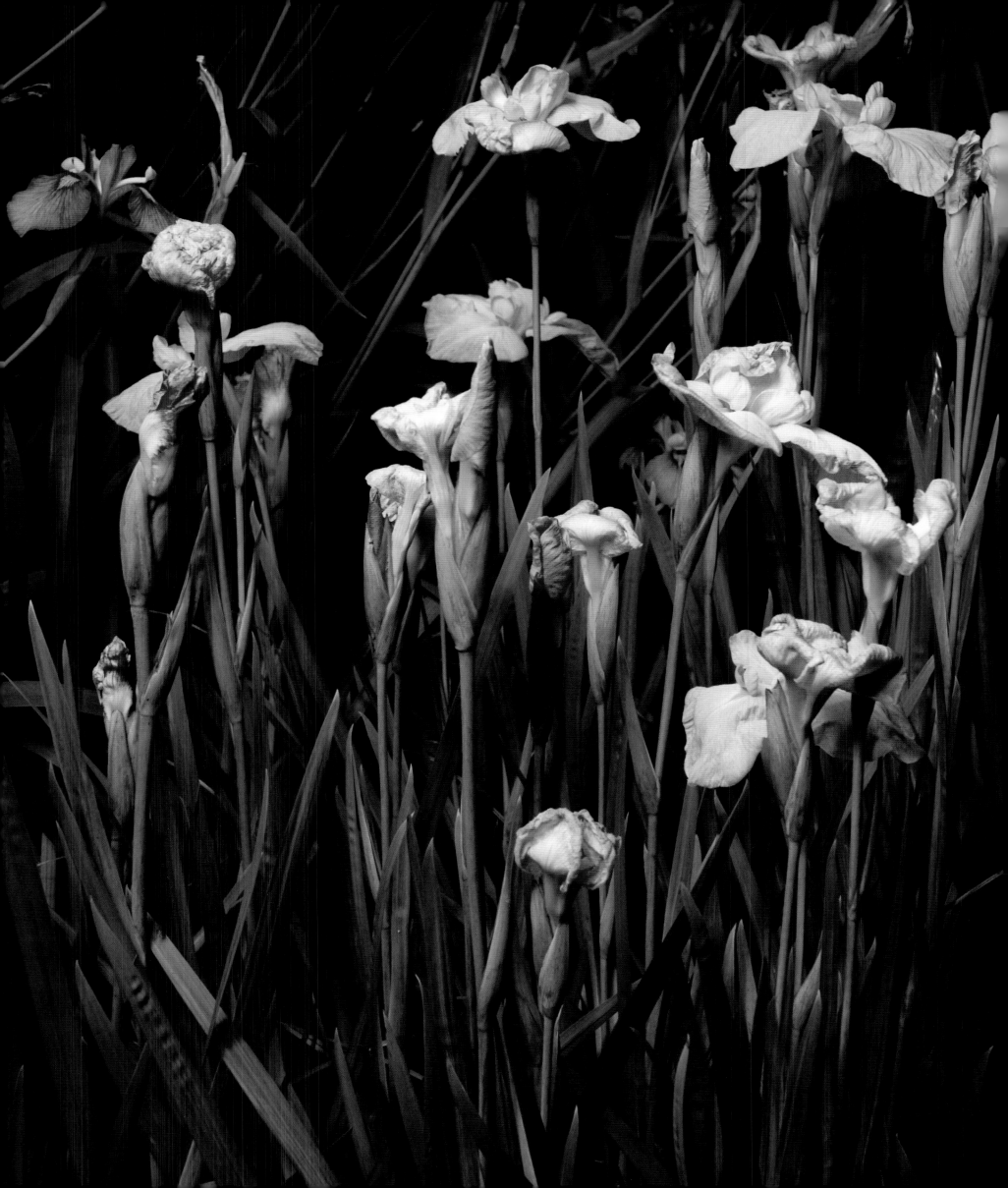

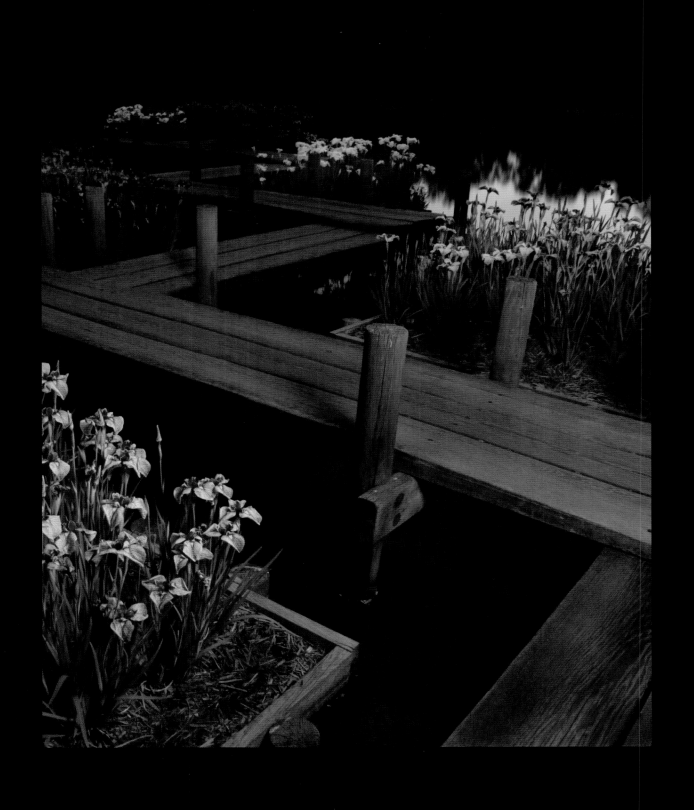

Opposite: ROCKY MOUNTAIN IRIS—*IRIS MISSOURIENSIS* *Above:* SEIWA-EN JAPANESE GARD

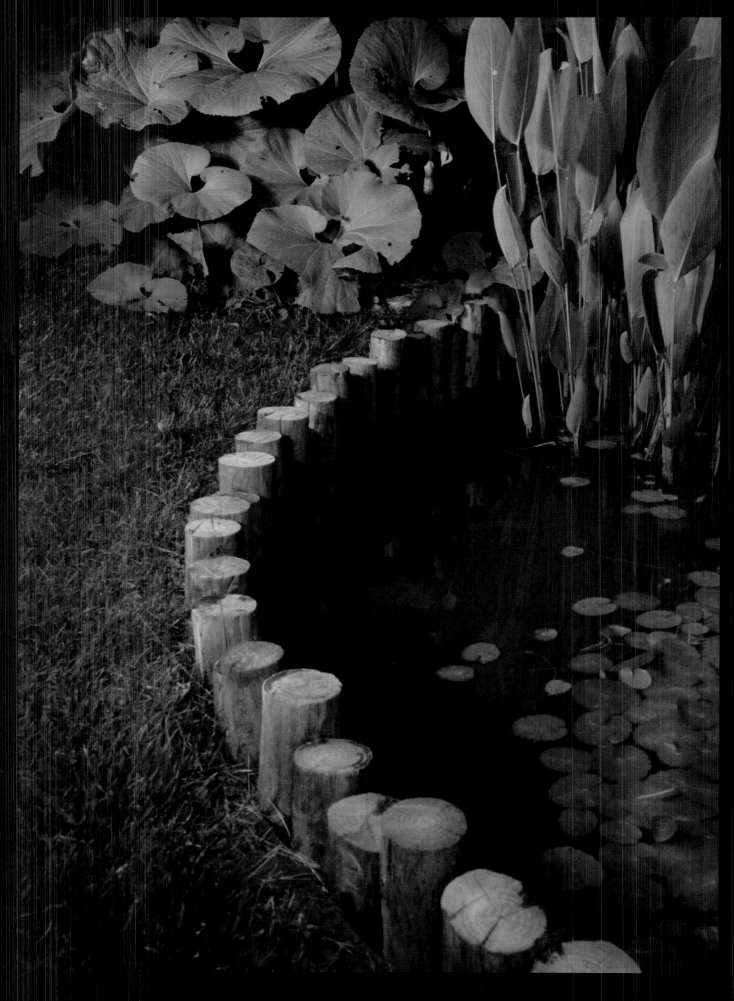

SEIWA–EN JAPANESE GARDEN

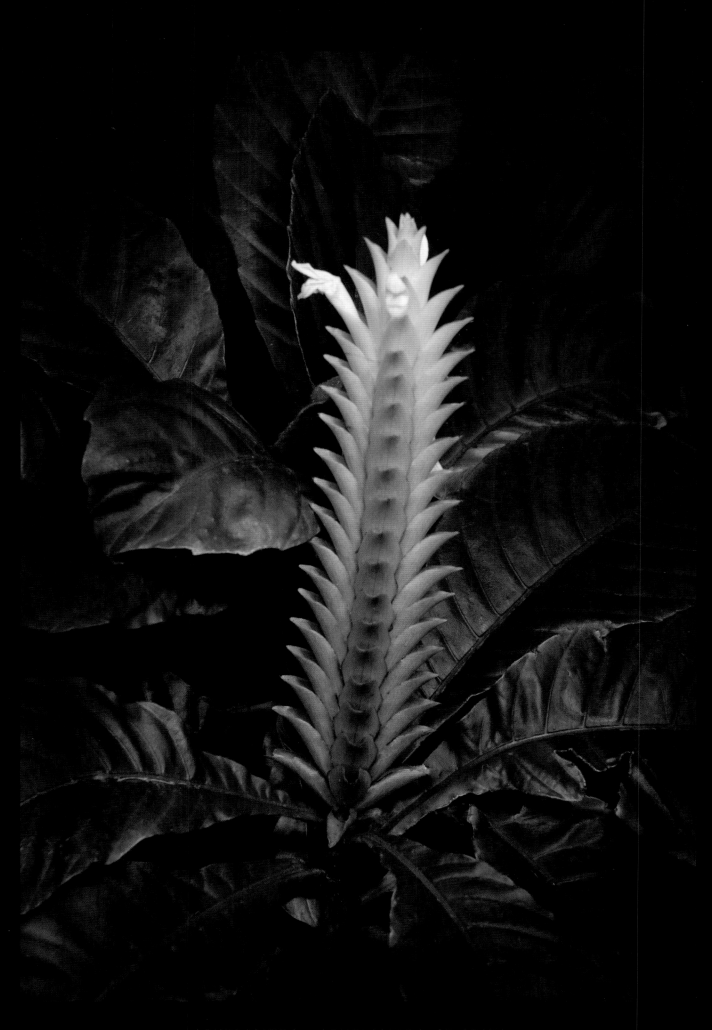

APHELANDRA—*APHELANDRA CRISPATA*

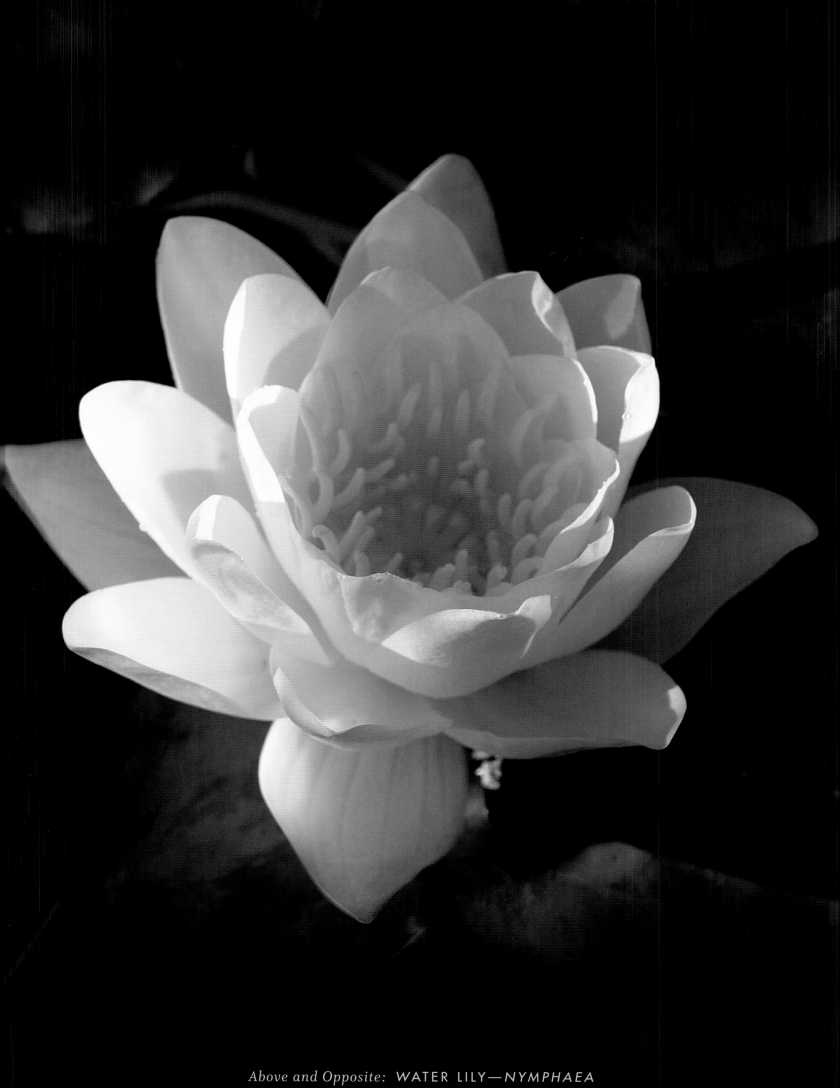

Above and Opposite: WATER LILY—NYMPHAEA

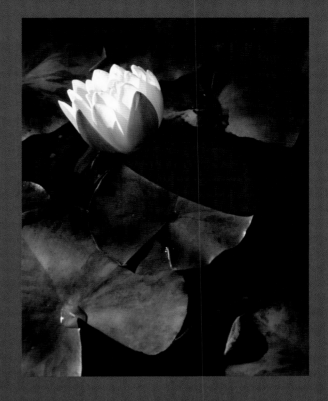

MONTREAL BOTANICAL GARDEN
ancestral knowledge

IN 1931, IN THE MIDST of the Depression, an eminent botanist and visionary by the name of Brother Marie-Victorin convinced the City of Montreal of the need for a public garden. Soon thereafter, thousands of unemployed men were hired to build the Montreal Botanical Garden, designed by Marie-Victorin and landscape architect Henry Teuscher. The 185-acre site is now home to a vast 98-acre arboretum, 10 exhibition greenhouses, approximately 22,000 plant species and cultivars, and some 30 thematic gardens. Visitors to the administration building, an important example of art deco architecture in Montreal designed by architect Lucien F. Kéroack, are greeted with a French-style garden surrounding cascading pools and fountains. Inspired by the private gardens found in the southern Yangtze River region from the fourteenth to seventeenth centuries, the Dream Lake Garden is a rustic-looking, authentic Chinese garden based on the four elements and displaying flowering almonds, Chinese matrimony vines, sweet osmanthus, tree peonies, and oriental thujas. The Courtyard of the Senses, built in accordance with the four basic "touches" (prickly, soft, sticky, and rough), houses

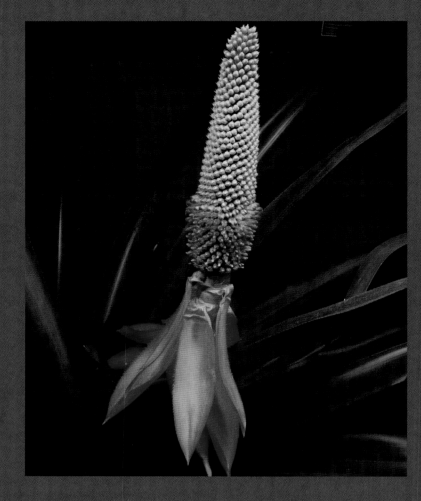

BROMELIAD—*AECHMEA MARIAE-REGINAE*

borages, eucalyptuses, and silver drops. Along the Flowery Brook, a lilac garden displays four hundred

shrubs, including a large collection of the genus *Syringa*, and a rose garden with over ten thousand

specimens is laid out beside a regal bronze lion, a gift from the City of Lyon to Montreal. Nearby, the

six-acre Japanese garden displays peonies, rhododendrons, irises, and crab-apple trees spread out

alongside a pond, a series of cascades, and a cultural pavilion. The pavilion was designed by Japanese

architect Hisato Hiraoka, and features Zen and bonsai gardens as well as a tea garden offering

traditional tea rituals. Divided into five zones, the First Nations Garden illustrates the ancestral

knowledge of indigenous peoples with some five thousand trees, shrubs, and grasses. To the north, a

youth garden welcomes children to spend the summer growing fruit and vegetables to share with

their families. One of the largest and most spectacular gardens in the world, the Montreal Botanical

Garden attracts over one million visitors each year. ✤

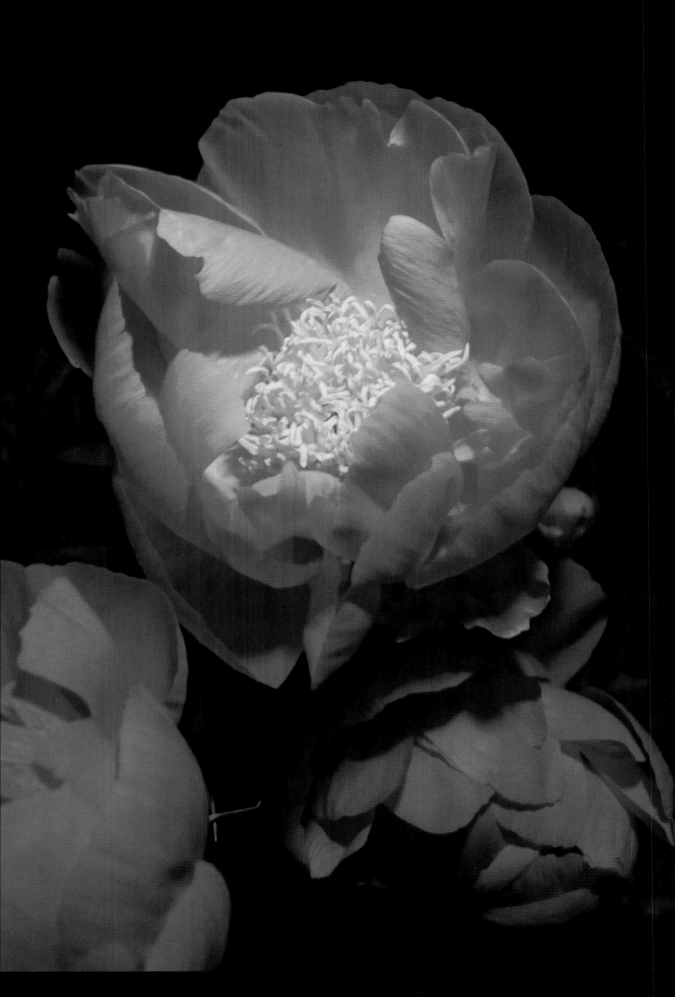

CHINESE PEONY—*PAEONIA LACTIFLORA*

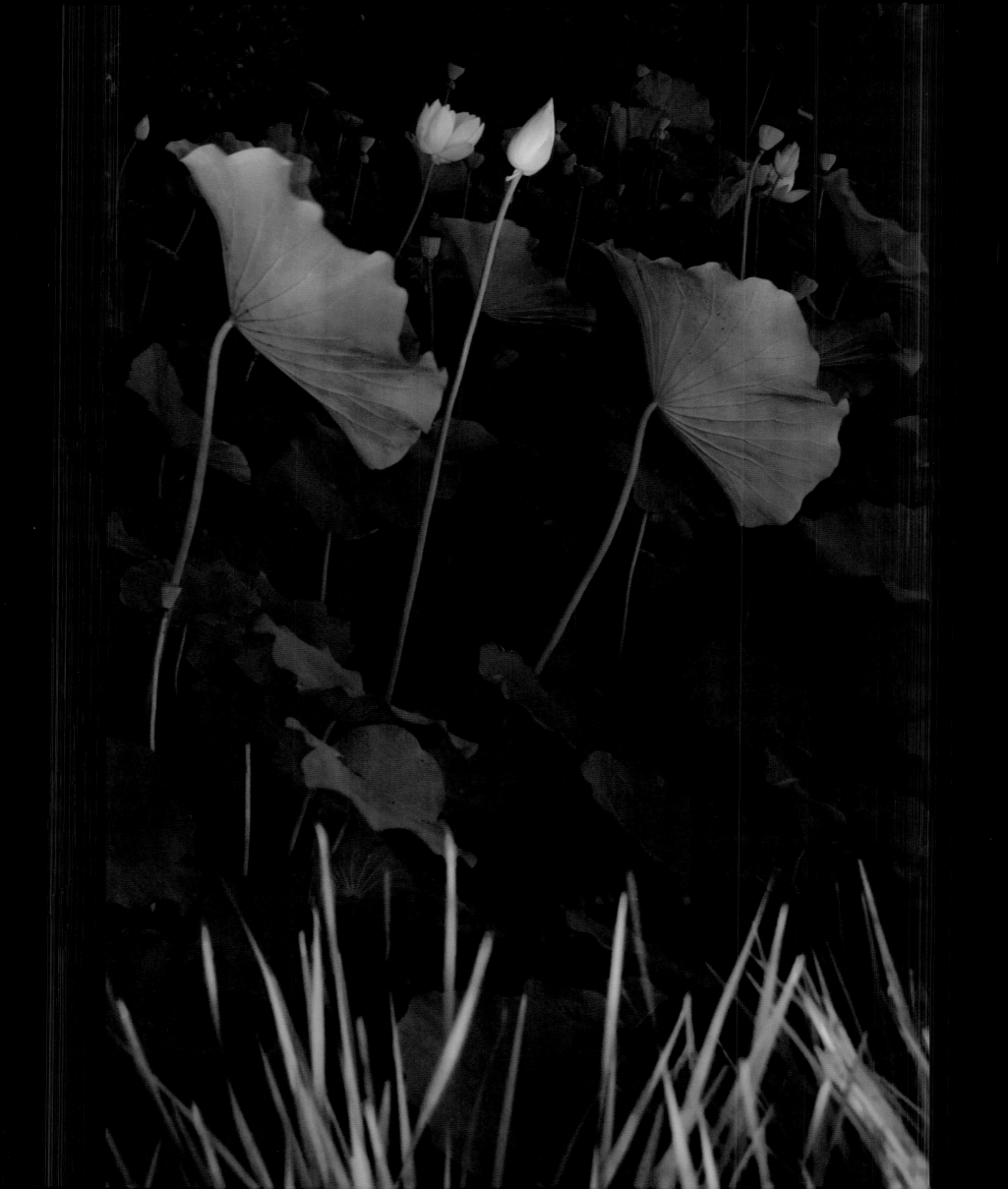

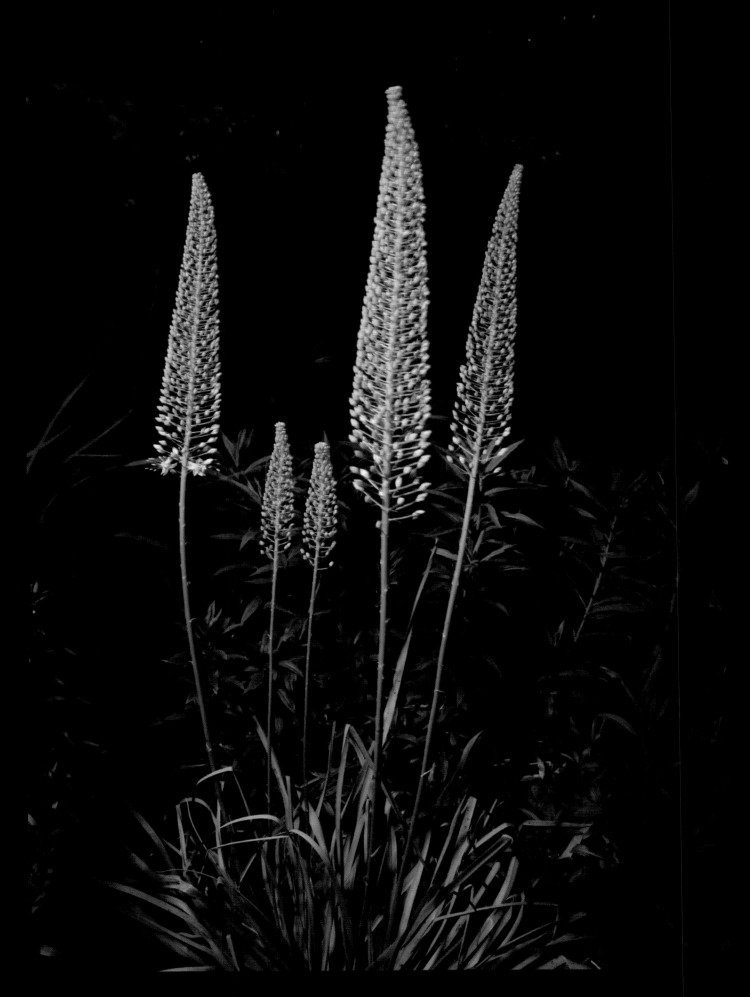

Opposite: AMERICAN LOTUS—*NELUMBO LUTEA*　*Above:* FOXTAIL LILY—*EREMURUS*

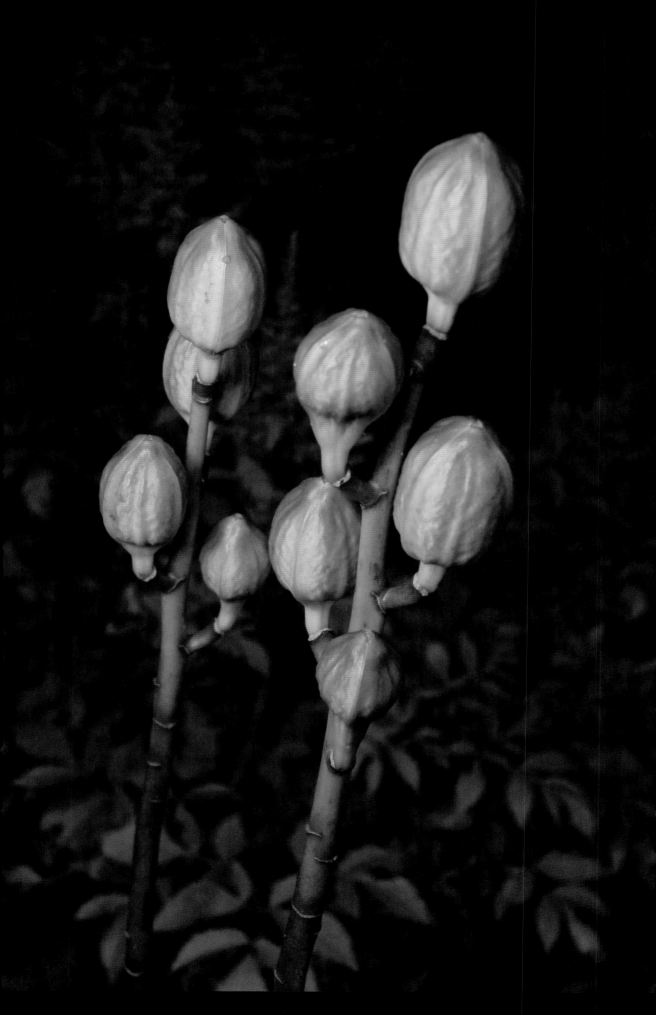

ASTILBE—*ASTILBE*

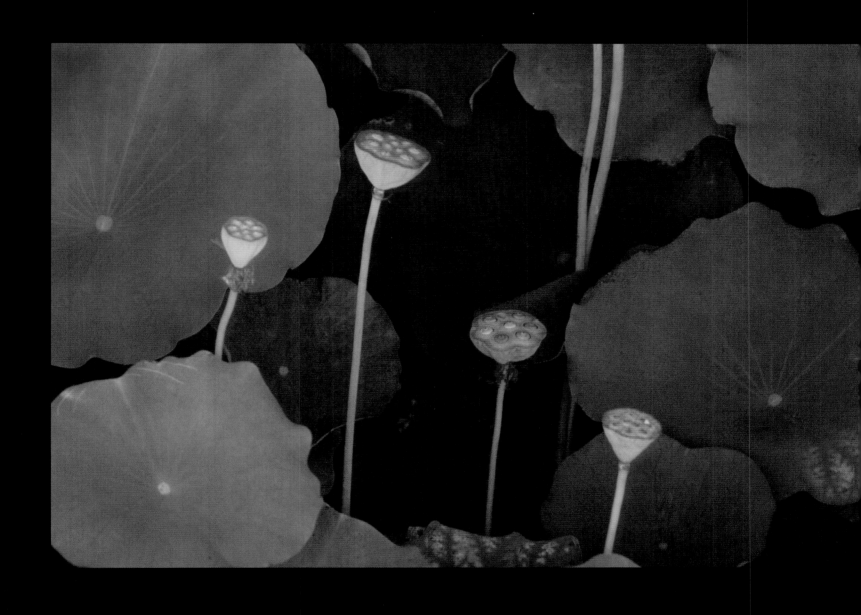

Above: AMERICAN LOTUS—*NELUMBO LUTEA* *Pages 118–119:* CALLA LILY—ZANTEDESCHIA

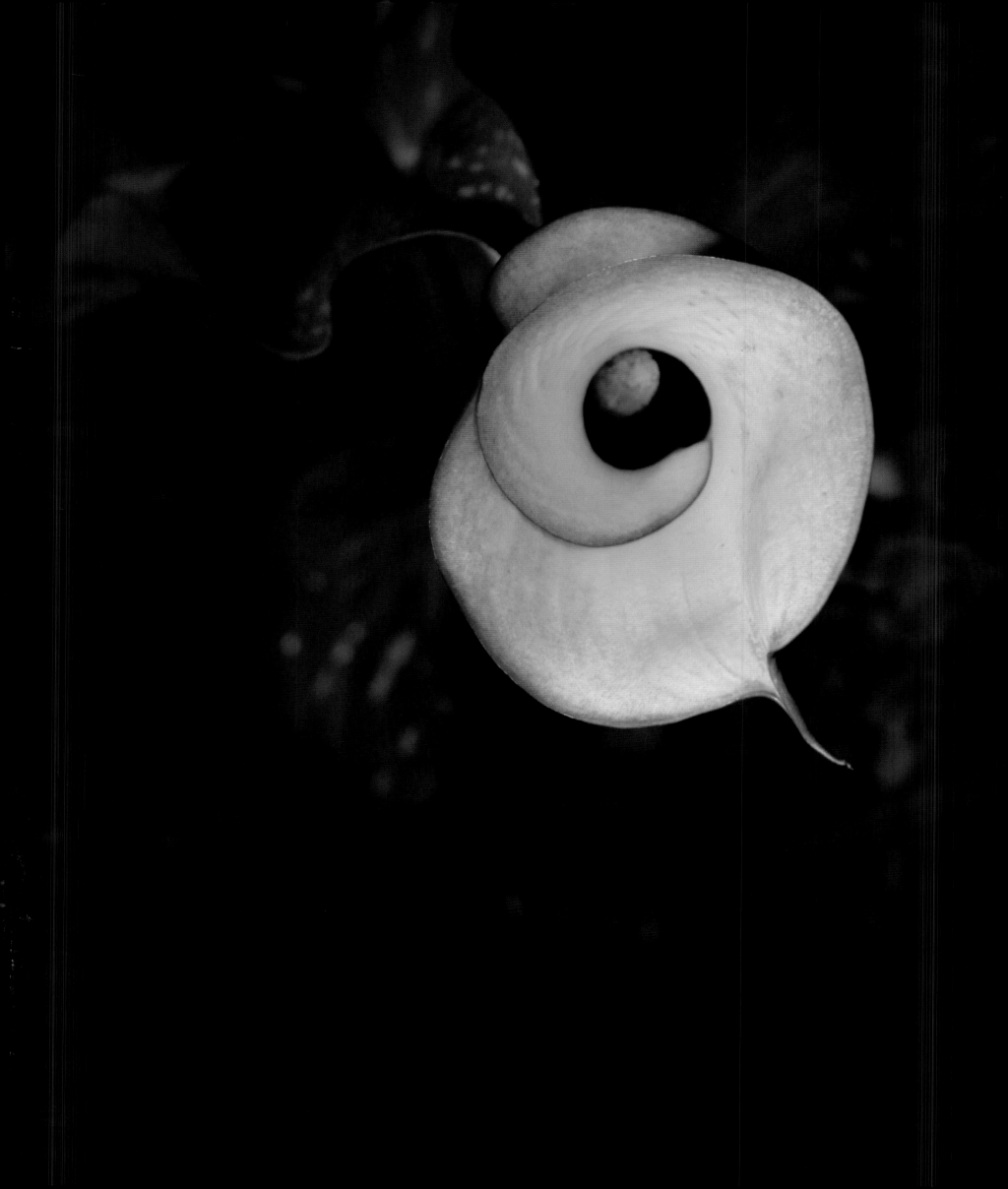

Mark how the yellow iris wearily

Leans back its throat, as though it would be kissed

By its false chamberer, the dragon-fly,

Who, like a blue vein on a girl's white wrist,

Sleeps on that snowy primrose of the night,

Which 'gins to flush with crimson shame, and die

beneath the light.

Oscar Wilde, *The Garden of Eros*

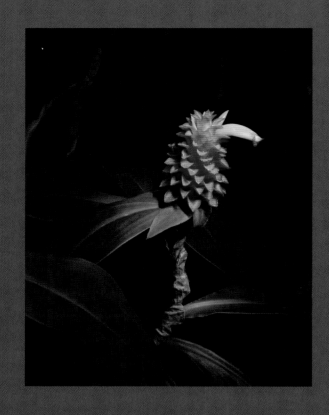

NEW YORK BOTANICAL GARDEN

a blaze of colour

CONTAINING 50 ACRES of the forest that once covered New York City, the New York Botanical Garden's 250-acre grounds display fifty gardens and plant collections created by some of the world's leading landscape and garden designers. The garden, founded in 1891 on a magnificent site of rolling hills in the northern section of the Bronx, was inspired by eminent botanists Nathaniel and Elizabeth Britton's visit to England's Royal Botanical Gardens at Kew. A National Historic Landmark, the garden is home to the nation's largest Victorian greenhouse, the Enid A. Haupt Conservatory. Opened to the public in 1902 and refurbished in 1997, this one-acre conservatory contains eleven glass galleries built around a courtyard in which giant lily platters float in two pools of water. A 90-foot-high dome shelters the Palm Court that includes a royal, an everglade, and a queen palm. An upland tropical rain forest exhibits a simulated volcanic-crater-turned-waterfall with an elevated skywalk, while two desert galleries feature cacti and succulents like saguaros, aloe trees, and stone plants. Outside, a native plant garden presents wildflowers, shrubs, ferns, and grasses in a naturalistic setting with a waterfall nearby.

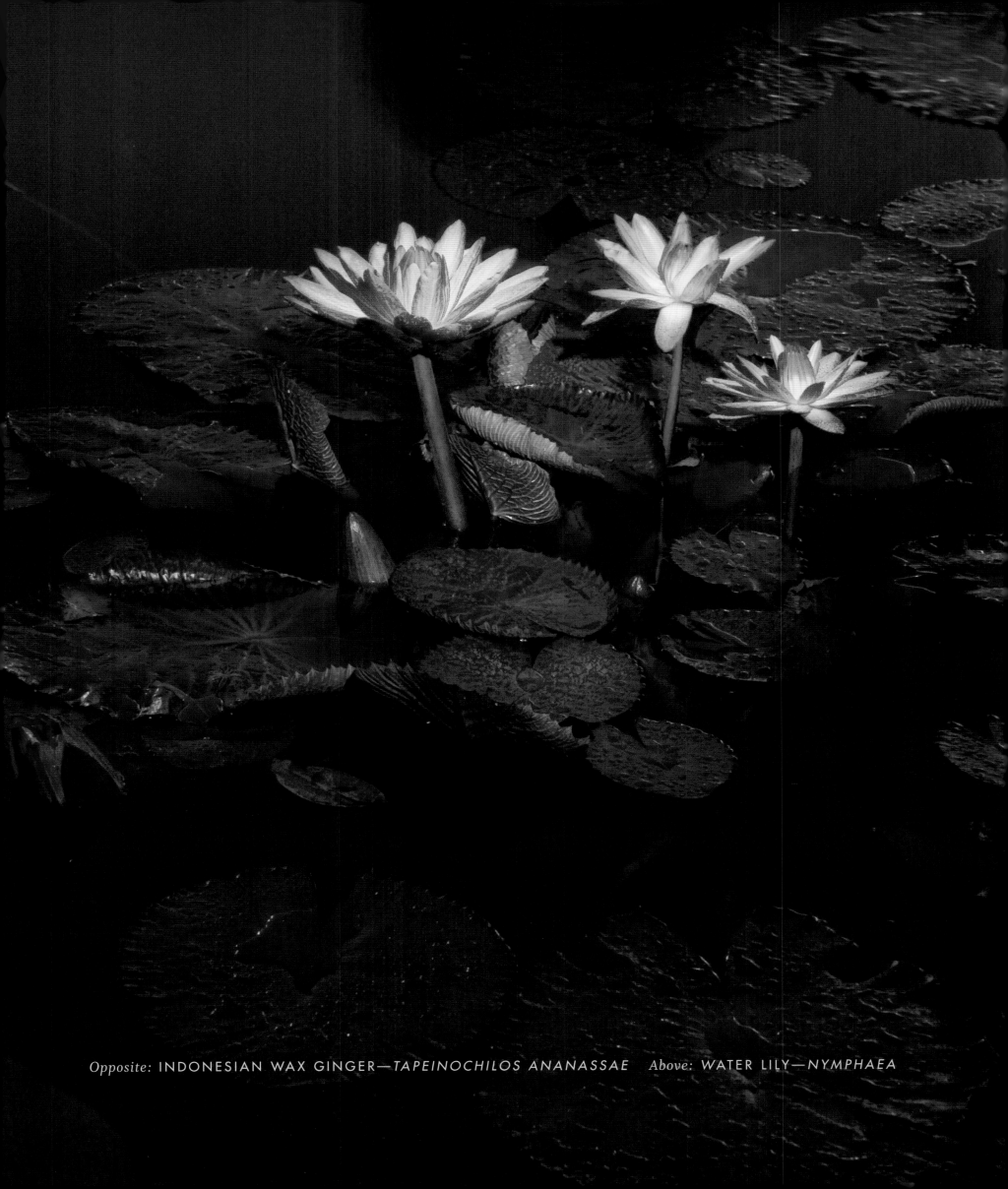

Opposite: INDONESIAN WAX GINGER—*TAPEINOCHILOS ANANASSAE* *Above:* WATER LILY—*NYMPHAEA*

RODNEY WHITE COUNTRY GARDEN

BLACK-EYED SUSAN VINE—*THUNBERGIA ALATA*

The New York Botanical Garden is also home to one of the greatest public rock gardens in America, displaying alpine pinks, rock jasmine, heath, and heather on rocky ledges and large boulders. In 1988, the Peggy Rockefeller Rose Garden was created, based on renowned American landscaper Beatrix Farrand's original concept dating from 1916. With over eighty rose bushes, including hybrid teas, grandifloras, and floribundas converging on a central domed gazebo, and with hundreds more at its perimeter, this garden is ablaze with color from June to September. A one-acre perennial garden exhibits various species of nicotiana, cleome, daisy, clematis, marigold, ageratum, spring tulip, and zinnia arranged by color, and two collections with over two hundred varieties of daylilies and lilies from China, Siberia, and Japan. The New York Botanical Garden owes its creation and growth to the Brittons' vision and inspired guidance through its first three decades. Now in its second century, the garden ranks among the foremost institutions in the world for horticulture, science, and education.

FLAMINGO FLOWER—*ANTHURIUM SCHLECHTENDALII*

SACRED LOTUS—*NELUMBO NUCIFERA*

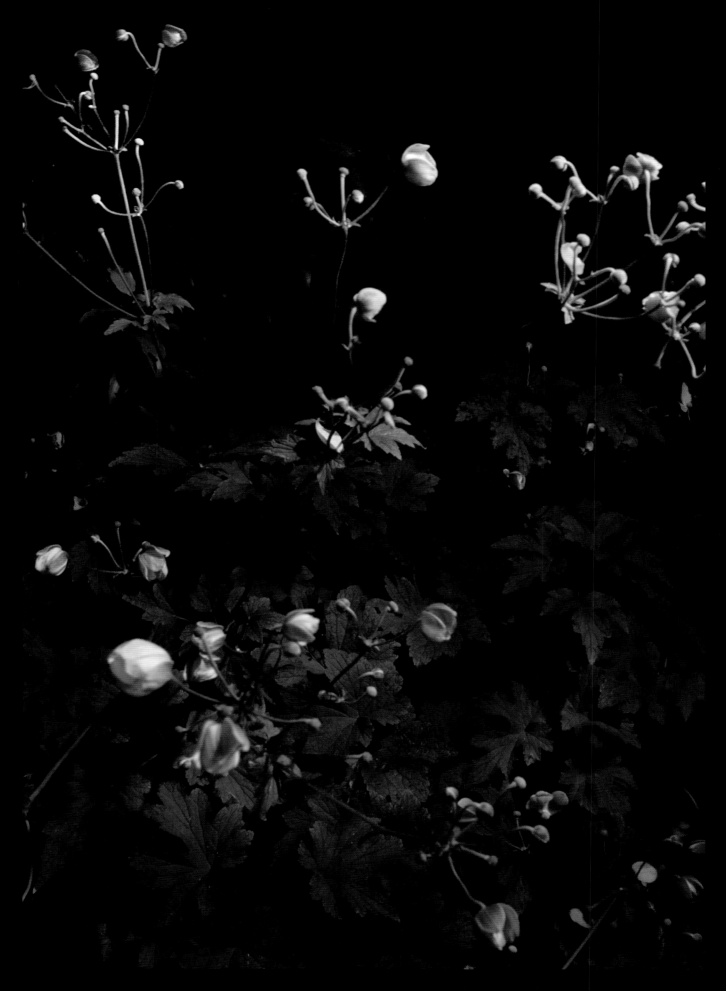

Above: JAPANESE WINDFLOWER—*ANEMONE HUPEHENSIS* *Opposite:* DAHLIA—*DAHLIA* 'SWEET DREAMS'

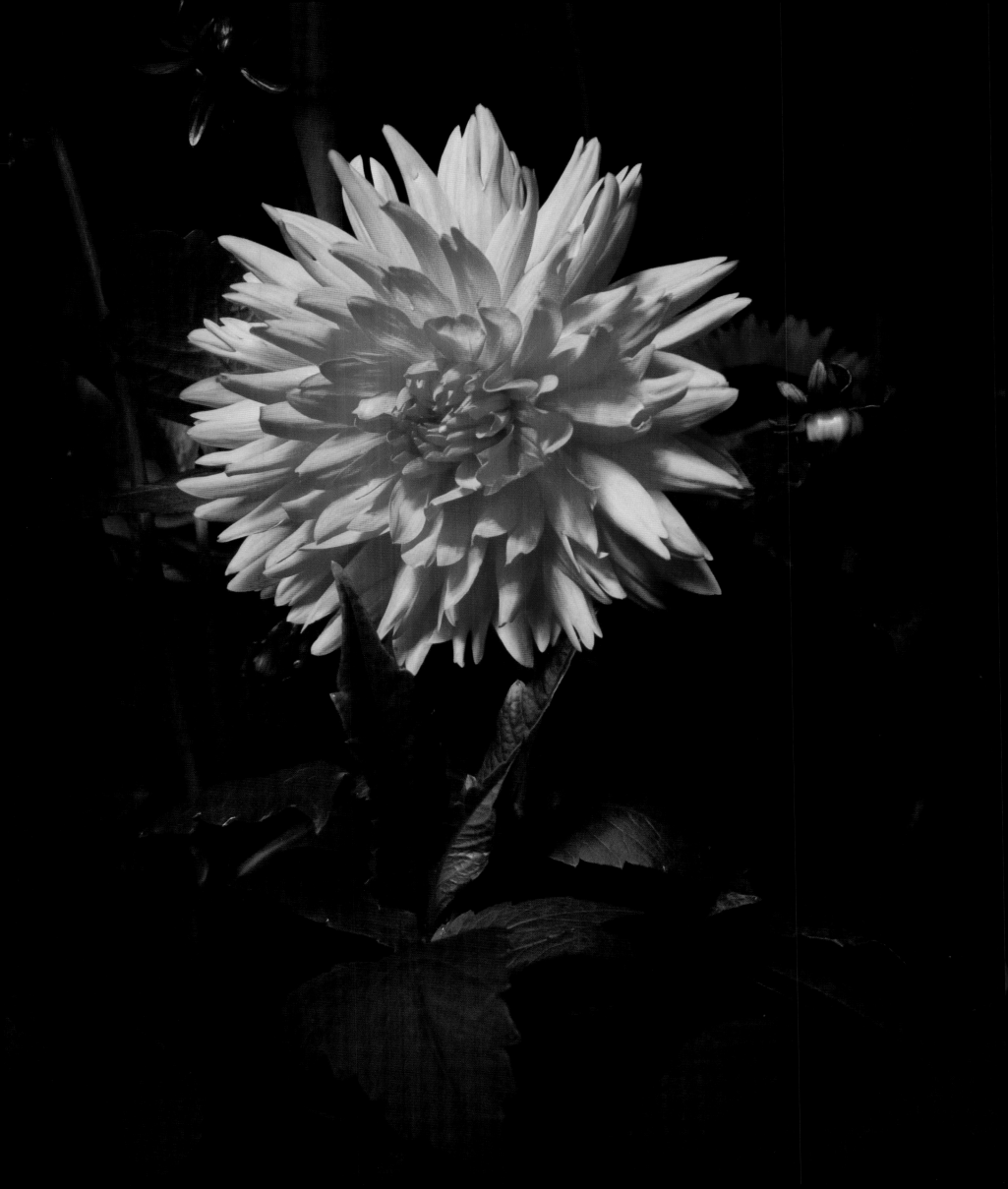

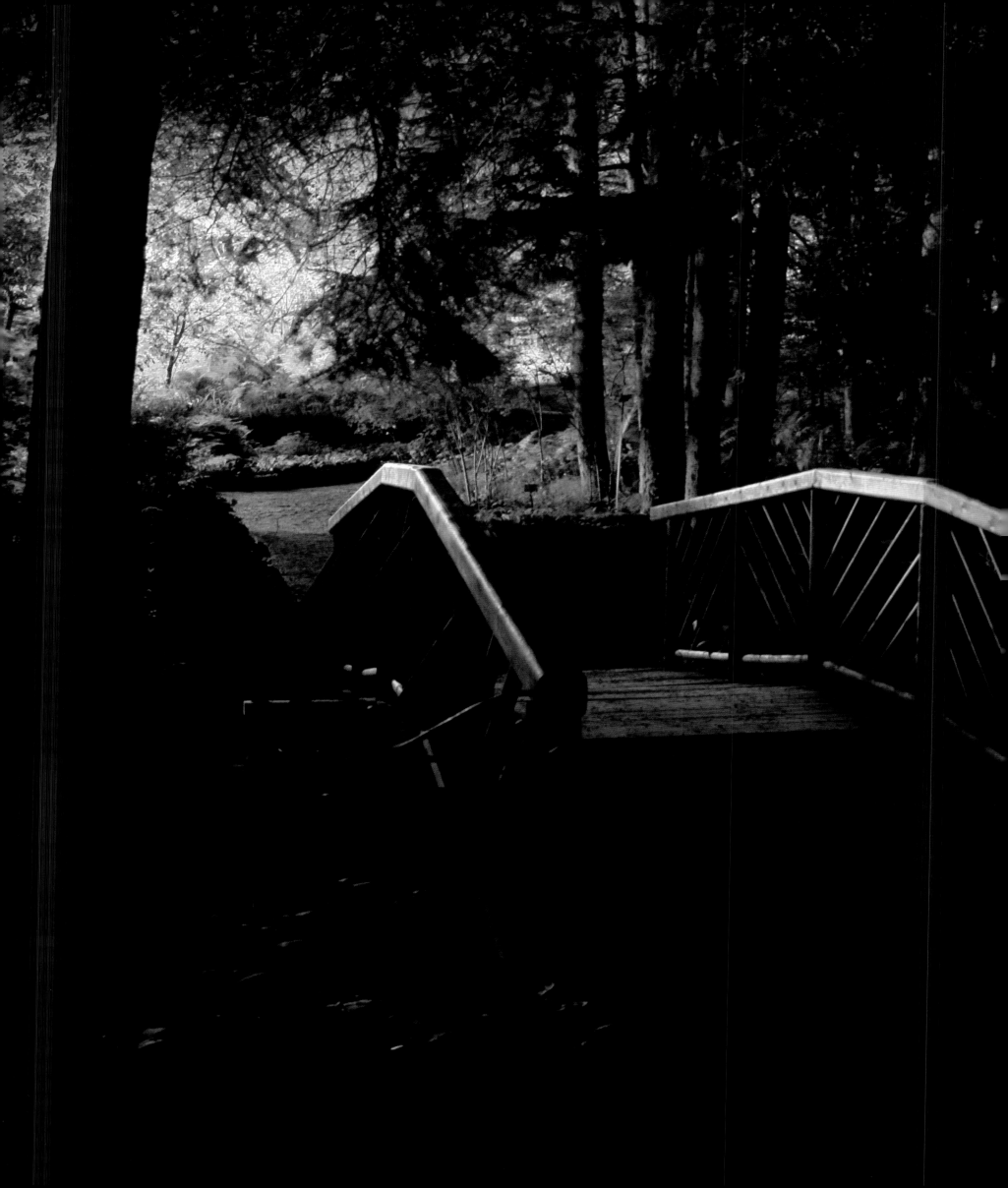

A BLACK CAT AMONG ROSES,

PHLOX, LILAC-MISTED UNDER A FIRST-QUARTER MOON,

THE SWEET SMELLS OF HELIOTROPE AND NIGHT-SCENTED STOCK.

THE GARDEN IS VERY STILL,

IT IS DAZED WITH MOONLIGHT,

CONTENTED WITH PERFUME,

DREAMING THE OPIUM DREAMS

OF ITS FOLDED POPPIES.

AMY LOWELL, "THE GARDEN BY MOONLIGHT"

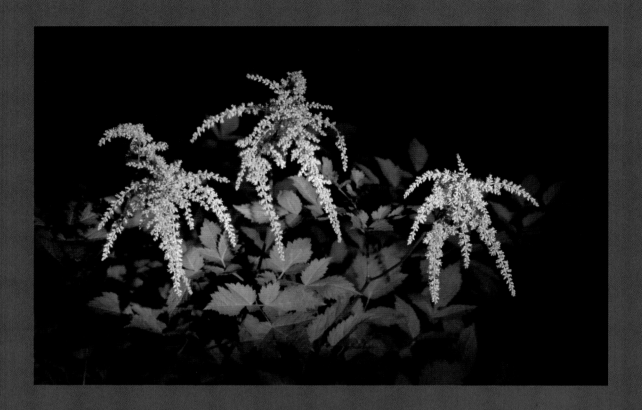

REFORD GARDENS

vista of the river

DURING THE MORE than thirty summers that Elsie Reford spent at her retreat in Grand-Métis, at the confluence of the Métis and St. Lawrence rivers in eastern Quebec, she transformed a simple fishing camp into the ornamental Reford Gardens. Beyond twin colonnades of white spruce trees, a meadow of wildflowers leads to the Estevan Lodge, built in 1887 and enlarged by Elsie and her husband, photographer Robert Wilson Reford, along with Montreal architect Galt Durnford, in 1926. The front of the house itself is remarkably plain, but the House Garden built in the 1920s and 1930s flanks the entrance with an enchanting assortment of crab apples and shrub roses, lupines, fireweed, and common valerian. Page's Brook is one of this garden's basic design features, with rough fieldstone containing walls. Within the High Bank Garden, which sits on the river's north side, stabilizing a sharp slope, grow several varieties of astilbes, a carpet of saxifrage, a mass of bloodroot, and a diminutive Boyd willow planted by Reford in the 1930s.

Pages 128–129: REFORD GARDENS BRIDGE *Above:* FALSE SPIRAEA—*ASTILBE 'STRAUSSENFEDER'*
Opposite: HYDRANGEA & CRAB-APPLE TREE—*HYDRANGEA & MALUS*

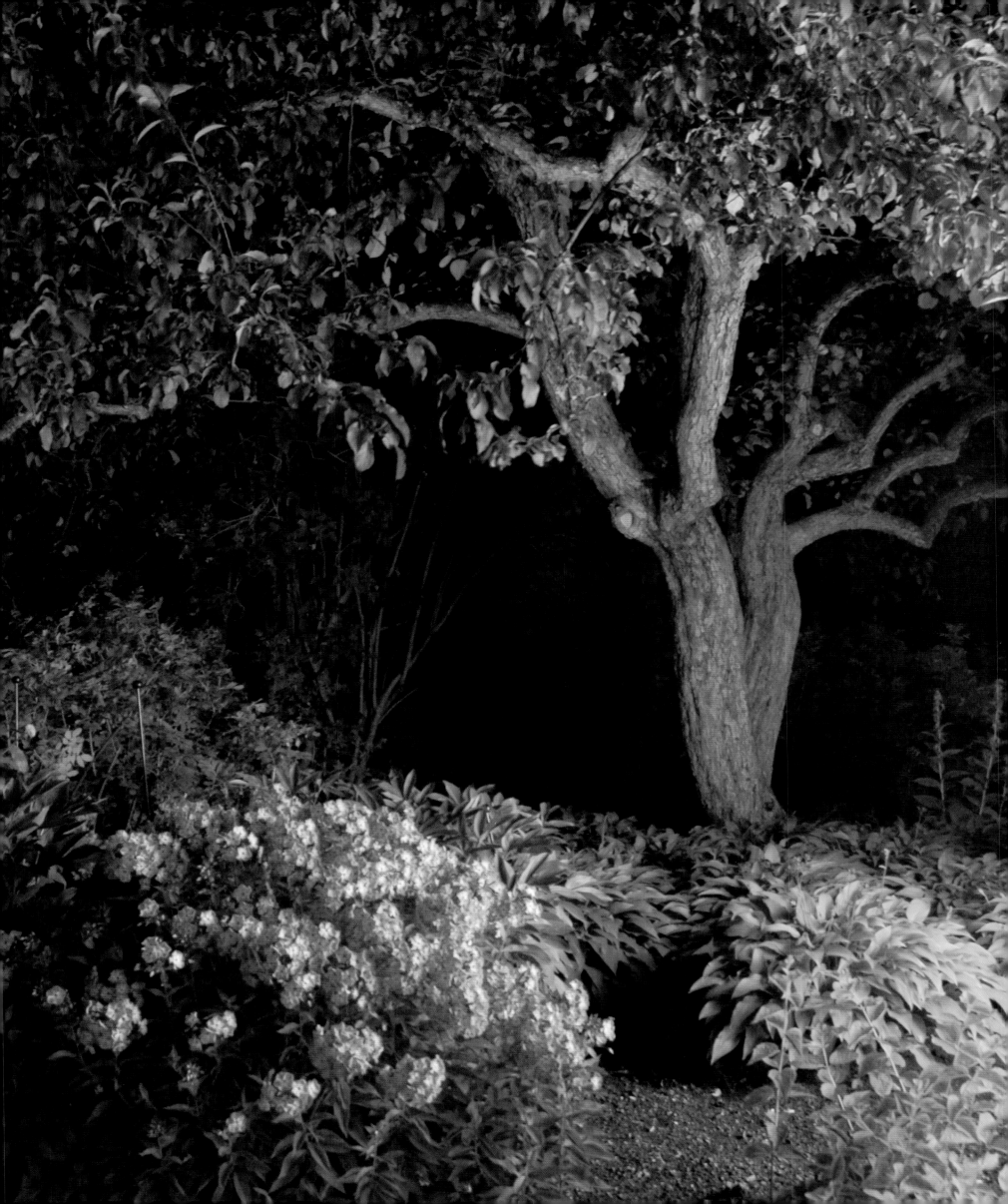

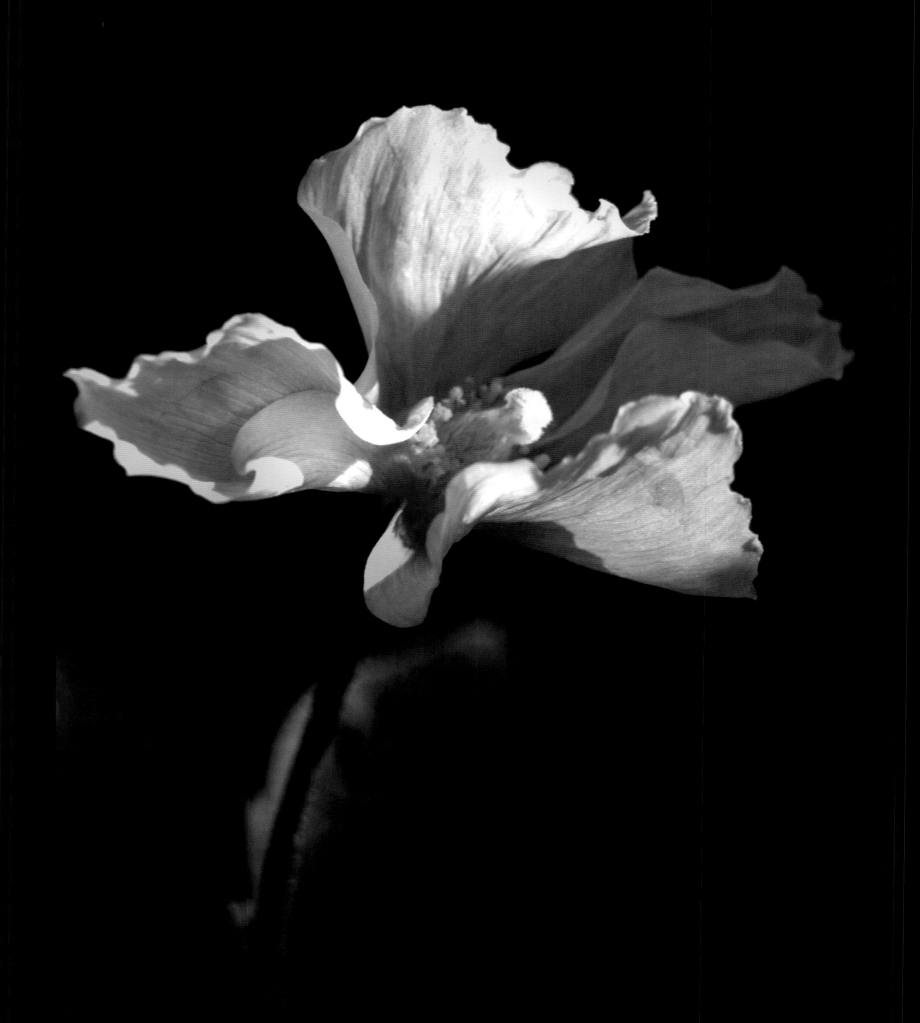

BLUE POPPY—*MECONOPSIS BETONICIFOLIA*

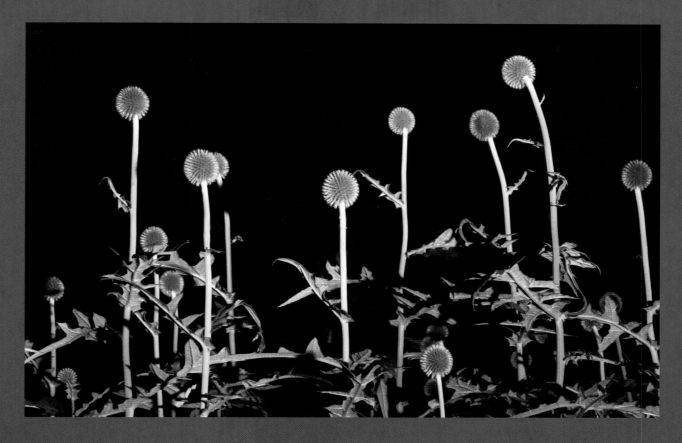

GLOBE THISTLE—*ECHINOPS RITRO*

Just beyond lies the Moss Garden, a work of art designed especially for the site and constructed by artist Francine Larivée from 1993 to 1996. The Blue Poppy Glade, nestled between martagon lilies and maidenhair ferns, displays one of Reford's rarest and most enchanting plants—the Himalayan blue poppy, native to the Tsangpo Gorge in the southeast corner of Tibet. Reford was among the first gardeners in North America to try the seeds obtained from the Royal Botanic Gardens in Edinburgh. Beyond the poppies, the Scree Garden hosts a multitude of alpine plants growing beside carefully selected stones, as well as a hundred different rock plants, such as rock leeks, mountain avens, pinks, and lewisia. The Long Walk, a reinterpretation of the work of British gardener Gertrude Jekyll, was designed by Robert Wilson Reford with two low stone walls made of cement, imitating flagstones, and leads to a vista of the St. Lawrence River. Farther on, more than thirty species and cultivars of primula, varying from yellow and purple to the spectacular red-hot poker primrose with its characteristic red-topped spikes, can be found in the Primula Glade. Every summer Reford Gardens hosts the International Garden Festival, the only one of its kind in North America, with temporary gardens created by Canadian designers highlighting global horticultural aesthetics ranging from the United Kingdom to Morocco.

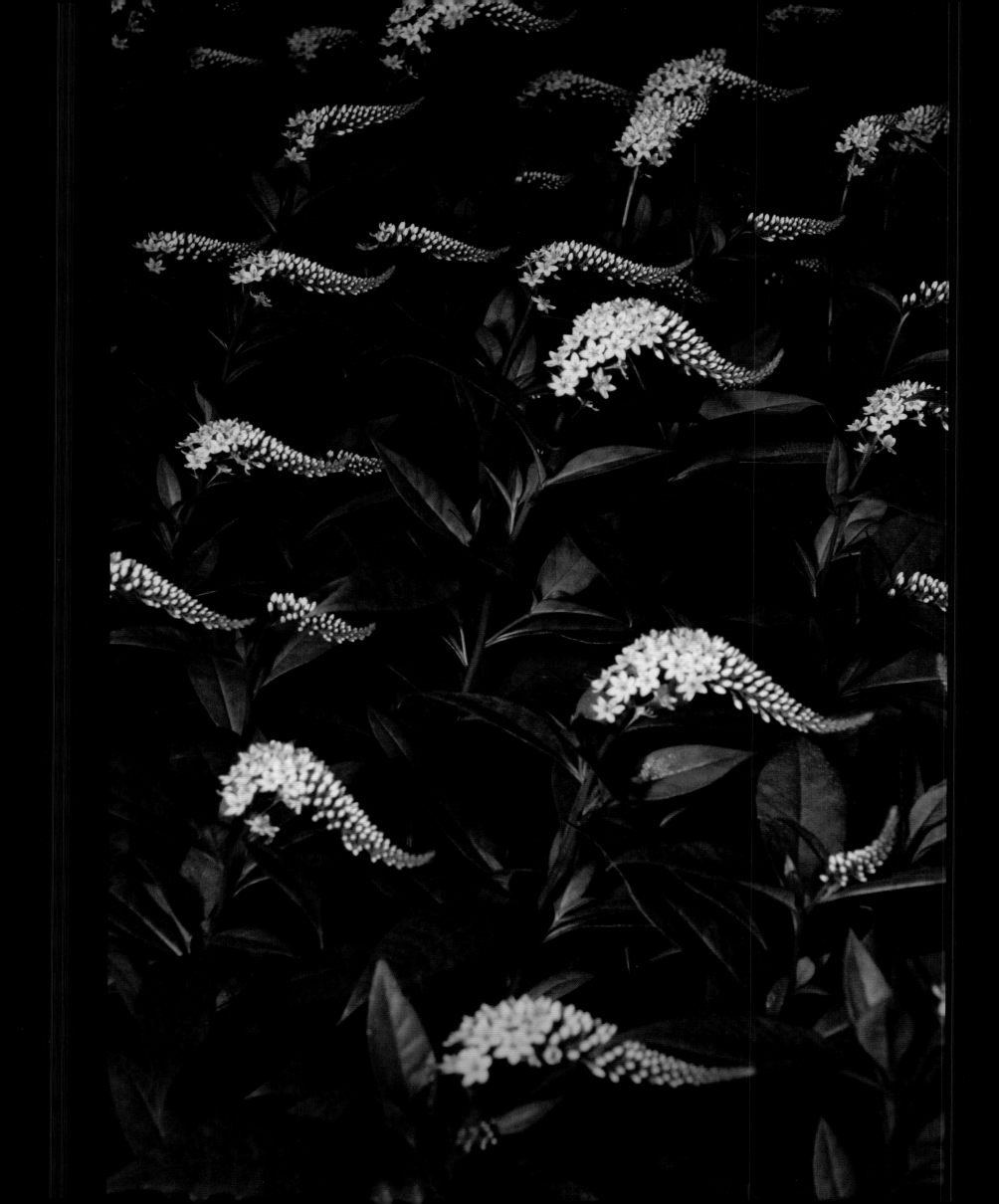

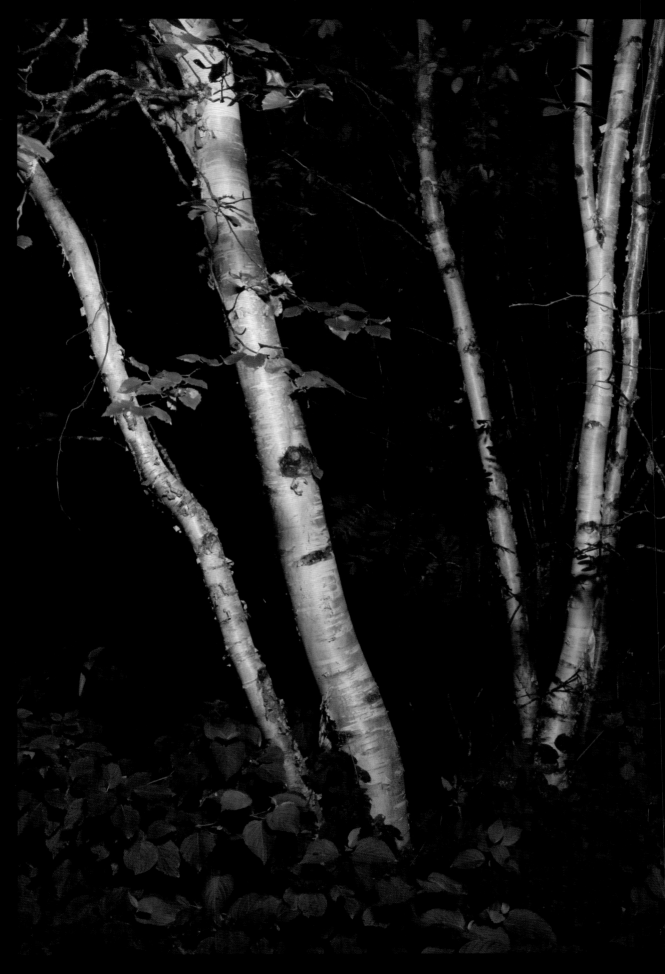

Opposite: GOOSENECK LOOSESTRIFE—*LYSIMACHIA CLETHROIDES*
Above: PAPER BIRCH—*BETULA PAPYRIFERA*

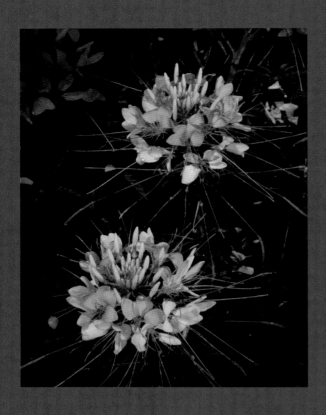

ROYAL BOTANICAL GARDENS

nature sanctuary

WHAT WAS, IN THE EARLY 1900S, a road lined with billboards and gas stations with an unpleasant view of papered shacks and boathouses, two decades later became the chosen site of Canada's Royal Botanical Gardens. It was Thomas Baker McQuesten, later Ontario's Minister of Highways and Public Works, who convinced the Hamilton Board of Parks Management to include Canada's largest botanical garden in the redevelopment plan of the unattractive entrance. Having obtained royal assent, McQuesten facilitated the purchase of the land, and by the end of World War II, the area was being developed by landscape architect Carl Borgstrom. A total of 297 acres were cultivated, while the remaining 2,403 acres were left as a managed natural area. These nature sanctuaries include the Cootes Paradise Sanctuary, a 620-acre marsh that is one of the most important waterfowl-staging habitats on the lower Great Lakes and the region's largest nursery fish habitat; the Rock Chapel, a 177-acre nature sanctuary located in part of the Niagara Escarpment UNESCO World Biosphere Reserve, which includes Borer's Falls, a classical 15-meter waterfall, and the escarpment

Opposite: SPIDER FLOWER, CLEOME, *above*: HENDRIE PARK GATES

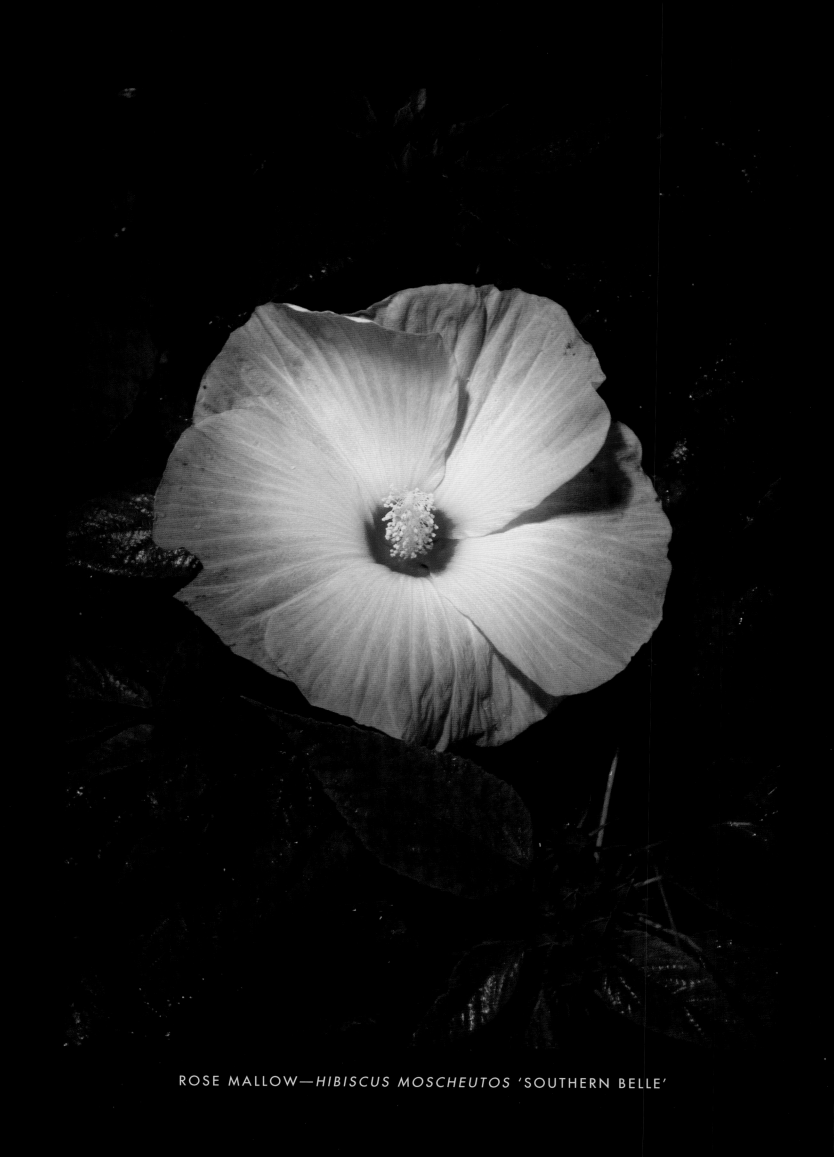

ROSE MALLOW—*HIBISCUS MOSCHEUTOS* 'SOUTHERN BELLE'

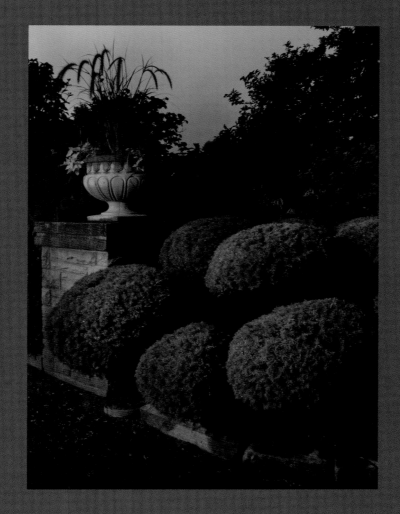

BIRD'S NEST SPRUCE—*PICEA ABIES* 'NIDIFORMIS'

valley; and the Hendrie Valley and Grindstone Creek, which drains an area of 90 square kilometers and comprises a mixed deciduous forest home to several rare and uncommon indigenous plants and animals. In the Cultivated Garden, visitors can view the largest lilac collection in the world, with twenty-six wild species native to eastern Asia and southern Europe. For its part, the Lilac Dell possesses over eight hundred species and cultivars of common lilacs, French hybrids, Preston hybrids (which originated in Canada, cultivated by Isabella Preston), early bloomers, and wild varieties. Other collections in the garden include magnolia, forsythia, beech, and rhododendron, along with a substantial area reserved for seventy species of trees native to Ontario, including hickory, sassafras, and maple. Hendrie Park features an exquisite centennial rose garden, as well as the Queen Beatrix Narcissus Collection. A living gift from the Netherlands' queen to commemorate her visit to the gardens in 1988, the collection includes three thousand bulbs from each of the twelve different horticultural classes of daffodils, an impressive reminder of the garden's royal ties. ❧

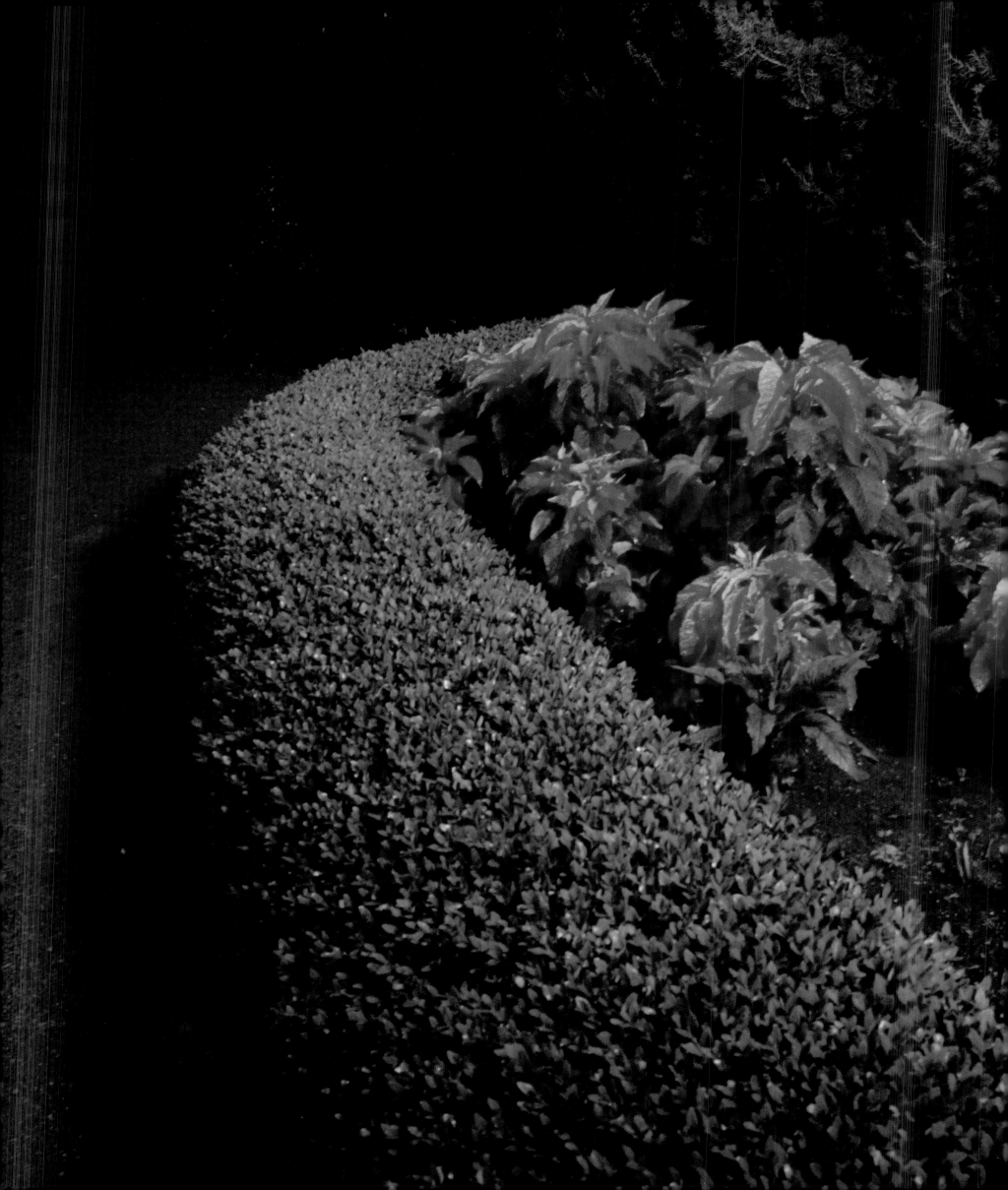

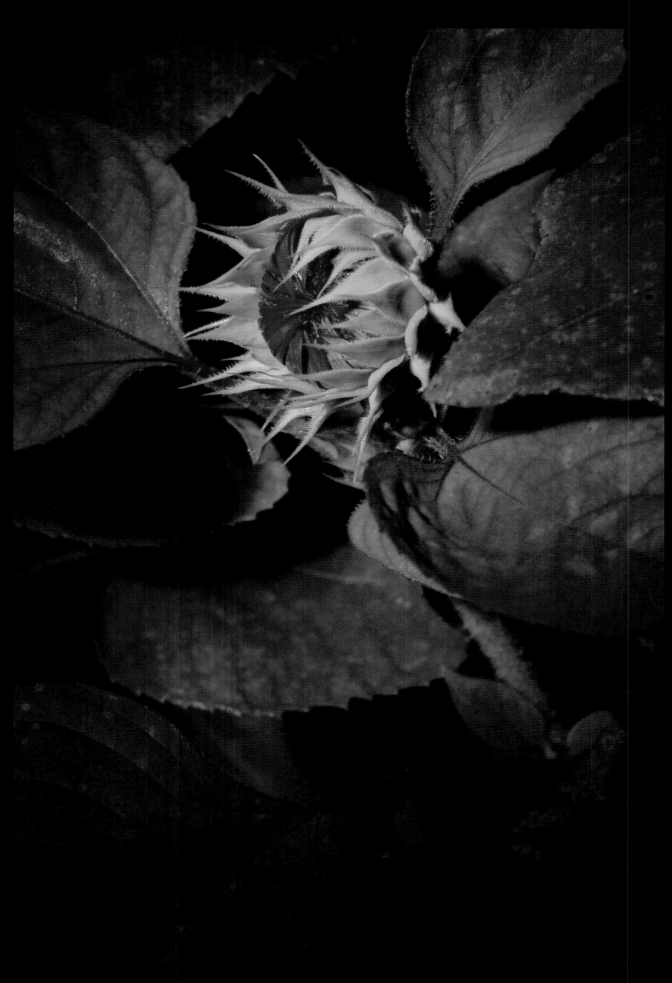

Opposite: AMARANTH—*AMARANTHUS TRICOLOR* 'FLAMING FOUNTAIN'
Above: GIANT SUNFLOWER—*HELIANTHUS GIGANTEUS*

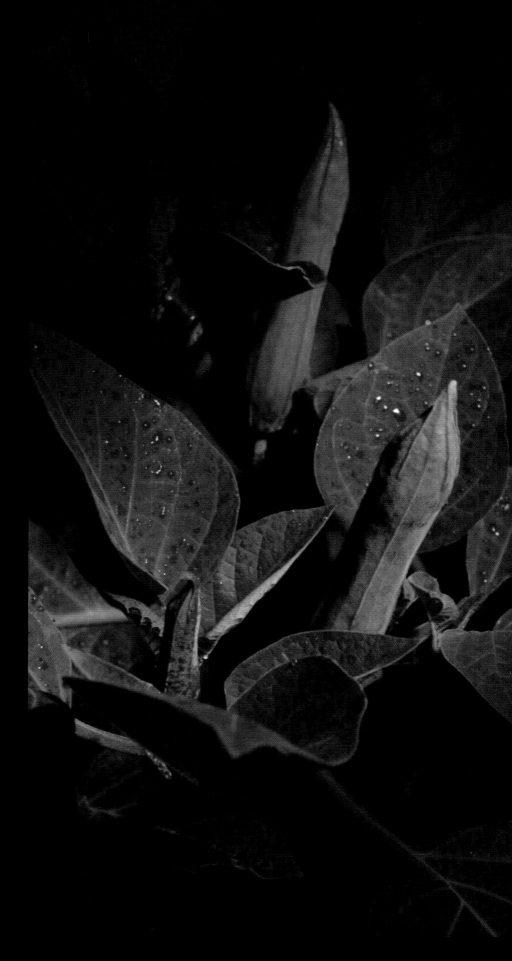

ANGEL'S TRUMPET—*DATURA*

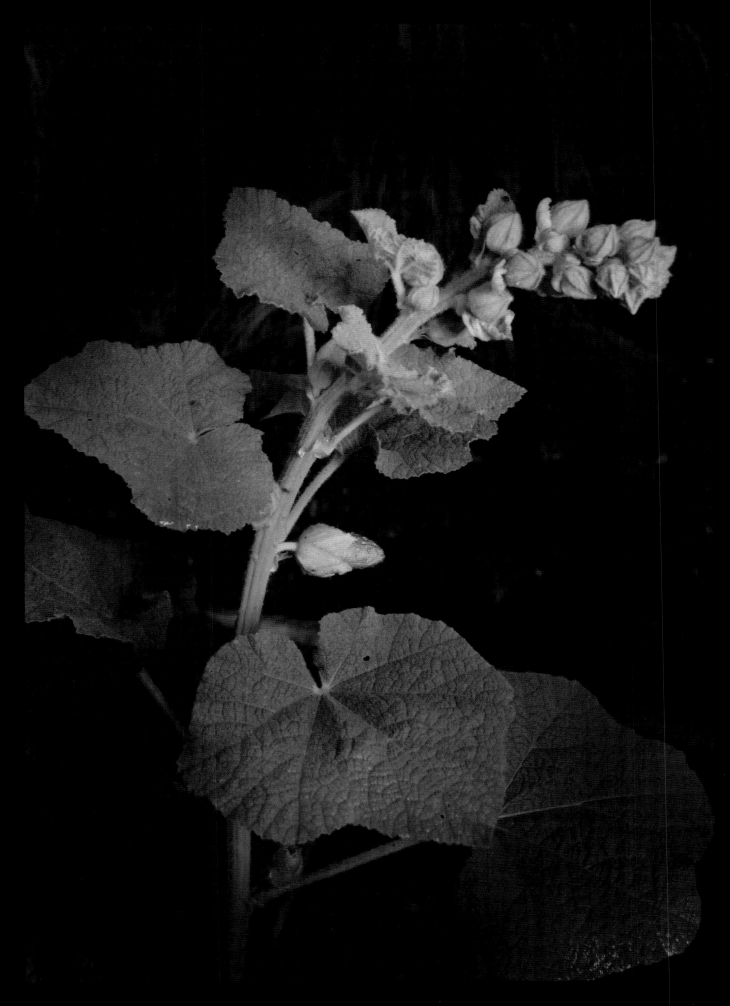

HOLLYHOCK—*ALCEA*

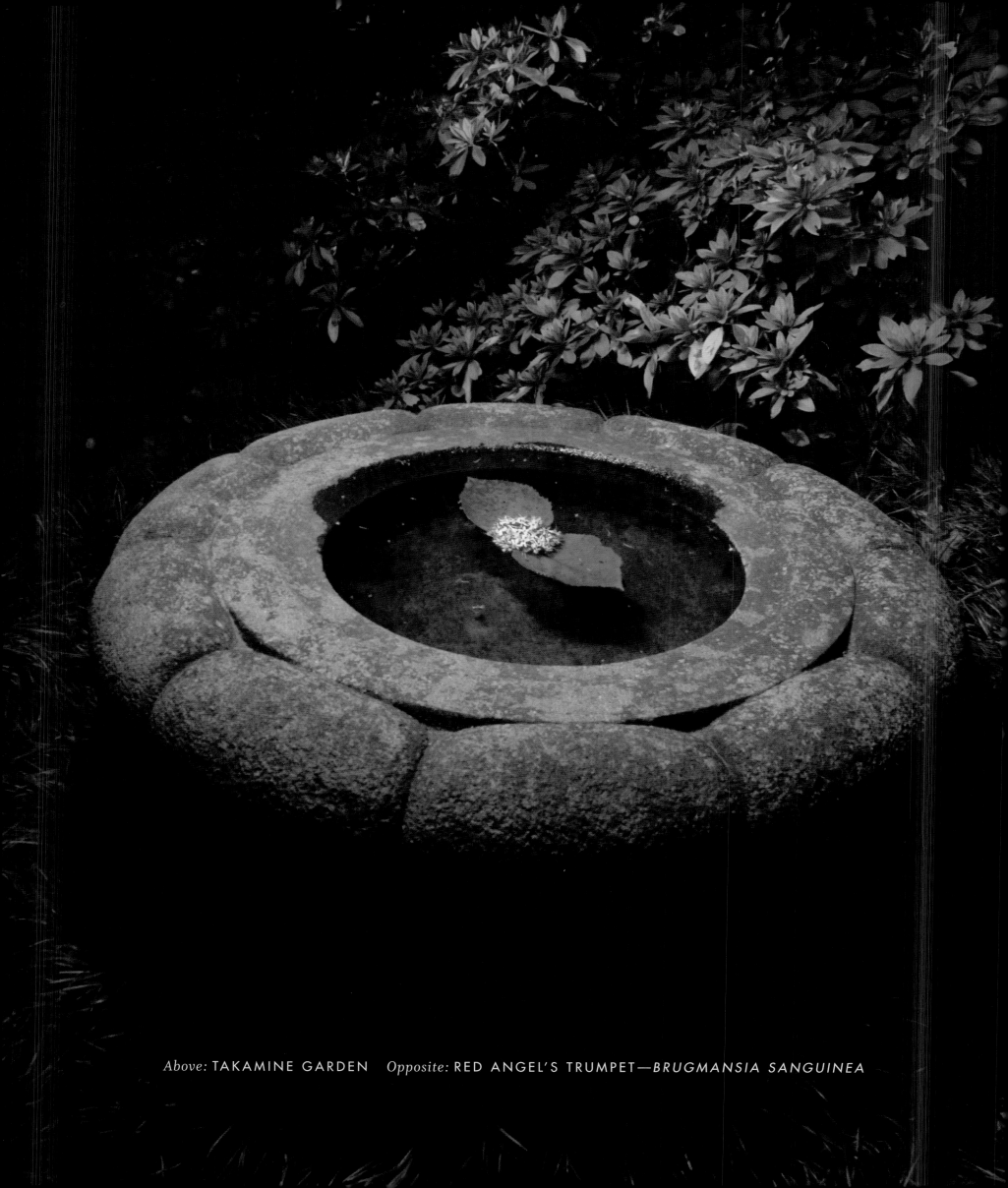

Above: TAKAMINE GARDEN *Opposite:* RED ANGEL'S TRUMPET—*BRUGMANSIA SANGUINEA*

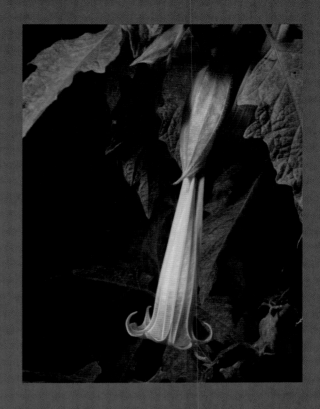

SAN FRANCISCO BOTANICAL GARDEN

a sensorial voyage

LOCATED NEAR THE PACIFIC coast in Golden Gate Park, the San Francisco Botanical Garden (which first opened as Strybing Arboretum in 1940) is home to more than 7,500 plant species. San Francisco's mild, Mediterranean climate, characterized by moderate temperatures, wet winters, and cool and foggy summers with little or no rainfall, mirrors that of many areas around the world, making this an ideal place to exhibit an international array of flora. As a result, the garden displays trees and plants from three major climates, separated into individual gardens representing various countries. A section of the Mediterranean gardens features a selection of plants native to California, such as the California lilac and orange poppy, butter-yellow meadowfoam, blue iris, clarkia, and buckwheat, in addition to redwood trails where ginger and redwood sorrel grow. Visitors can also find such diverse offerings as South African proteas, heathers, aloes, and silver trees; southern Australian myrtles, ten-foot grass trees, tree ferns, and red-, green-, and yellow-flowered kangaroo paws; and Chilean mayten trees, bellflowers, and winter's bark. Representing the temperate and mild temperate climates are the Japanese Tea Garden, with its

SPIRAL ALOE—*ALOE POLYPHYLLA*

reflecting ponds, and the Takamine and Moon-Viewing gardens, displaying serene Japanese maples, water irises, and camellia hybrids. Between these two areas, visitors climb sixty steps to experience Heidelberg Hill's soaring views of the garden and its woodlands, made up of Maddenii rhododendrons, winter-blooming tree rhododendrons, and various magnolias. Collections from Australia and New Zealand's temperate zones have amassed some of the oldest tree specimens in the gardens: flax, purple-flowering herbs, red-flowering New Zealand Christmas trees, drought-resistant bottlebrushes, acacias, grevilleas, and lilly-pilly trees with their lavender flowers and berries. The New and Old World Cloud Forests, highlighting foggy, mountainous tropical regions that exist throughout Chiapas, Mexico, and Southeastern Asia, allow for a wide assortment of plants, including passion vines, fuchsias, tree dahlias, magnolias, and Vireya rhododendrons. Specialty gardens with collections of primitive plants, conifers, perennials, and fragrance plants illustrate this fifty-acre garden's commitment to conserving biological diversity. ℘

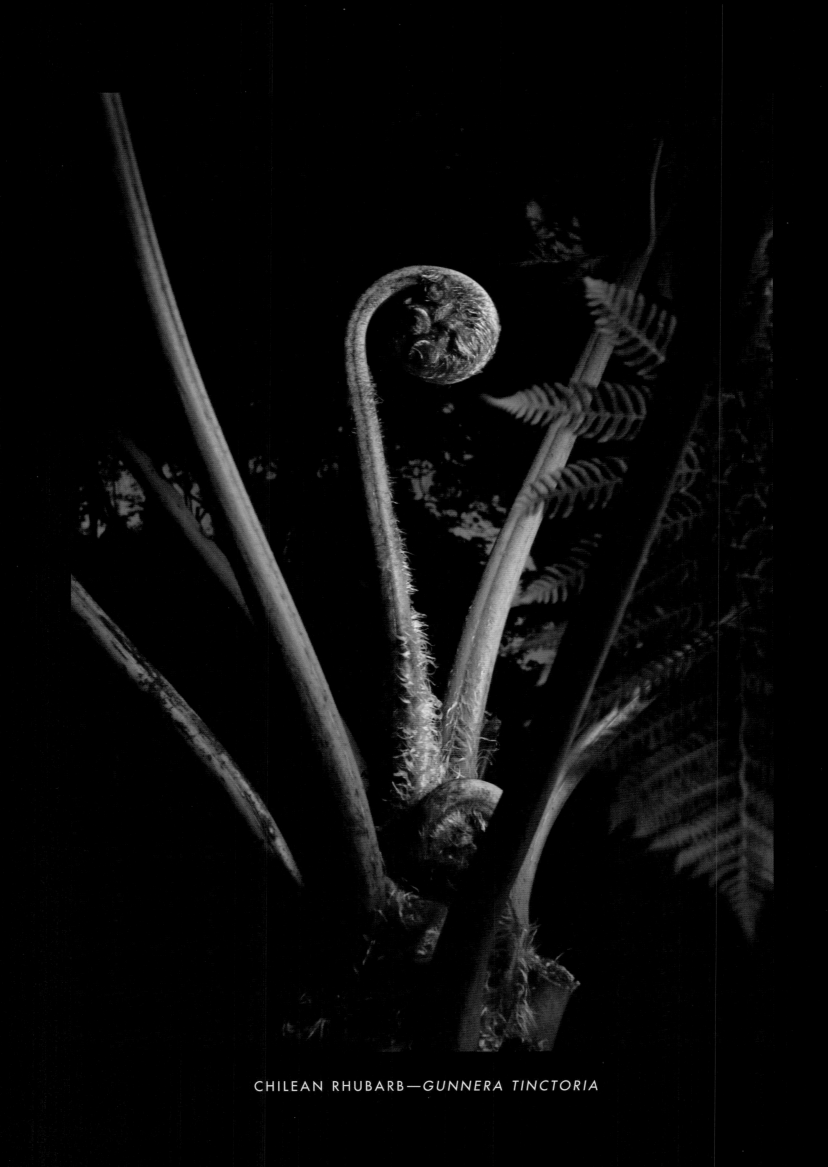

CHILEAN RHUBARB—*GUNNERA TINCTORIA*

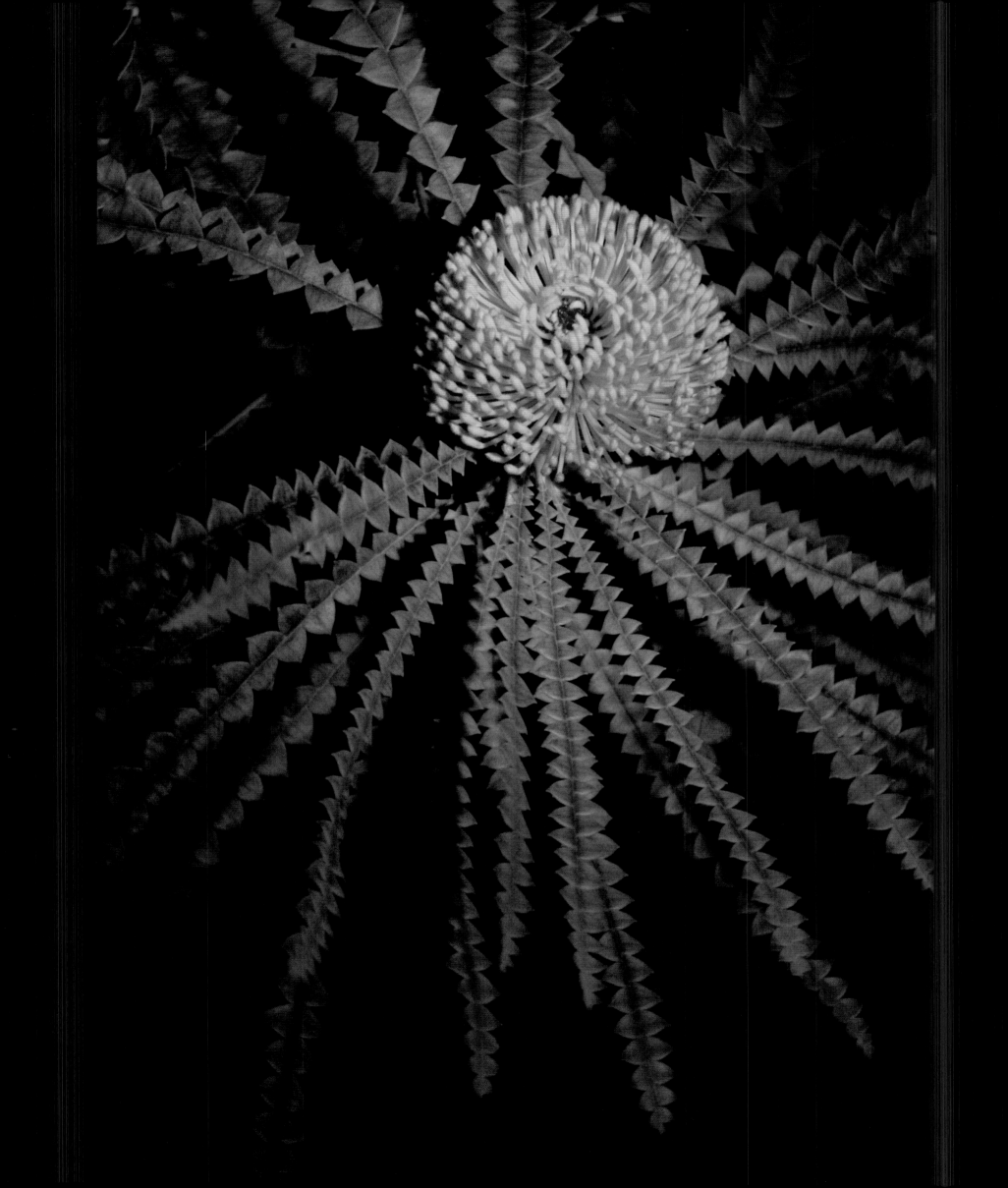

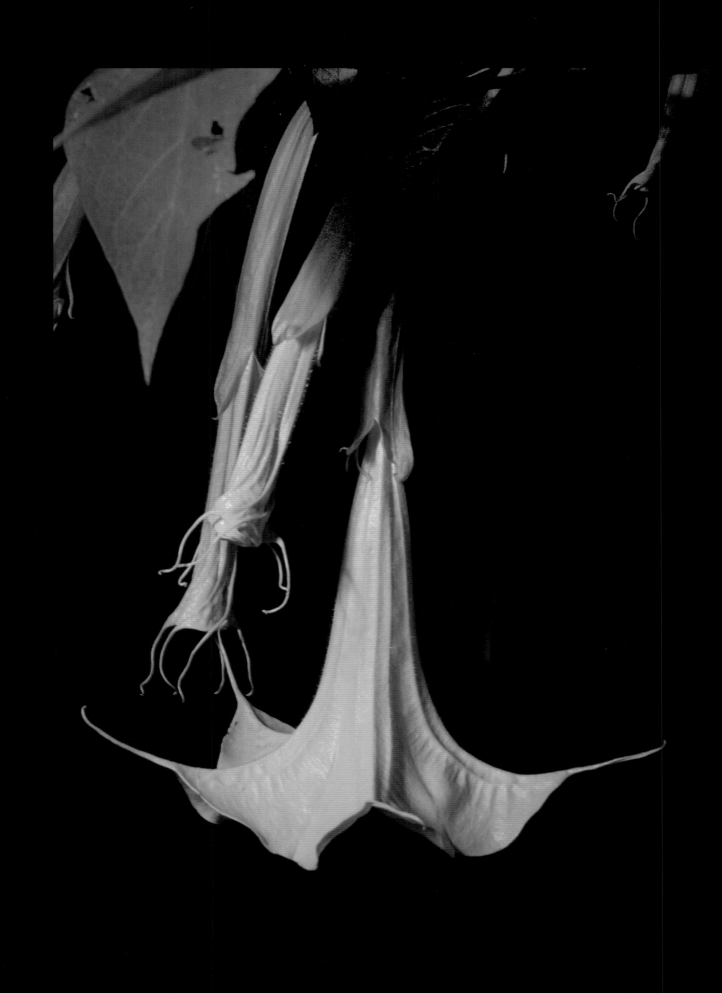

Opposite: PROPELLER BANKSIA—*BANKSIA CANDOLLEANA* *Above:* ANGEL'S TRUMPET—*BRUGMANSIA AUREA*

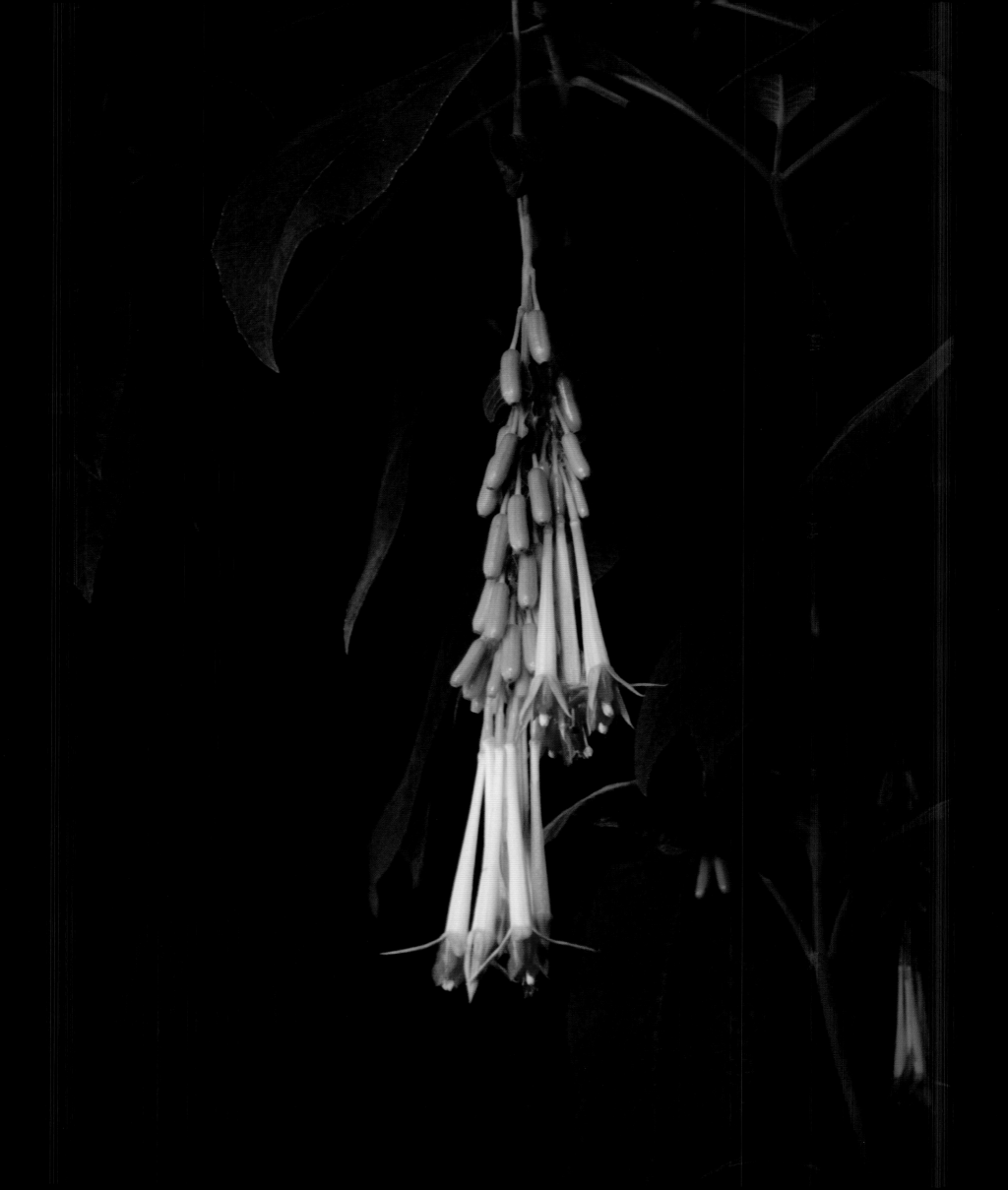

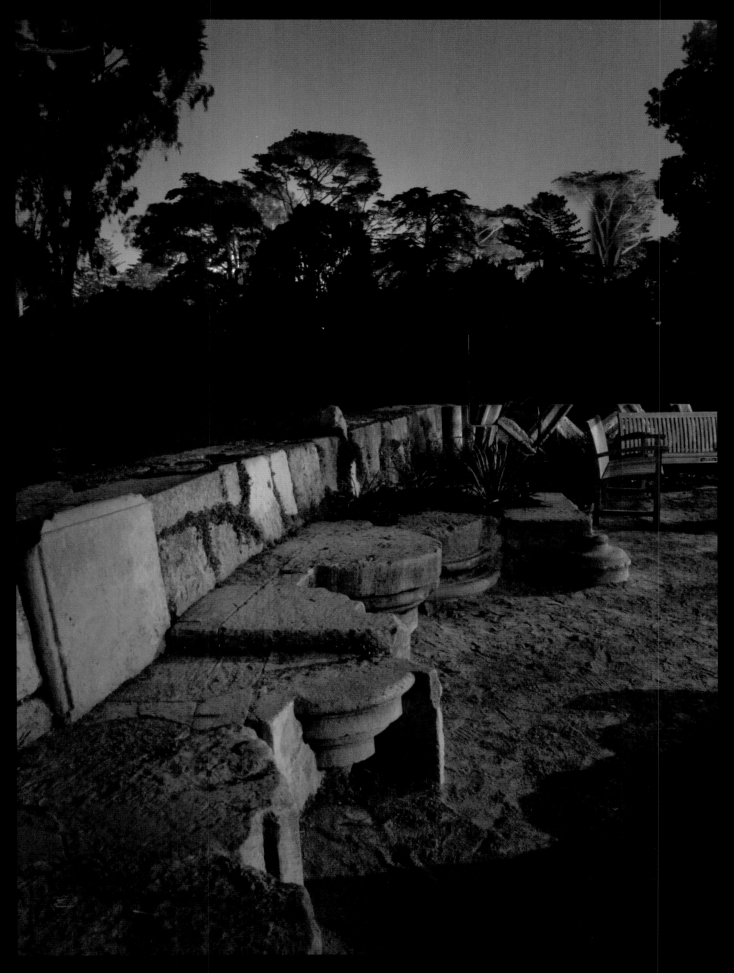

Opposite: BOLIVIAN FUCHSIA—*FUCHSIA BOLIVIANA* VAR. *ALBA*

Above: LIBRARY TERRACE GARDEN

UNITED STATES NATIONAL ARBORETUM

patriotic landmark

ON A KNOLL in the Ellipse Meadow, in the United States' capital's arboretum, stand a series of sandstone Corinthian columns, a striking landmark in a garden first established in 1927 by an act of Congress and today administered by the United States Department of Agriculture. Nearby, the thirty-acre National Grove of State Trees represents the fifty states (and the District of Columbia) with groups of trees acquired from each. Outside the modernist administration building, designed by Albert G. Mumma Jr., is a soothing aquatic garden made up of pools of water, fountains, and waterfalls that present Victoria hybrid water lilies and dwarf cattails, among which fish, frogs, and insects dwell. In the vicinity is the National Bonsai and Penjing Museum, which displays one of the largest collections of bonsai trees and their Chinese precursor, penjing trees, in North America; the trees are surrounded by enchanting paths, pagoda-like entrances, and serpentine walls. The National Herb Garden, which includes annuals,

Above: AZALEA ROAD *Opposite:* FLOWERING DOGWOOD—*CORNUS FLORIDA*

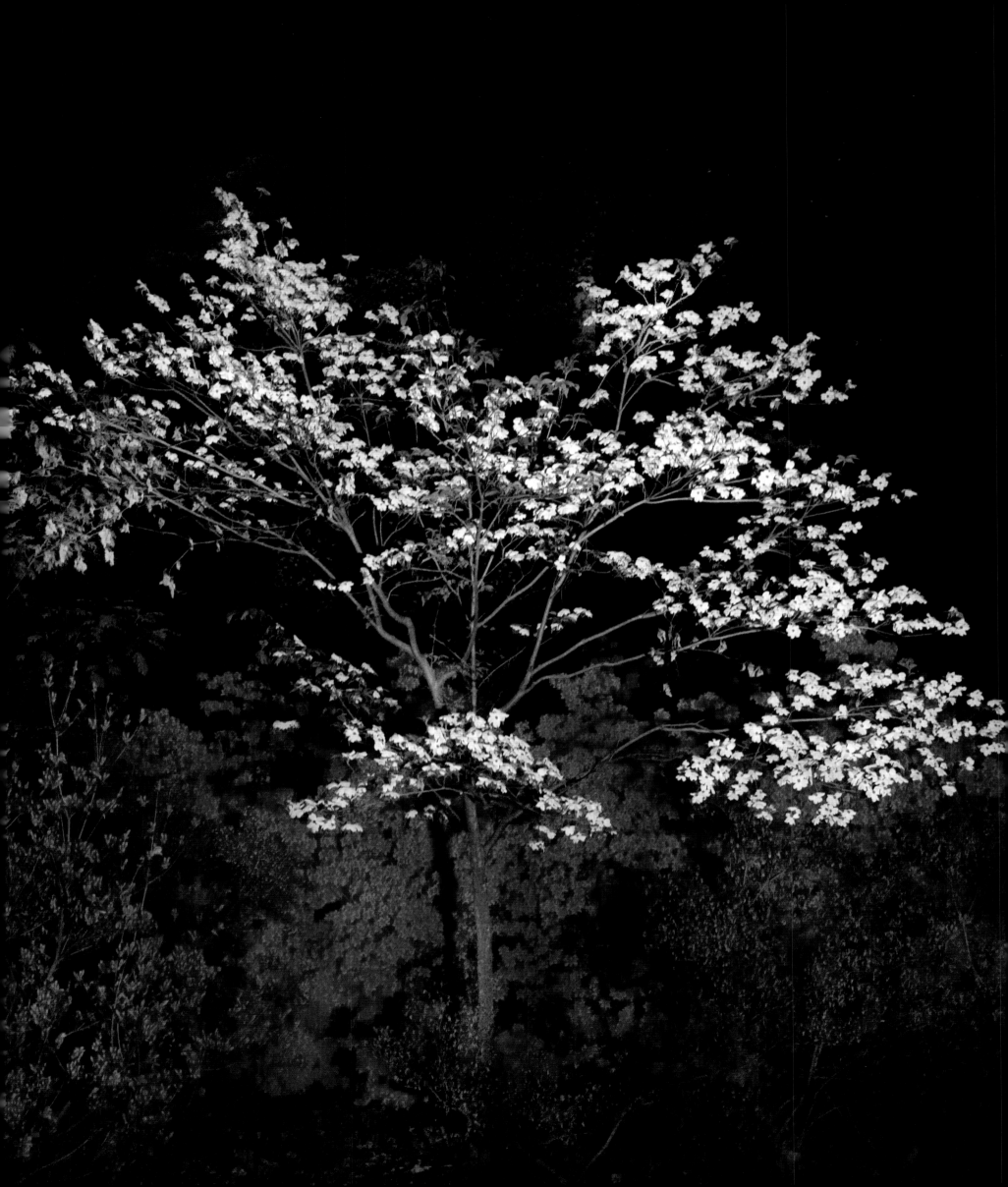

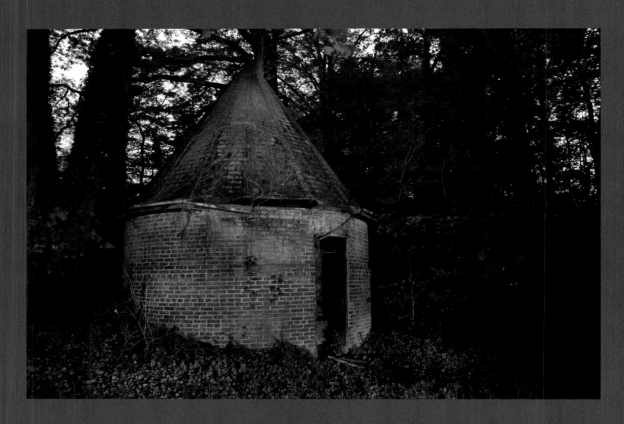

OLD SPRING HOUSE

perennials, and woody herbal plants, is the largest in the nation, made up of ten themed areas where plants from around the world are brought together to illustrate the ways that herbs help us and their importance in different cultures. Here, rosemary, lavender, scented geraniums, salvias, and more than one hundred varieties of peppers, from habañeros to sweet peppers, create a kaleidoscope of color and scents. Around the former caretaker's residence grow ornamental grasses, daffodils, and evergreens—part of the Friendship Garden designed in the New American Garden style by landscape architects Wolfgang Oehme and James van Sweden. With the exceptional Holly and Magnolia Garden and the Gotelli Dwarf and Slow-Growing Conifer Garden, the Arboretum possesses one of the most complete collections of boxwoods in the world, with over 150 different species and cultivars. And within the walled Morrison Garden, on the south slopes of Mount Hamilton, springtime alights upon Washington, D.C., with an array of azalea blooms that beckon the summer delights ahead. ∝

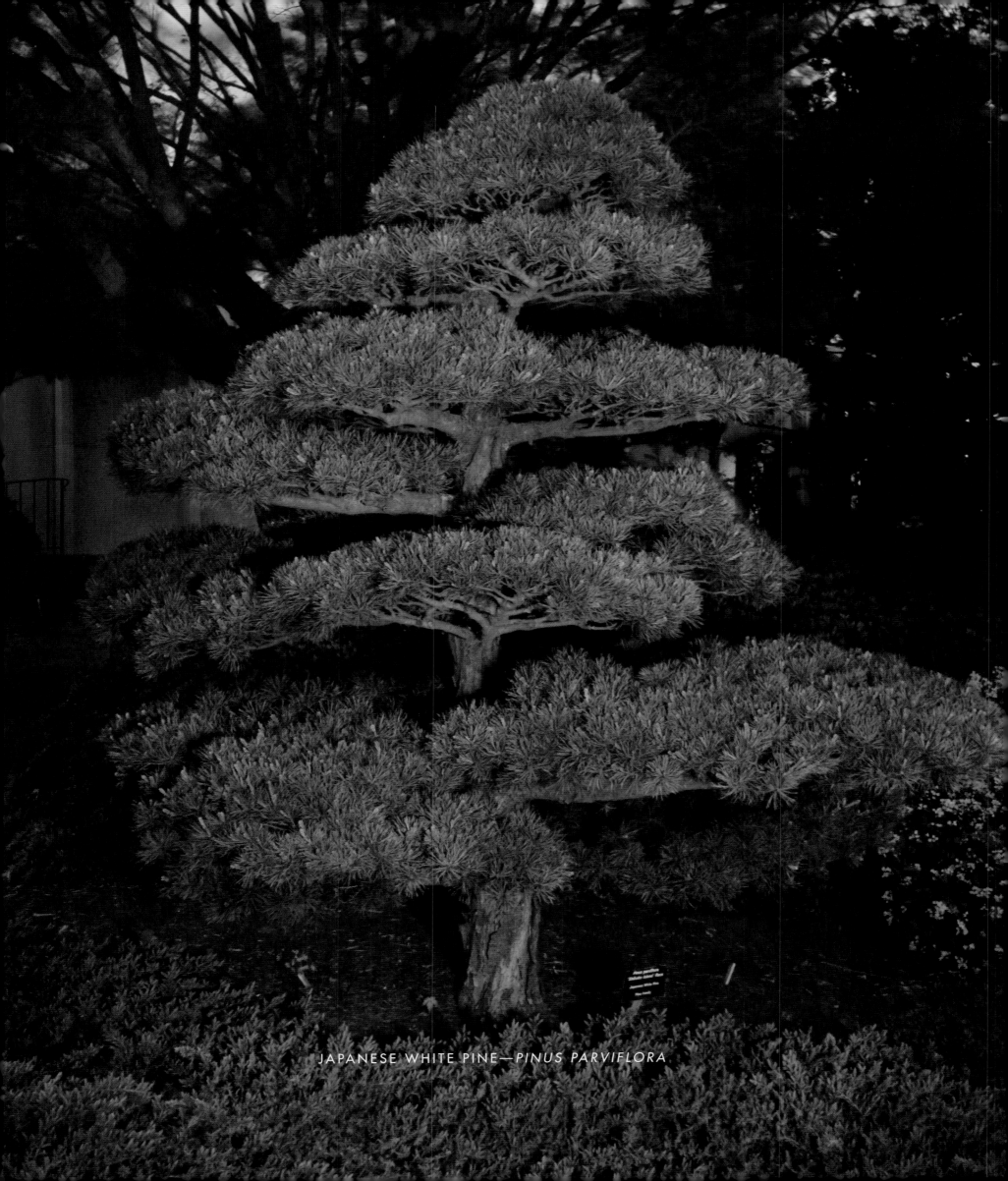

JAPANESE WHITE PINE—*PINUS PARVIFLORA*

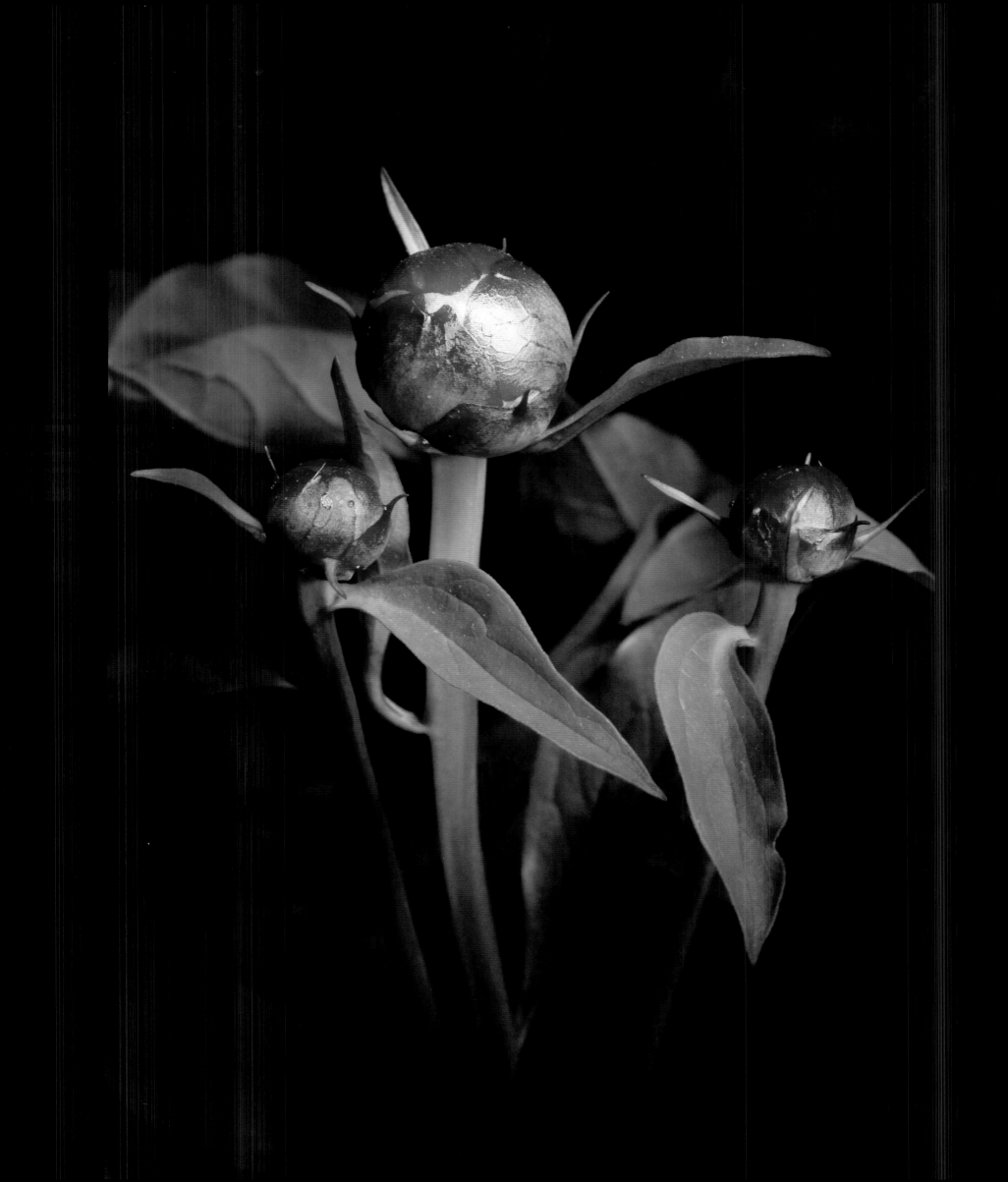

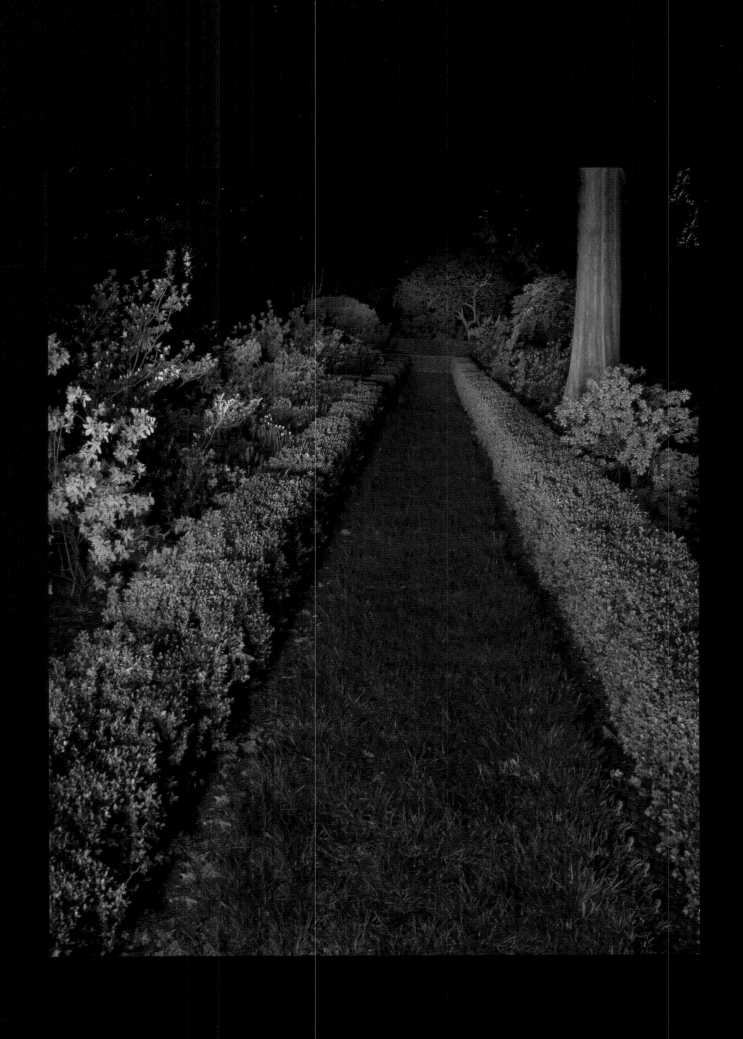

Opposite: PEONY—*PAEONIA* *Above:* AZALEA ROAD

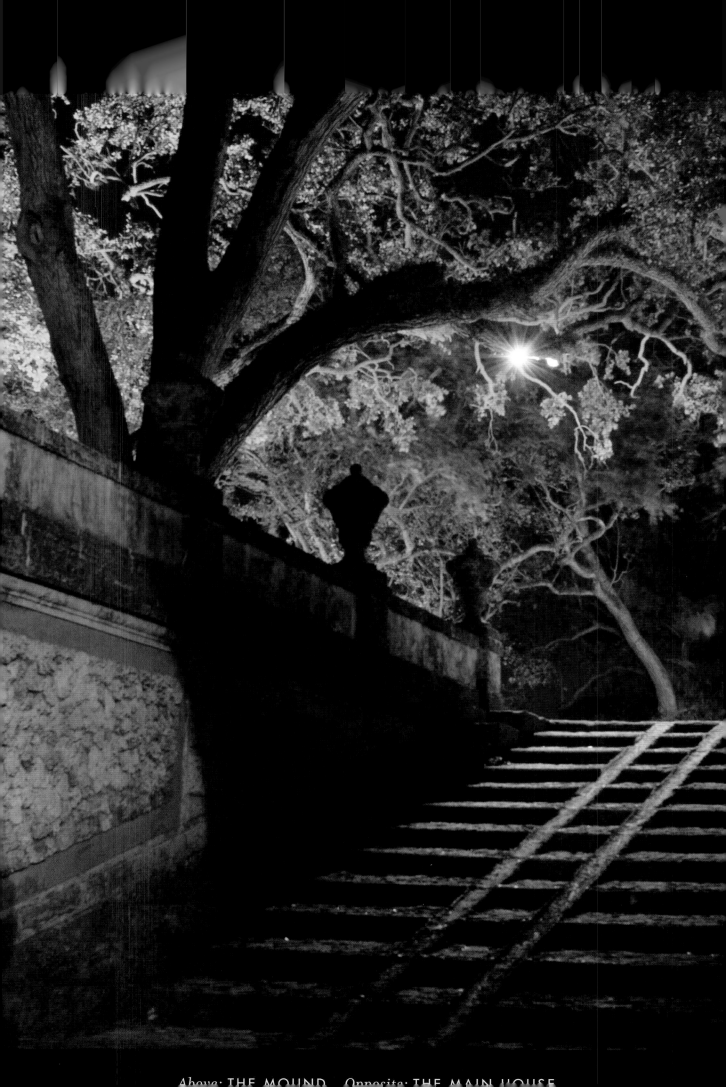

Above: THE MOUND Opposite: THE MAIN HOUSE

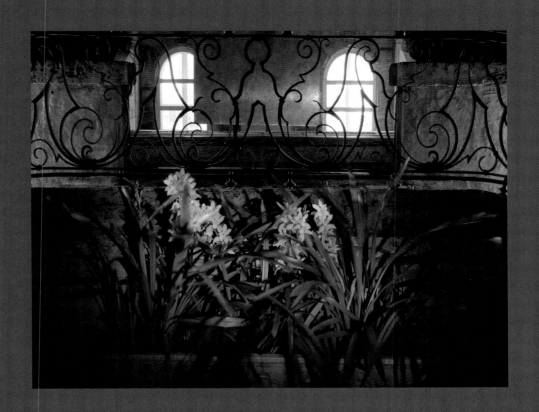

VIZCAYA MUSEUM AND GARDENS

collection of treasures

IN THE WATERS AROUND MIAMI, on the Biscayne Bay, floats a stone-carved Roman barge guarding a large Italian-style villa and garden that make up the Vizcaya Museum and Gardens. In 1914, New York painter Paul Chaflin, architect F. Burrall Hoffman, and landscape designer Diego Suarez were invited by International Harvester Company vice-president James Deering to design his winter home. The palazzo, which was built by more than a thousand workers, was made to look like an estate that had existed for four hundred years, its thirty-four rooms decorated with furniture and objects from the fifteenth through nineteenth centuries. From the entrance loggia's marble floors to the library door (hidden in a bookcase) to the Chinese-style guest room where Lillian Gish once stayed, Vizcaya is a collection of treasures from around the world. The grounds that surround the villa, initially a subtropical forest and swamp, are today made up of a native hardwood hammock forest with a walkway lined by fountains and foliage leading to a series of outdoor rooms that create a sort of theatrical mise-en-scène for visitors. Little of the traditional bright colors associated with Florida landscapes can be

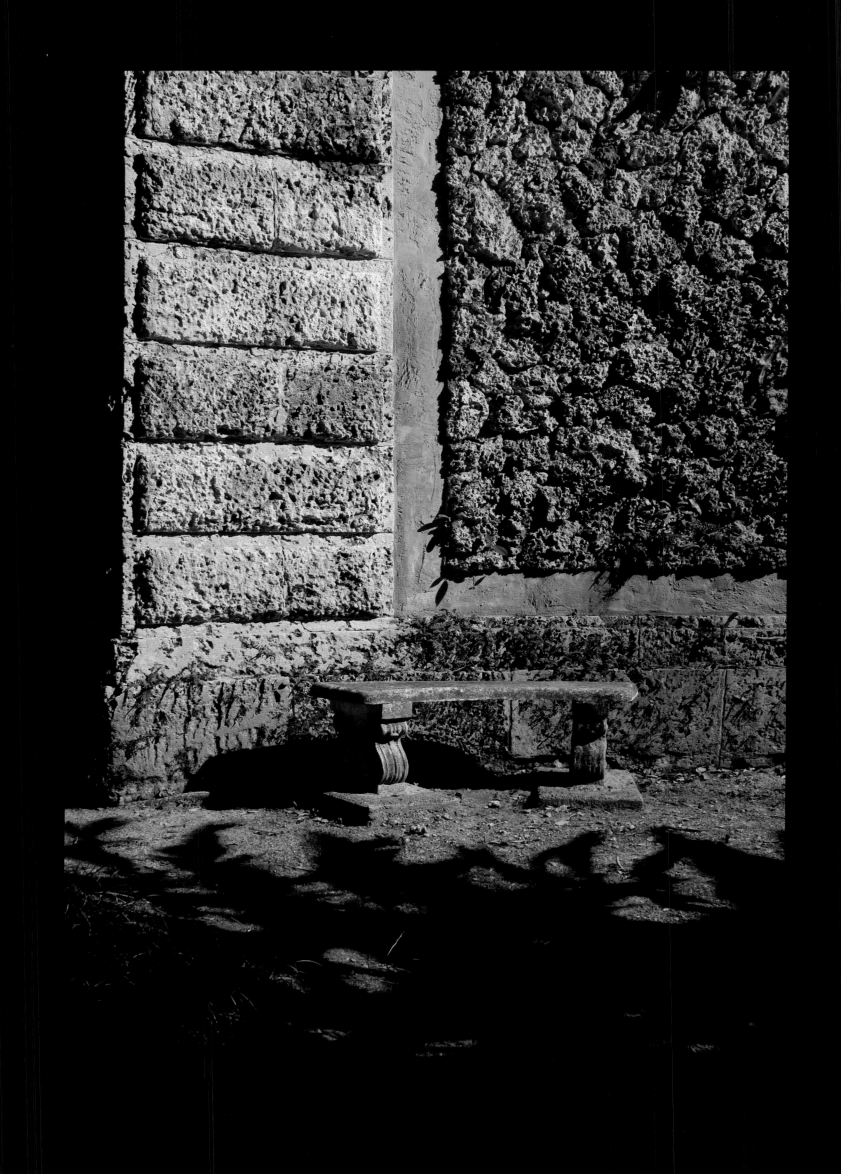

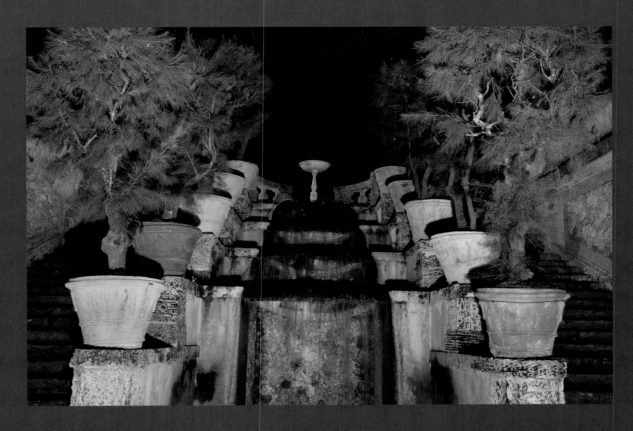

Opposite: THE CASINO *Above:* WATER STAIRWAY

found throughout this space; instead, the classical gray tones of stone paths and sculptures and the greens of shrubbery and trees predominate. A series of trimmed hedges surround terraces where formal statues watch over mysterious nooks, columns, grottos, and a reflecting pool containing a floating island. In the direction of the bay lie a series of parterres, a fountain, and low steps leading to the limestone barge, which acts as a breakwater against tidal surges and brings the aesthetic elements out into the vista. Above a grove of ilex, another set of steps leads up to the Mound, from which the Casino, a lively two-roomed pavilion, overlooks the Italian Renaissance-style formal gardens. Various themed gardens are dispersed throughout, including the Maze Garden with its orange-jasmine hedges; the walled Secret Garden; and the David A. Klein Orchidarium, featuring Vanda orchids, aromatic cattleya hybrids, and exotic swan orchids. In 1952, Deering's heirs donated the property and the majority of its furnishings to Dade County, ensuring its ongoing restoration from damage caused by humidity, and confirming its role as a public museum. ❧

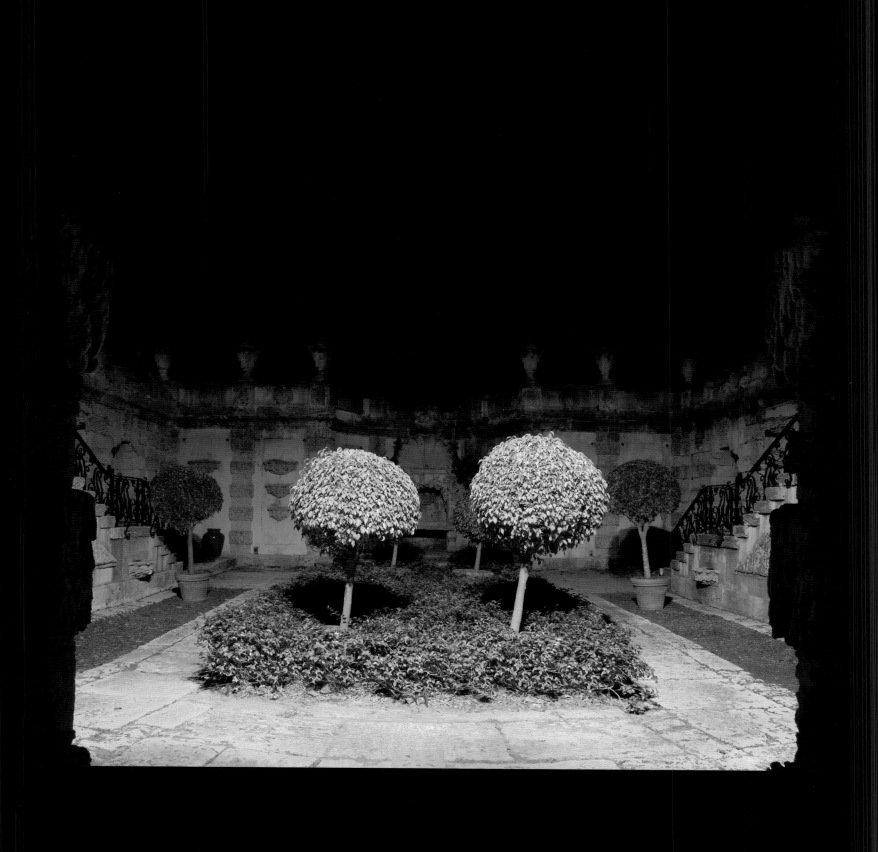

Above: SECRET GARDEN *Opposite:* SOUTH TERRACE

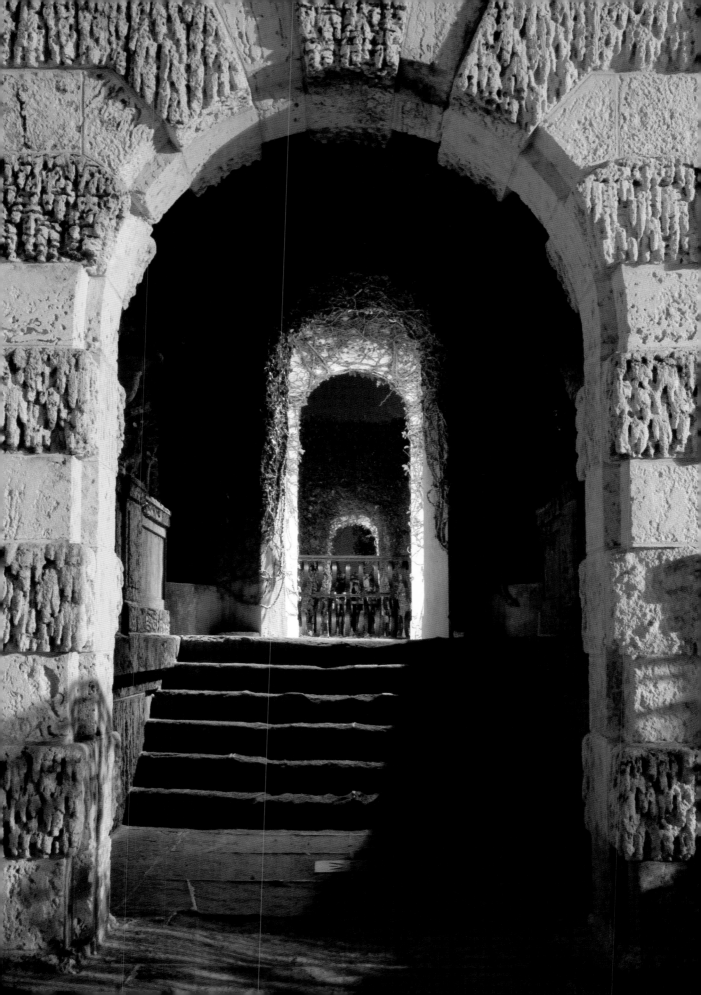

Above: JAPANESE PINE—*PINUS JAPONICA* *Opposite:* CANDELABRA PRIMROSE—*PRIMULA HELODOXA*

WASHINGTON PARK ARBORETUM

fiery foliage

FOUNDED IN 1934, the Washington Park Arboretum is part of the University of Washington's

Botanic Garden in Seattle, and the last of the great taxonomic arboretums designed by the Olmsted

Brothers landscape firm. Landscape architect James F. Dawson was the chief designer during its

construction, which took place in the heart of the Depression, with five hundred men from the Public

Works Administration hired to construct certain of its main features, including the Stone Cottage and

Azalea Way, a large path that crosses the park on its north-south axis. But it was the late arboretum

director Brian O. Mulligan who, after the Second World War, planted the majority of the accessions

that still grow today, and who also created a more developed focus on design for the garden. The 230-acre

site, situated on the shores of Lake Washington, exhibits a collection of trees representing nearly every

temperate region of the world. The western portion is primarily a valley of open vistas and sunny

glades, with the meandering course of the Arboretum Creek winding between crab-apple, walnut,

olive, larch, birch, poplar, and hawthorn trees. The garden's forested eastern slopes and ridge provide

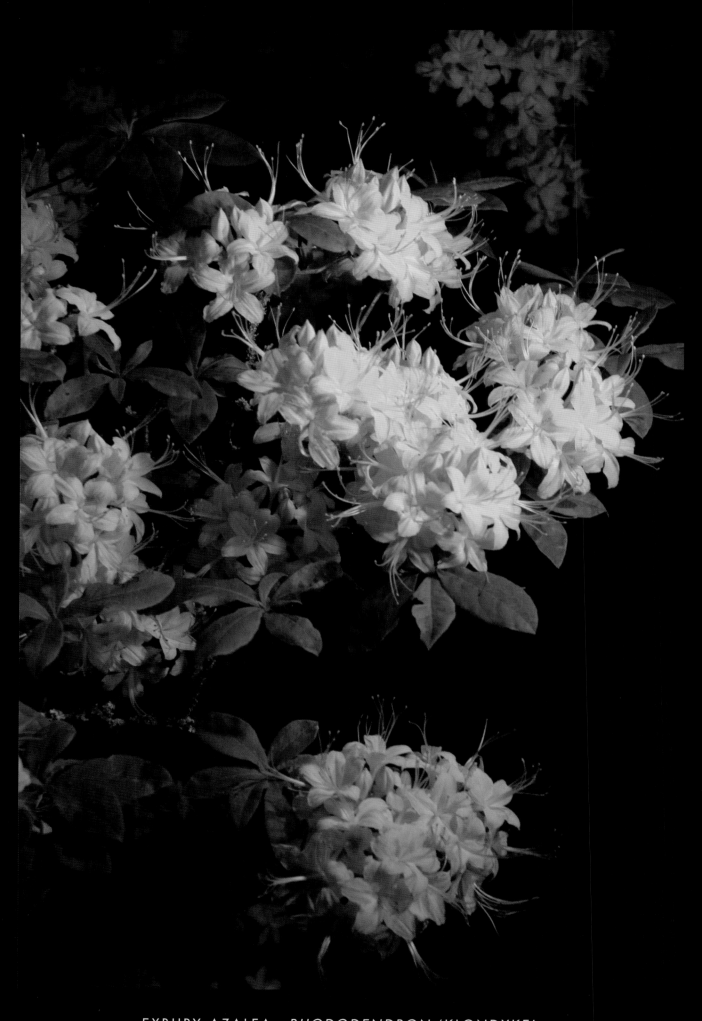

EXBURY AZALEA—*RHODODENDRON* 'KLONDYKE'

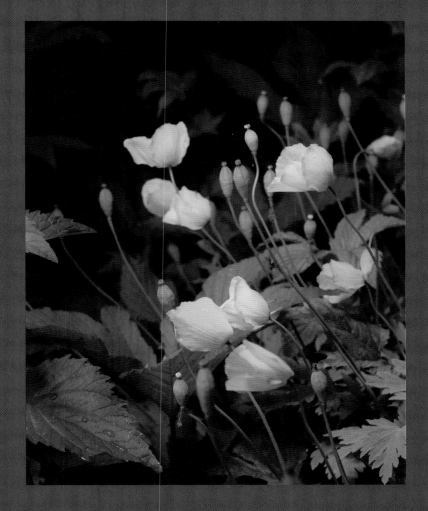

ICELAND POPPY—*PAPAVER NUDICAULE*

views of the entire arboretum, and encompass the Winter Garden, the Japanese and Asiatic Maple Collection (the largest in North America), and individual collections of mountain ashes, rhododendron (azalea), and camellia trees. The garden is flanked to the north by the lagoons of Duck Bay, and to the south, near its entrance, by ponds belonging to the Seattle Japanese Garden. From the crisscrossing system of winding trails, the arboretum's nearly ten thousand trees, shrubs, and vines may be viewed throughout every season of the year. In spring, an explosive display of azalea, magnolia, dogwood, and crab-apple trees commands center stage, set against the fresh greens of newly emerging foliage. Summer is lush with the sweet scent of honeysuckle, verdant colors, dappled shade, and the cooling tones of hydrangea blossoms. As cooler evenings signal the arrival of autumn, ripening fruits and fiery foliage cause a second explosion of color. And in this mild, maritime climate, even winter brings many surprises, with flower, fruit, foliage, and bark viewed beside the second-largest collection of hollies in North America. ❧

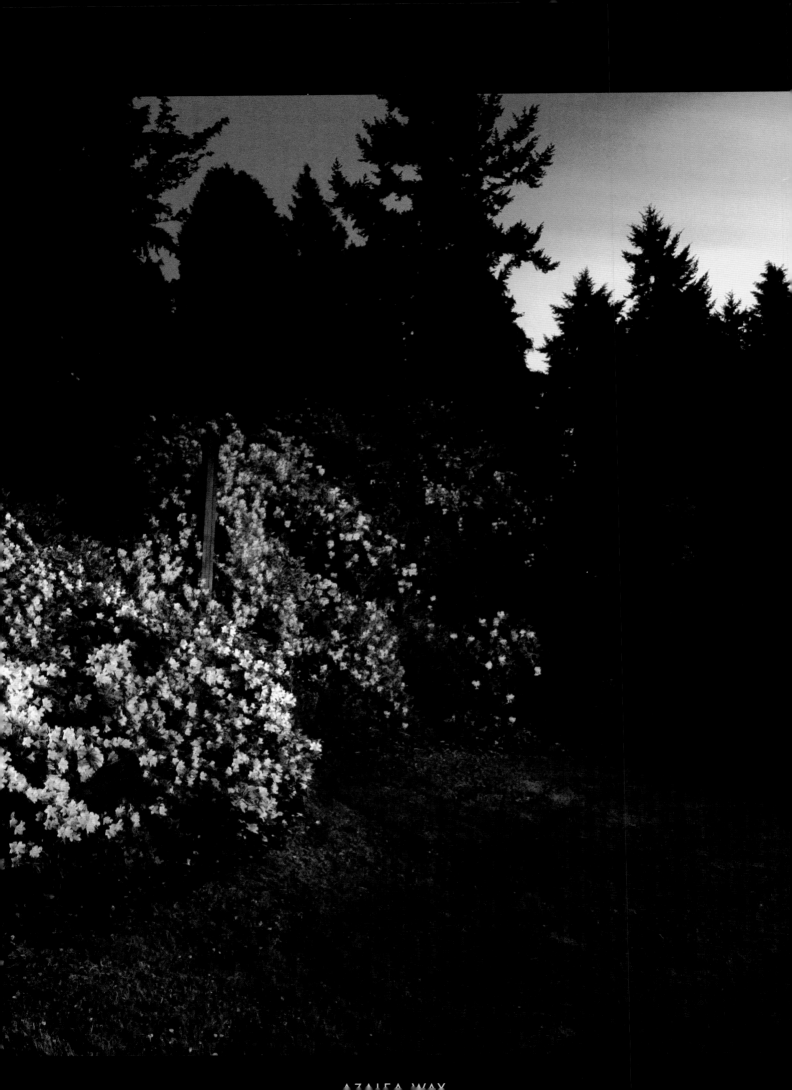

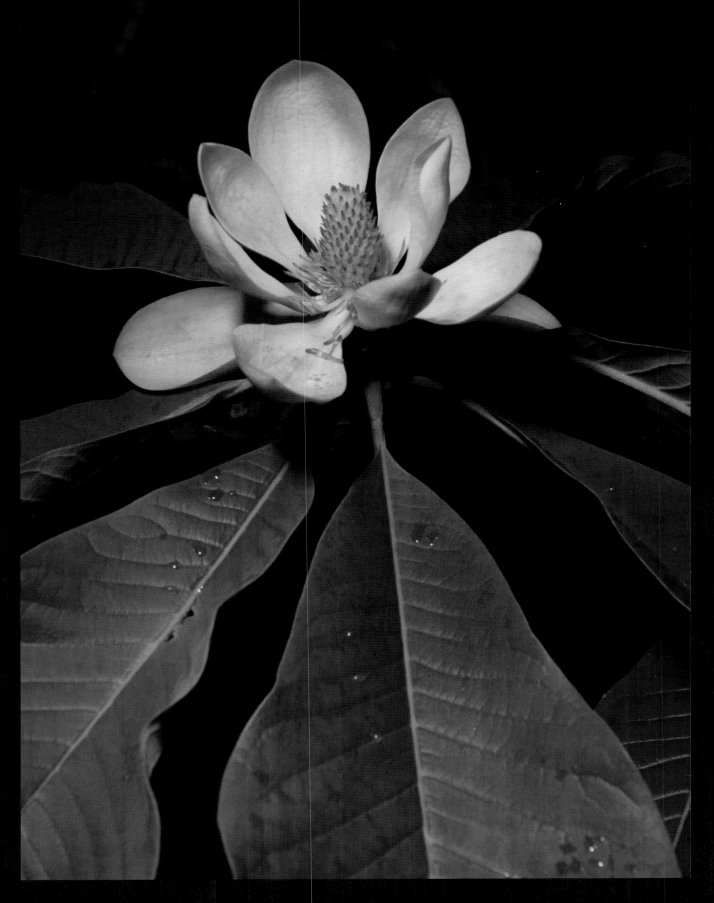

SOUTHERN MAGNOLIA—*MAGNOLIA GRANDIFLORA*

THE SKY WOULD RAIN DOWN ROSES, AS THEY RAIN

FROM OFF THE SHAKEN BUSH. WHY WILL IT NOT?

THEN ALL THE VALLEY WOULD BE PINK AND WHITE

AND SOFT TO TREAD ON. THEY WOULD FALL AS LIGHT

AS FEATHERS, SMELLING SWEET: AND IT WOULD BE

LIKE SLEEPING AND YET WAKING, ALL AT ONCE.

GEORGE ELIOT, "ROSES"

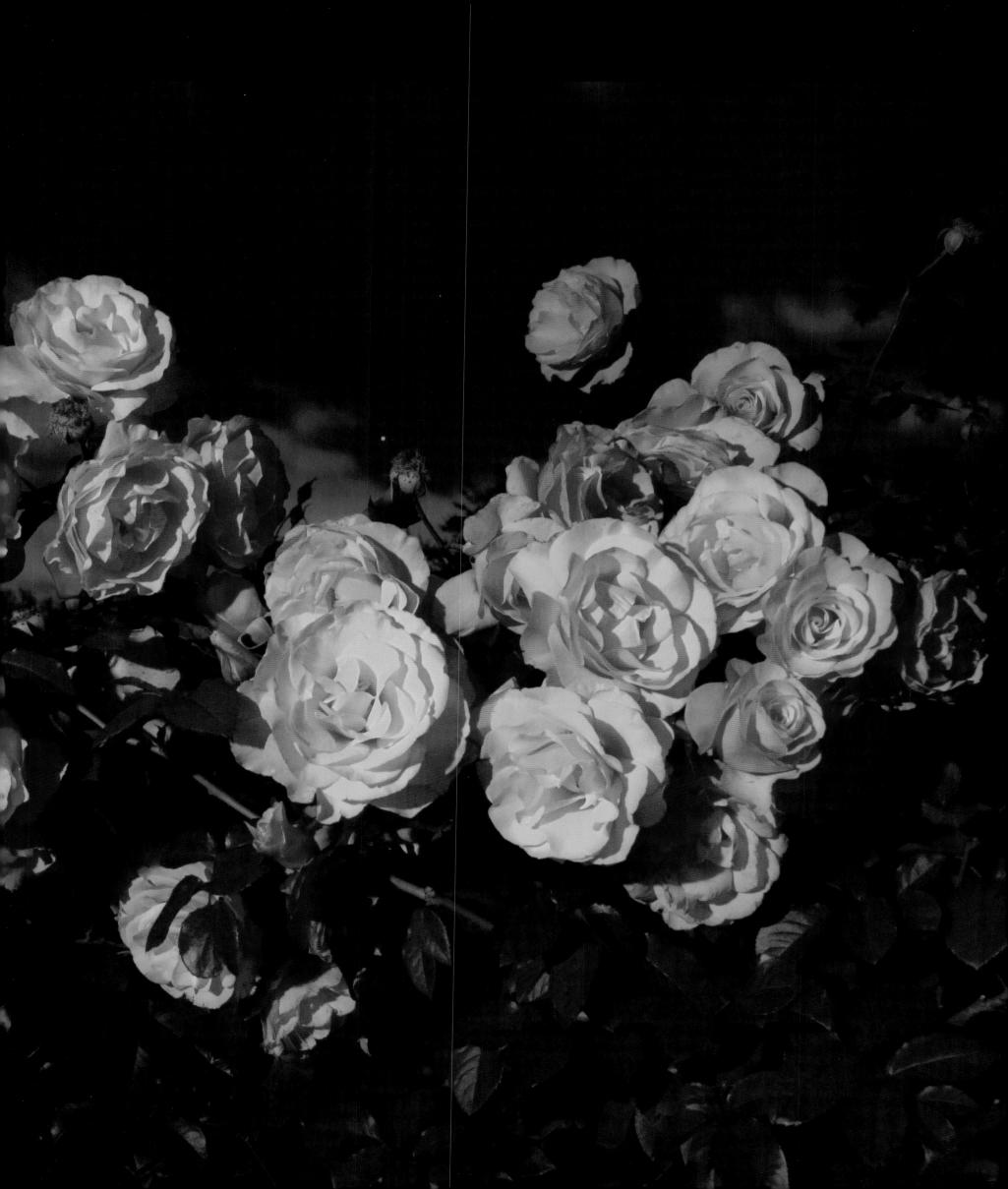

ARTIST'S STATEMENT

BY LINDA RUTENBERG

ONE NIGHT IN A GARDEN, thanks to a simple magazine assignment, proved to be the beginning of an extraordinary journey.

I had been photographing cities, parks, and gardens for twenty-five years, but until that night I had never recognized how darkness could provide such a significant and magnificent setting.

In July 2005 I was commissioned by *Landscape Architecture* magazine to take photographs at the annual International Garden Festival at Reford Gardens in Grand-Métis, Quebec. The festival brings together twenty landscape architects from around the world to create contemporary gardens. The director, Alexander Reford, suggested that the early morning would provide the best light and offered to open the garden for me. I, in turn, requested permission to roam about and photograph the garden throughout the night. He immediately agreed.

That night, my husband, Roger Leeon, and I spent several trying hours in the historical gardens attempting to illuminate pathways, trees, and individual flowers with flashlights. Despite the difficulties, the resulting images captured my imagination.

Several weeks later, the Montreal Botanical Garden's annual Chinese Lantern Festival provided another opportunity for nighttime access, this time in a different garden. The Festival's colorful paper shapes highlighted the plants and trees, revealing their sensuous mystery. The photographs I took using basic ambient light and long exposures were spellbinding, and I knew at once I had discovered an original and exciting project.

Thus inspired, I set off to visit twenty public gardens across the United States and Canada. I chose only publicly accessible, much-visited gardens, as I wanted to reveal a familiar place in a novel guise. I intended my images to transcend the literal and unveil the extraordinary poetic, lyrical, and sensory richness of the nocturnal garden.

To spend the night in each of these gardens was a special privilege. The calm and tranquility infused with the scent of damp earth was almost overwhelming. It felt primordial, as if my husband and I were the only two beings on earth, suspended in time. Gardens at night, I discovered, are spiritual places.

I selected each garden for its historical, cultural, and architectural importance, with an emphasis on the plant collections. I also wanted my images to capture the spirit and essence of the individual gardens, to interpret their botanical mission.

Most of the gardens we visited are in or near large cities, and therefore the night sky was always bright. We used no traditional photographic lighting—just moonlight, the reflection of city lights, garden lighting, and, occasionally, a little handheld beam to emphasize the textures and sculptural quality of the plants.

The resulting photographs unearth an extraordinary secret—plants and flowers that appear commonplace by day turn into something ethereal by the light of night. I'm intrigued by the ambiguity of scale, deep recesses of space that fade into darkness, and infinity of rich textures and lustrous surfaces that are revealed in these photos. I want, most of all, to share my sense of wonder with others.

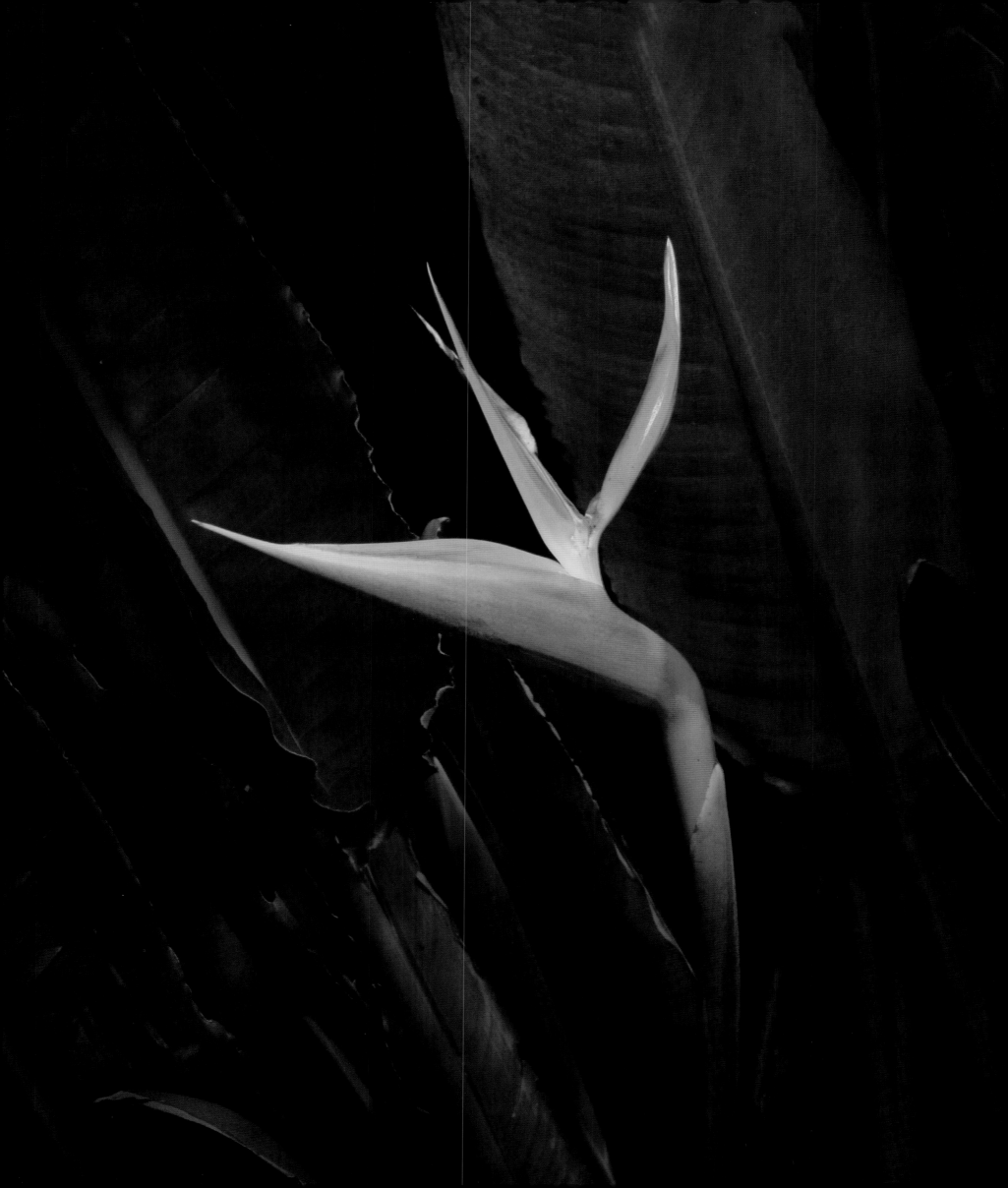

GARDEN INDEX

Atlanta Botanical Garden
1345 Piedmont Avenue NE, Atlanta, GA 30309
info@atlantabotanicalgarden.org
www.atlantabotanicalgarden.org/home.do

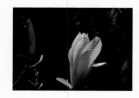

Descanso Gardens
1418 Descanso Drive, La Cañada Flintridge, CA 91011
pr@descansogardens.org
www.descansogardens.org

Brooklyn Botanic Garden
1000 Washington Avenue, Brooklyn, NY 11225
visitorservices@bbg.org
www.bbg.org

Desert Botanical Garden
1201 N. Galvin Parkway, Phoenix, AZ 85008
administration@dbg.org
www.dbg.org

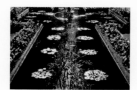

Butchart Gardens
800 Benvenuto Avenue, Brentwood Bay, BC, Canada V8M 1J8
email@butchartgardens.com
www.butchartgardens.com/main.php

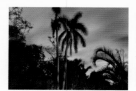

Fairchild Tropical Botanic Garden
10901 Old Cutler Road, Coral Gables, FL 33156
Phone: 305-667-1651
www.fairchildgarden.org

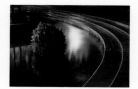

Chicago Botanic Garden
1000 Lake Cook Road, Glencoe, IL 60022
Phone: 847-835-5440
www.chicagobotanic.org

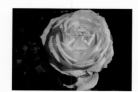

Harry P. Leu Gardens
1920 North Forest Avenue, Orlando, FL 32803
Phone: 407-246-2620
www.leugardens.org

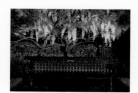

Dallas Arboretum
8525 Garland Road, Dallas, TX 75218
Phone: 214-515-6500
www.dallasarboretum.org

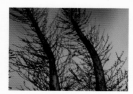

The Huntington Library, Art Collections, and Botanical Gardens
1151 Oxford Road, San Marino, CA 91108
publicinformation@huntington.org
www.huntington.org

Longwood Gardens
1001 Longwood Road, Kennett Square, PA 19348
infodesk@longwoodgardens.org
www.longwoodgardens.org

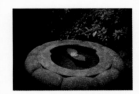

Royal Botanical Gardens
680 Plains Road, West Burlington, Ontario, Canada L7T 4H4
info@rbg.ca
www.rbg.ca

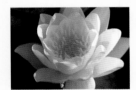

Missouri Botanical Garden
4344 Shaw Boulevard, St. Louis, MO 63110
Phone: 314-577-9400
www.mobot.org

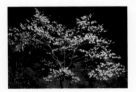

San Francisco Botanical Garden
9th Avenue at Lincoln Way, San Francisco, CA 94122
info@sfbotanicalgarden.org
www.sfbotanicalgarden.org

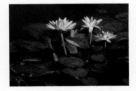

Montreal Botanical Garden
4101, rue Sherbrooke Est, Montréal, Québec, Canada H1X 2B2
jardin_botanique@ville.montreal.qc.ca
www2.ville.montreal.qc.ca/jardin/en/menu.htm

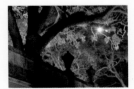

United States National Arboretum
3501 New York Avenue, NE, Washington, DC 20002
Phone: 202-245-2726
www.usna.usda.gov

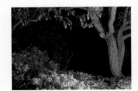

New York Botanical Garden
200th Street and Kazimiroff Boulevard, Bronx, NY 10458
Phone: 718-817-8700
www.nybg.org

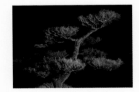

Vizcaya Museum and Gardens
3251 South Miami Avenue, Miami, FL 33129
vizcayainformation@vizcayamuseum.org
www.vizcayamuseum.org

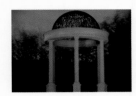

Reford Gardens
200, route 132, Grand-Métis, Québec, Canada G0J 1Z0
info@jardinsmetis.com
www.jardinsmetis.com/english

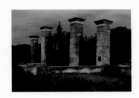

Washington Park Arboretum
University of Washington, Box 358010, Seattle, WA 98195
uwbg@u.washington.edu
depts.washington.edu/wpa

PLANT INDEX